Technicolor Movies

TECHNICOLOR MOVIES

The History of Dye Transfer Printing

by RICHARD W. HAINES

McFarland & Company, Inc., Publishers
Jefferson, North Carolina, and London

British Library Cataloguing-in-Publication data are available

Library of Congress Cataloguing-in-Publication Data

Haines, Richard W., 1957–
 Technicolor movies : the history of dye transfer printing / by
Richard W. Haines.
 p. cm.
 Includes bibliographical references and index.
 ISBN 0-89950-856-1 (lib. bdg. : 55# alk. paper) ∞
 1. Color cinematography — Printing processes — Dye transfer —
History. 2. Color motion pictures — United States — History.
I. Title.
TR853.H28 1993
778.5′342 — dc20 92-56648
 CIP

Manufactured in the United States of America

McFarland & Company, Inc., Publishers
 Box 611, Jefferson, North Carolina 28640

This book is dedicated to Herbert Kalmus,
who created the best and most durable
color film process ever used on a commercial basis
and to three filmmakers who used it artistically:

Alfred Hitchcock David O. Selznick Michael Powell

and to Mary Woodard and the families

ACKNOWLEDGMENTS

This book would not have been possible without the assistance of the following individuals and institutions:

Beijing Film and Video Lab, Larry Benequist, Robert E. Carr, Lawrence Cohn of *Variety*, Eddie Cochran and the staff of the American Film Institute, Joanna Conner of the *Plain Dealer*, Leslie Delano, Lester Delano and Robert Lasky, Jr., of the Classicolor Company, Robert DePietro of Mead Films, Richard Ducar, John Ewing of the Cleveland Cinematheque, Eric Federing, Robert Frischmuth of RAF Productions, Dr. Richard Goldberg, Richard D. Haines, Lesia Haines, Robert A. Harris, John Harvey, Frank Houser, Jeff Joseph, Bob Leader, Al Lofquist, John Lozowski, Richard P. May, Kevin Miller and Harry Pearson of the *Perfect Vision*, Robert Osborne of the *Hollywood Reporter*, Paramount Center of the Arts, Dave Parker of the Library of Congress, Jim Pollit, Steve Pond of the *Washington Post*, Douglas Pratt of the *Laserdisc Newsletter*, Jack Rizzo, Frank Santopadre of *Cinefantastique*, Jeffrey Selznick, Martin Scorsese, Stan Solo, Ray Sundlin, Eric Spilker, the Smithsonian Air and Space Museum, James Vernon, William Ward, Pete Warren, Mary Woodard, and Gary Weyer.

CONTENTS

Acknowledgments vii

Preface xiii

Introduction xv

1 TWO STRIP TECHNICOLOR 1

Technicolor Process Number One: Two Strip Additive Color 1
Technicolor Process Number Two: Two Strip Cemented
 Positive 4
Technicolor Process Number Three: Two Strip Dye Transfer 8
The Matrix 11
The Blank 12
Two Strip Technicolor in the Thirties 13

2 THREE STRIP TECHNICOLOR 17

Technicolor Process Number Four: Three Strip Dye Transfer 17
Successive Exposure Animation 17
Live Action Photography 19
The Three Strip Camera, 1932–1955 21
Three Strip Matrices 23
The Gray Printer 24
Color Timing 24
Opticals 25
Reclaim Blank 26
Color Consultant 27
Monopack 27
True Life Adventures 29

Blue Track Technicolor 30
16mm Dye Transfer Prints 30
The British Lab 31
The Technicolor Package 32
Technicolor Films in the Thirties and Forties 35

3 CONSENT DECREE 49

Distribution Versus Exhibition 49
The Government Versus Technicolor 51
Eastmancolor Negative 53
Other Color Processes 56
Safety Base Film 59
Television 60

4 THE FABULOUS FIFTIES 65

Technicolor Process Number Five: Three Strip Dye Transfer
 Print Derived from Color Negative 66
Cinerama 66
3-D 69
CinemaScope 74
VistaVision 81
Widescreen "Flat" Films 86
First Generation Opticals 86
The Wet Gate Optical Printer 87
Thrillarama 99
CinemaScope 55 99
Superscope 100
Todd AO 102
Technirama and Super Technirama 106
Panavision 108
Other Anamorphic Systems 112
MGM Camera 65 and Ultra Panavision 70 113
Technicolor Italiana 116
End of an Era 116

5 DECLINE AND DEMISE 121

This "Was" Cinerama 121
Kalmus Dies 124

Techniscope 125
Super Panavision 70 and Panavision 70 128
Automatic Selective Printing 128
Sovscope 70 129
8mm and Super 8mm Dye Transfer 130
Technicolor on Television 130
Color Reversal Internegative 131
Demise 132
Technicolor Process Number Six: Eastmancolor 134
Purge 135
Decline in Exhibition 136
The Platter 136
Fallout 136

6 EASTMANCOLOR TODAY 139

Continuous High Speed Contact Printer 139
The Beijing Film Lab 140

Bibliography 145

Index 149

PREFACE

This book is the result of ten years of research which included the screening of hundreds of original dye transfer prints in the various formats and firsthand interviews with many of the surviving technicians who worked at Technicolor during the years 1932–1975. The author talked to archivists who gave accurate information on motion picture base and image stability and spent one week at the Beijing Film Lab, the last surviving imbibition plant in the world.

With few exceptions, this book deals exclusively with feature films printed in the dye transfer process at the U.S. Technicolor plant. To examine the sheer volume of short subjects, industrials, documentaries and cartoons printed at the facility combined with foreign films printed at the London and Italian plants would have required a separate book. This book lists as many features printed in the dye transfer process as could be verified through archives and film collectors. However, it was not uncommon for Technicolor to do other labs' release printing without noting it in the credits (e.g., imbibition prints of *Giant* labeled as "Color by WarnerColor"). Therefore, there may be other features printed in the process not contained on the lists.

For those people who remember the days when color meant "Technicolor" and movies looked far more beautiful than real life, this book will serve as a reference to the process that made them look so "Glorious" as well as a history of motion picture color in general. It is the author's goal to inspire young filmmakers to preserve the worldwide color film legacy and bring back quality release printing to the general public.

— Richard W. Haines

INTRODUCTION

The lights dimmed in the Paramount Center of the Arts, a restored movie palace in Peekskill, New York. Theatrical exhibitor Robert Frischmuth walked up to the stage and announced, "Ladies and Gentlemen, welcome to our 'Glorious Technicolor' Festival. Tonight we're not only celebrating a film but the process it was printed in . . ."

The screening began and a breathtaking 35mm dye transfer print of *Around the World in 80 Days* was shown. The quality of the projected film was spectacular, and many viewers under the age of thirty had never seen anything like it. The image was razor sharp and had no apparent grain. The vibrant primary colors seemed to glow from the screen in a three dimensional relief. Certain hues like red and purple had a unique intensity, and blacks were pitch black.

The Glorious Technicolor Festival, which ran in 1988, lasted for six weeks. Original dye transfer prints of classics like *The Wizard of Oz, West Side Story* and *It's a Mad, Mad, Mad, Mad World* were shown to enthusiastic audiences. Everyone commented how vastly superior Technicolor prints looked compared to Eastmancolor copies shown in theaters today. They asked the obvious question: Why didn't anyone use Technicolor anymore?

The answer was simple. The Technicolor company no longer offered the process that made them "The Greatest Name in Color" for 40 years. In 1975, the company shut down its proprietary dye transfer printing method and switched over to the less impressive Eastmancolor process. Given precise lab work (which was rare), Eastmancolor prints looked good but not "glorious." The dyes were not as vibrant as those used in the Technicolor process. Primary colors were not as vivid and blacks were transparent. This resulted in

weak contrast and more apparent grain. Put another way, a viewer "watched" an Eastmancolor print but "experienced" a Technicolor print.

Technicolor copies not only looked better, they aged better. The earliest surviving dye transfer prints still have their colors intact. All negatives and prints made in the Eastmancolor process prior to 1983 faded.

Several years after Technicolor shut down their machines in the United States, the British and Italian plants switched over to contact printing, leaving the Beijing Film Lab as the only facility that still used the dye transfer process. In 1989, I traveled to China to make dye transfer prints of the feature *Space Avenger*, which played theatrically in the United States. The reintroduction of Technicolor attracted a great deal of interest in, as well as misinformation and inaccuracies about, the process. The time seemed right to tell the complete story of the best and most durable color film process ever used on a commercial basis.

Two Strip Technicolor

TECHNICOLOR PROCESS NUMBER ONE:
TWO STRIP ADDITIVE COLOR

The story of the Technicolor process began in the year 1912, when the firm of Kalmus, Comstock and Wescott was formed. Herbert Kalmus (1881–1963) was an aspiring chemist who received a bachelor of science degree from Massachusetts Institute of Technology. Among his associates was a young art student named Natalie Dunfee, whom he had married in 1902.

Another classmate was Daniel Comstock, whom Kalmus traveled with to Europe on a graduate fellowship. Kalmus received his doctorate from the University of Zurich, and Comstock received his from Basel.

The third man in the partnership was W. Burton Wescott, a mechanical wizard who acted as their technical consultant. Initially, the company functioned as an industrial research and development council for scientific problem solving. One of its clients was an independent company of abrasive manufacturers that was having trouble competing with the process used by Carborundum, another company. Kalmus and associates were able to develop a similar process that produced silicon carbide without infringing upon existing patents.

The success of this deal gave Kalmus, Comstock and Wescott enough clout to branch off into a new and potentially rewarding field, color motion pictures. Up till then, the production of color film had been limited to tinting and toning black and white release prints, hand stenciling frames and utilizing complicated additive color systems that required special projectors. These techniques were

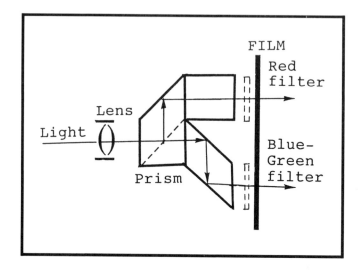

Fig. 1. Optical system of 1917 Technicolor camera.

cumbersome and could hardly be considered an accurate rendering of a color image.

Kalmus realized that whoever came up with a viable color film process could corner the market, which he eventually did. However, the first attempts by the company were only minor improvements over what was already available. Comstock designed a new camera that would take simultaneous exposures of the same image through two color filters, one red and the other green (fig. 1).

For projection, the double frame image was shown with filters and a prism that combined them for a two color effect (fig. 2). This was a slight improvement over a process developed by the Kinemacolor Company, which exposed the same filtered two frame image successively rather than simultaneously. Because the Kinemacolor system exposed two different images, severe fringing was obvious whenever the subject moved. Comstock's method alleviated this problem because the two frames were a simultaneous exposure of the same image.

In 1915, Kalmus, Comstock and Wescott formed another company called Technicolor, the fragment "Tech" being derived from their alma mater, MIT. A feature film was produced to show off the new process, which was referred to as Technicolor Process Number One, or "additive color."

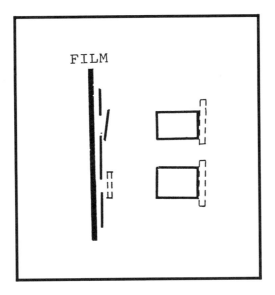

Fig. 2. Two color additive projector.

The name of the feature was *The Gulf Between*, with principal photography taking place in Florida. In 1917, a portable lab was made in a railroad car in Boston, where the Technicolor company was first located. This unique lab had the ability to develop negatives and make positive black and white release prints. The release prints in Technicolor Process One did not contain dyes. The color was "added" by tinted filters on the projectors. Comstock brought three of his physics students from MIT — Leonard Troland, Joseph Ball and Eastman Weaver — into the corporation to assist in the development of the process.

The Gulf Between premiered on September 21, 1917, at the Aeolian Hall in New York City. The screening was not a success. Unfortunately, Comstock had not compensated for the level of technical expertise of most projectionists. While the prism used to combine the two filtered images had the potential of alleviating fringing, the precise adjustment was beyond the capabilities of the average operator. As a result, severe color fringing was apparent. It was clear that a new system had to be invented that could be projected in a conventional manner by anyone.

Technicolor Process Number Two: Two Strip Cemented Positive

In the basement of the building occupied by Kalmus, Comstock and Wescott in Boston, another pilot plant was opened to develop Technicolor Process Number Two. This two color method was subtractive rather than additive; the hues were contained on the release copy rather than added by filters on the projector.

Principal photography was done with a new camera that exposed the dual red and green filtered black and white negative images simultaneously. A new prism was used in this unit which exposed the green record upside down (fig. 3). The technique was developed under the direction of Leonard T. Troland, Comstock's former pupil, who later became Technicolor's research director. This kind of negative was used for both cement positive and dye transfer two strip films (fig. 4).

To make release prints, a special film stock was used which was known as a matrix. A matrix was a black and white positive stock that contained silver halides (which generated the latent image) and a

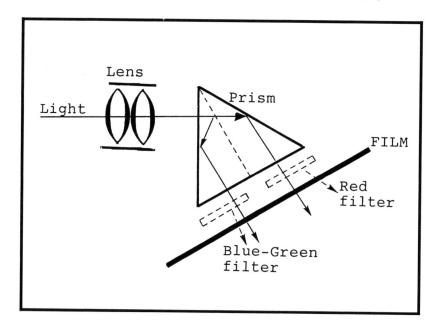

Fig. 3. Optical system of two strip Technicolor camera, 1922–32.

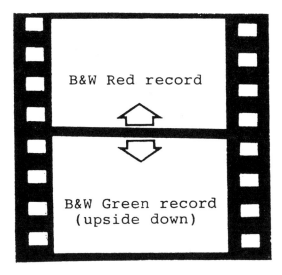

Fig. 4. Two strip Technicolor negative.

gelatin that hardened during development and replicated the latent silver image in "relief." (Matrix manufacture will be described in greater detail in the next chapter.)

This special kind of matrix stock was half the thickness of conventional 35mm film. The negative was exposed through the base of the thin matrix stock to generate the appropriate color record on a step printer. First, the black and white silver record of the red layer was exposed onto the matrix stock. The negative was then flipped upside down so the green silver record could be exposed onto another roll of the thin matrix stock.

The two matrices (each half the thickness of normal stock) were cemented together and then dyed by flotation with the appropriate red-orange and blue-green dyes to make a two color release print with normal thickness that could be projected conventionally (fig. 5). This technique was actually an early variation of the dye transfer process with an important difference: the matrices were used for direct screening rather than for simply transferring dyes onto a release print.

With the improved two color technique, Technicolor made a deal with Joseph Schenck (who produced many of the Buster Keaton silents) to supervise the first production in this process as well as secure distribution through the Metro Film Company (which later

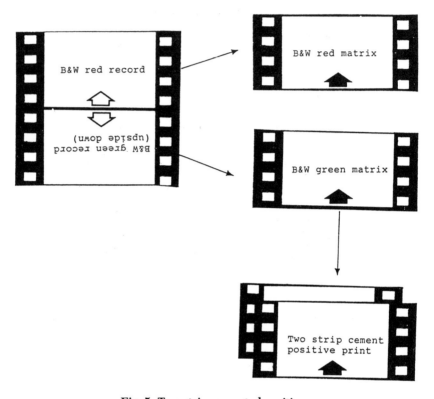

Fig. 5. Two strip cemented positive.

merged to become Metro-Goldwyn-Mayer). The feature was *Toll of the Sea,* a Chinese version of *Madame Butterfly,* which starred Anna May Wong.

The premiere was held at the Rialto Theater in New York on November 26, 1922, with a general release following in 1923. The film grossed more than $250,000, of which the Technicolor company received approximately $165,000. It was the first time the hard work of Kalmus, Comstock and Wescott had shown a return.

Plant number two was built in Boston in a building adjoining the pilot plant (the basement of the Kalmus, Comstock and Wescott offices). Shortly afterward, a small laboratory was set up in Holly-wood in a rented building that served as West Coast headquarters. (Technicolor later developed their West Coast operation into the landmark facility located at Cole and Romaine in Hollywood.)

The next feature to use the cement positive process was Cecil B.

DeMille's *The Ten Commandments,* although this time the color was limited to special sequences. *Wanderer of the Wasteland,* an outdoors Western from Paramount, was the next all color feature.

Samuel Goldwyn's *Cytherea* marked the first time artificial lighting was used. The black and white negative stock that was used in the Technicolor cameras was slow and required extensive lighting for an exposure. As a result, the actors practically baked under the hot klieg lights. Still, color film was an exploitable entity, and in 1925 six studio releases containing Technicolor scenes and one all color independent short, *Marionettes,* featured the cement positive process.

The big break came in 1926 when Douglas Fairbanks made a deal to shoot his million dollar epic (a huge sum for the era) *The Black Pirate* in the process. Although the picture was a financial success, inherent flaws in the cement positive method plagued the release.

The first flaw was the difficulty in color correcting each shot to match precisely or make a usable set of dyed matrices. A great deal of film was wasted before an acceptable release copy was made. The second flaw was in the tendency for the film to "cup" in the extended runs. Prints had to be sent back to Technicolor for "decupping" after each theatrical date.

The most serious problem was when the cemented films started to come apart. The standard illumination for projectors at the time was the carborn arc lamphouse. A burning carbon filament generated the high intensity white light, which proved to be too extreme for the cement to hold. Considering the flammability of pre–1950 nitrate film, this was also a fire hazard. A long-term problem with the dyes was poor stability. Cement positive Technicolor prints eventually faded to orange.

During the year 1927, the research department started to work on an improved release printing method, while five more films were made using the cement positive system for sequences or the entire feature.

TWO STRIP ADDITIVE COLOR FEATURES

35mm Additive Color silent features derived from double frame
black and white negative (all features printed on nitrate base)

The Gulf Between (Technicolor, 1917)	Way Down East (sequences) (UA, 1920)

TWO STRIP CEMENT POSITIVE FEATURES

35mm Cement Positive silent features derived from double frame
black and white negative (all features printed on nitrate base)

Toll of the Sea (Metro, 1922)
The Ten Commandments (se-
 quences) (Par, 1923)
Cytherea (First National, 1924)
The Uninvited Guest (sequences)
 (MGM, 1924)
Wanderer of the Wasteland (Par,
 1924)
The Big Parade (sequences) (MGM,
 1925)
The King on Main Street (se-
 quences) (Par, 1925)
Marionettes (short subject) (Ind,
 1925)
The Merry Widow (sequences)
 (MGM, 1925)
The Phantom of the Opera (se-
 quences) (U, 1925)
Pretty Ladies (sequences) (MGM,
 1925)

Seven Chances (sequence) (MGM,
 1925)
Stage Struck (sequences) (Par, 1925)
An American Venus (sequences)
 (Par, 1926)
Beau Geste (sequences) (Par, 1926)
Ben-Hur (sequences) (MGM, 1926)
The Black Pirate (UA, 1926)
Irene (sequences) (Fox, 1926)
Michael Strogoff (sequences) (UA,
 1926)
The Fire Brigade (sequences)
 (MGM, 1927)
The Flag (short) (Technicolor/MGM,
 1927)
A Gentleman of Paris (insert) (Par,
 1927)
The King of Kings (sequences)
 (Pathé, 1927)
The Joy Girl (Fox, 1927)

TECHNICOLOR PROCESS NUMBER THREE: TWO STRIP DYE TRANSFER

A crucial step in the Technicolor process was taken in 1928 with
the introduction of dye transfer printing, referred to by the company
as Technicolor Process Number Three. The two strip negatives were
exposed in the same fashion as in the cement positive method, with
the red record appearing normally and the green record flipped up-
side down beneath it on the black and white negative.

The major change was in the method used to make the release
prints. Rather than manufacturing a thin dyed matrix and cementing
it together for direct screening, the company coated a normal
thickness 35mm matrix with the appropriate dye and transferred it
onto a special blank stock. The matrix and blank would come into
direct contact in a machine that used pressurized rollers to emboss
the dyes into blank. The process was also referred to as imbibition
printing (fig. 6). With modifications (the addition of the third color

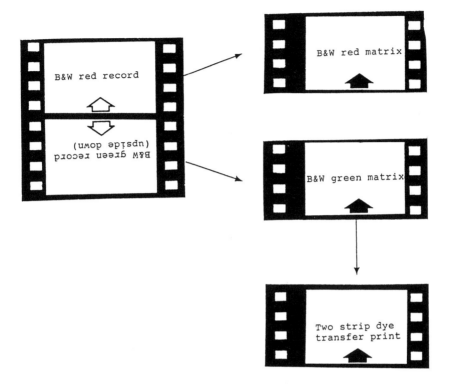

Fig. 6. **Two strip dye transfer.**

in 1934), this process of imbibing dyes from a matrix onto blank stock became the standard of Technicolor release print manufacture through 1974.

Another breakthrough was the addition of a soundtrack to accompany the two strip Technicolor images. In 1926, Warner Bros. introduced the first successful synchronized sound system, called Vitaphone, to *Don Juan,* starring John Barrymore, and to numerous short subjects. Vitaphone was a cumbersome process that mechanically interlocked an oversized wax disc record with a standard 35mm release print. The record contained a start mark (or "pit"), as did the film leader. When the projector was started, the interlocked record player (synchronized with a belt) began to play the soundtrack, which was amplified through horn-type speakers placed behind the screen.

Don Juan had no dialogue, and the soundtrack was limited to

sound effects and music. In the next Vitaphone feature, *The Jazz Singer,* Al Jolson not only sang but ad-libbed a few lines. The film became a top grossing picture of 1927. The success of Vitaphone was probably more attributed to the star power of Al Jolson than to the quality of the sound, which was far from perfect. Numerous synchronized sound systems had been introduced earlier but had made little impact. It was the novelty of hearing Jolson tell the audience "You ain't heard nothin' yet" that made sound films commercially viable.

Following the release of *The Jazz Singer,* the competing studios scrambled to create their own synchronized sound systems. The most notable ones were Western Electric's Movietone and RCA's Photophone methods. Both processes contained photographed optical soundtracks that were printed onto the left side of the frame, resulting in an unacceptably elongated image when the film was projected. Labs later modified the release copies by surrounding the image with a 1.33 × 1 black border to compensate for the track area. A sound reader was bolted to the bottom of the silent projectors. A low intensity optical bulb behind a tiny lens focused the light beam and "read" the optical soundtracks, converting the photographed sound waves into electrical impulses that were amplified through the same horn-type speakers used for Vitaphone.

The advantanges to the sound on film versus synchronized wax disc were obvious to exhibitors. The wax records wore out quickly and were subject to the "snap, crackle and pop" of most phonograph recordings of the era. In addition, if the print snapped and lost frames, the entire thousand foot reel would be out of synch. It was also difficult to mix the records without a loss of quality. When background music was required in early Vitaphone films, it had to be played live on the set.

The photographed optical soundtrack lasted the life of the print, and if frames were lost, there might be a word missing but the track would remain in synch and was thus foolproof in terms of exhibition. It was also possible to record separate optical tracks of the dialogue, sound effects and music and mix them to make a final composite optical track negative, from which quality release copies could be derived.

The difference between the Movietone optical track (used by Fox, MGM and Paramount) and the Photophone optical track (used by RKO, Tiffany and Pathé) was as follows: The Movietone system

used a variable density track, which had to be processed precisely. If the soundtrack was printed too lightly or darkly, it sounded muffled and distorted. The Photophone system used a variable area track, which did not have as wide a range as the density track, since the size was limited by the portion of the frame allotted for the soundtrack. However, the processing was not as critical as it was with the density track. If the area track was a little off in terms of labwork, the sound would still be acceptable. Both kinds of optical tracks were used by the industry until the late 1950s, when the variable density track was phased out.

The first dye transfer feature to use a Movietone optical track was *The Viking* in 1928. The mix was limited to sound effects and music. In 1929, 14 features with Technicolor sequences used the Movietone track, six features were released with the Photophone track and only four used the Vitaphone method. The latter would have been printed full frame without an optical track.

Since the new matrix and blank stock were so vital to understanding the dye transfer process, each element will be examined in greater detail.

THE MATRIX

As previously mentioned, the matrix used in the dye transfer process was a special black and white print stock that contained both silver halides and gelatin. In the printer, light was exposed through the emulsion (the side of the film that contains an image) of the camera negative onto the base (the side of the film that is clear and has no image) of the matrix stock. The matrix was then processed like a conventional black and white print with the following modifications: The developing solution contained agents to develop the silver halides into a latent image as well as a chemical called pyrogallol. Pyrogallol hardened the gelatin in the same areas of the silver latent image. A warm water jet removed the residue gelatin not used in replicating the silver densities. The end result was a black and white positive print of one color that had a gelatin relief image. A matrix could be summarized as a "rubber stamp" impression of one color on film similar to the printing plates used in lithography.

To adjust the contrast in each matrix after exposure in the printer, the undeveloped matrix would be "flashed" (exposed to light

again in a special machine) prior to development. After a series of tests was done, a "flash card" for the matrix (which indicated the proper voltage on the flasher lamp) was saved so additional matrices could be manufactured at the desired exposure over and over again, depending on the customer order. After flashing the matrix, it went into the developer as described above.

Depending on the voltage of the flash, the contrast (lightness or darkness of the final release print) could be altered to the desired effect. For example, if a dark night scene was required, the matrix would be underexposed. At first, the manufacture of matrices was pure guesswork. Eventually, during the three strip years, it became a science, and the technicians were able to generate a usable set in only two or three tries. In the twenties, it took many more attempts before an acceptable set of matrices was manufactured for dye transfer release printing.

Another function of the matrix flashing was to alleviate apparent grain. Generally speaking, the darker the contrast, the less apparent grain is to the audience and the greater the appearance of sharpness. Dye transfer prints were usually made with above average contrast, which gave them less apparent grain than other color processes. The rich contrast often made the dyes stand out in relief and generated a three dimensional illusion.

THE BLANK

The blank stock the dyes were transferred onto was a black and white positive film that contained mordant, a chemical with an affinity for dye. It literally locked the dyes into the emulsion of the film as they were transferred. Without mordant, the dyes would have smeared all over the release print or rubbed off. Over the years, different methods were used, including adding mordant to the film after soundtrack development. For most releases, mordant was contained in the emulsion of the blank.

In the two strip dye transfer technique, there were two methods of imbibing the dyes. For Vitaphone films (which contained no optical soundtrack), the blank was washed clean of all silver and transferred onto the clear emulsion. For Movietone and Photophone features, the blank first had to go through a printer, where the silver optical soundtrack was exposed and developed prior to the transfer

of the dyes. In some cases, a latent halftone key image of the black-and-white green record was exposed prior to development, another method of altering the shadow detail and contrast. Since most three strip productions contained a latent black and white key image, this process will be covered in greater detail in the next chapter.

To summarize the dye transfer process: Blank film would first have a silver soundtrack exposed, then a black and white halftone key image (in some cases) and 1.33 × 1 framelines exposed prior to development. After processing, the blank (which now contained a 1.33 × 1 mask and soundtrack) would travel on rollers to the imbibition machines. The blank film would come into contact with the matrix, which had previously been coated with dye. The dye transfer machine contained a pin belt, which held the matrix and blank in place as they came into contact. The pin belt had two sets of registration pins, one normal size and the other reduced size to compensate for shrinkage. The result was a two strip dye transfer release print with a silver black-and-white optical soundtrack. (The silver soundtrack, or "gray track," was one easy method of identifying both two and three strip Technicolor prints.)

TWO STRIP TECHNICOLOR IN THE THIRTIES

From 1930 through 1934, the two strip process continued to be used primarily for selected scenes and only occasionally for entire features. Films like *Hell's Angels, Mammy* and *Paramount on Parade* all had two-color sequences. Among the notable full length all color films were Universal's *King of Jazz* and MGM's *The Rogue Song*, which costarred Laurel and Hardy in their only Technicolor production (only one sequence from this film has survived).

The number of productions that used the process declined by 1933 with the production of only two notable all color features, *Doctor X* and *Mystery of the Wax Museum*. It was clear that interest was waning in the limited range of colors which was considered by most critics to be a gimmick rather than an artistic choice. The other problem facing Technicolor was mediocre quality control in the company's limited space. Many two strip dye transfer prints had apparent grain caused by improperly exposed matrices and reels with an inconsistent color balance. It was clear Kalmus had to add the third color and expand his operation or go out of business.

From The Vagabond King,
starring DENNIS KING,
with JEANETTE MacDON-
ALD (Paramount).

A year ago it was SOUND that brought big business to

the box-office. Today it is COLOR. And Color means Technicolor.

The whole world is unanimous as to Technicolor. The greatest

producers are making pictures in Technicolor as fast as Techni-

color's cameras and laboratories can turn out the prints.

Technicolor Hits
are the Big Hits

TWO STRIP TECHNICOLOR FEATURES

35mm dye transfer silent features derived from black and white
double frame negative (all features printed on nitrate base)

Casanova (sequences) (MGM, 1928)
Court Martial (Col, 1928)
None but the Brave (Fox, 1928)
Red Hair (sequence) (Par, 1928)

The Water Hole (Par, 1928)
The Wedding March (sequences)
(Par, 1928)

TWO STRIP TECHNICOLOR FEATURES

35mm dye transfer features derived from black and white
double frame negative with synchronized soundtracks (some part talkie)
(all features printed on nitrate base)

[1]The Viking (Technicolor/MGM, 1928)
[1]Broadway (sequences) (U, 1929)
[1]Broadway Melody (sequences) (MGM, 1929)
[2]The Cuckoos (sequences) (RKO, 1929)
[1]Dance of Life (sequences) (Par, 1929)
[1]Devil May Care (MGM, 1929)
[3]The Desert Song (sequences) (WB, 1929)
[1]Footlights and Fools (First National, 1929)
[1]Glorifying the American Girl (sequences) (Par, 1929)
[3]Gold Diggers of Broadway (WB, 1929)
[1]Good News (sequences) (MGM, 1929)
[1]His First Command (sequences) (Pathé, 1929)

[1]Hollywood Revue of 1929 (sequences) (MGM, 1929)
[1]Loves of Casanova (MGM, 1929)
[2]Mamba (Tiffany, 1929)
[1]Mysterious Island (MGM, 1929)
[3]On with the Show (WB, 1929)*
[1]Paris (sequences) (First National, 1929)
[2]Peacock Alley (sequences) (Tiffany, 1929)
[1]Pointed Heels (sequences) (Par, 1929)
[2]Radio Rambler (sequences) (RKO, 1929)
[2]Red Hot Rhythm (sequences) (Pathé, 1929)
[1]Redskin (Par, 1929)
[2]Rio Rita (sequences) (RKO, 1929)
[3]The Show of Shows (WB, 1929)

[1]*Movietone* [2]*Photophone* [3]*Vitaphone* *First all talking two strip Technicolor feature.*

TWO STRIP TECHNICOLOR FEATURES (TALKIES)

35mm all talking dye transfer features with optical tracks
derived from black and white double frame negative
(all features printed on nitrate base)

Ben-Hur (sequences) (reissue) (MGM, 1930)
Bride of the Regiment (First National, 1930)

Bright Lights (First National, 1930)
Chasing Rainbows (sequences) (First National, 1930)
Dixiana (sequences) (RKO, 1930)

The Floradora Girl (sequences) (MGM, 1930)

Follow Thru (Par, 1930)

General Crack (sequences) (WB, 1930)

Golden Dawn (WB, 1930)

Hell's Angels (sequences) (Hughes/UA, 1930)

Hit the Deck (sequences) (MGM, 1930)

Hold Everything (WB, 1930)

Hollywood Revue of 1930 (sequences) (MGM, 1930)

It's a Great Life (sequences) (MGM, 1930)

King of Jazz (U, 1930)

Leathernecking (RKO, 1930)

Life of the Party (WB, 1930)

Lord Byron of Broadway (sequences) (MGM, 1930)

Lottery Bride (sequences) (UA, 1930)

Mammy (sequences) (WB, 1930)

The March of Time (unreleased) (MGM, 1930)

The Melody Man (Col, 1930)

No, No, Nanette (sequences) (First National, 1930)

Paramount on Parade (sequences) (Par, 1930)

Phantom of the Opera (reissue) (U, 1930)

Puttin' on the Ritz (sequences) (UA, 1930)

The Rogue Song (MGM, 1930)

Sally (First National, 1930)

Showgirl in Hollywood (sequences) (First National, 1930)

Son of the Gods (sequences) (First National, 1930)

Song of the Flame (sequences) (First National, 1930)

Song of the West (WB, 1930)

Sweet Kitty Bellairs (WB, 1930)

They Learned About Women (sequences) (MGM, 1930)

Toast of the Legion (sequences) (First National, 1930)

Under a Texas Moon (WB, 1930)

The Vagabond King (Par, 1930)

Whoopee (Goldwyn/UA, 1930)

Fanny Foley Herself (sequences) (RKO, 1931)

Fifty Million Frenchmen (WB, 1931)

Kiss Me Again (First National, 1931)

The Runaround (aka Lovable and Sweet) (sequences) (RKO, 1931)

Viennese Nights (WB, 1931)

Waiting at the Church (sequences) (RKO, 1931)

Woman Hungry (First National, 1931)

Doctor X (First National, 1932)

Manhattan Parade (sequences) (WB, 1932)

Below the Sea (sequences) (Col, 1933)

Mystery of the Wax Museum (WB, 1933)

Three Strip Technicolor

TECHNICOLOR PROCESS NUMBER FOUR: THREE STRIP DYE TRANSFER

While Kalmus expanded the Hollywood plant, his technicians began the development of the three strip camera that would be used in live action principal photography to generate the entire color spectrum for Techniclor Process Number Four. By 1932, Technicolor had completed construction of the first three-component camera at the cost of $30,000 per unit. The Hollywood Plant was equipped to handle a moderate amount of three strip matrix manufacture and dye transfer printing.

Unfortunately, interest in the Technicolor company was by then minimal. Few producers used the two strip process, and the pitfalls of three strip photography were unknown. Kalmus tried an alternate method of three strip color photography to launch the process.

SUCCESSIVE EXPOSURE ANIMATION

Walt Disney had already made a technological breakthrough with *Steamboat Willie* in 1928, the first cartoon that contained a synchronized optical soundtrack. Color was the next logical step. Disney had almost completed a short titled *Flowers and Trees* in black and white when Kalmus approached him about shooting a three color cartoon. Disney decided to take the plunge, and against the objections of his business partner and brother, Roy, scrapped the film and started again in color by painting the animation cells.

To photograph the three colors, Disney and the Technicolor

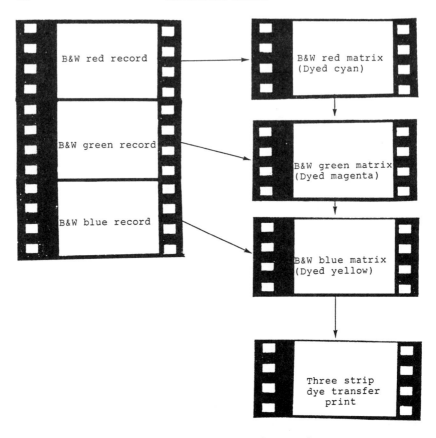

Fig. 7. Successive exposure dye transfer.

research department developed the successive exposure method, suitable exclusively for animation. On each roll of black and white negative, the animation cells were photographed on three successive frames filtered to emit the red, green and blue spectrum of color in silver densities.

A step printer was used to derive the three matrices, with each matrix exposing every third frame of the black and white negative. The red, green and blue matrices were dyed with their complementary colors — cyan, magenta and yellow — and transferred onto the same blank stock used in the two strip process (fig. 7).

The first three strip Technicolor cartoon was an enormous success and won Disney his first Academy Award (Best Cartoon of 1931–32). Disney signed a contract to shoot all animated films coming out

of his studio in the Technicolor process and honored it until the shutdown of the Hollywood plant in 1975. Kalmus gave Disney a three year exclusive on three strip animated shorts while allowing the competing studios to use the two color method. However, when MGM requested the three strip process for their shorts, Disney agreed to limit the exclusive to one year rather than incur the wrath of Louis B. Mayer. It is possible Disney's distributor, RKO, might have influenced this decision. Disney did not control the distribution of his pictures until 1956, when he formed Buena Vista.

The technique of successive exposure for animation became the standard for all Technicolor cartoons and was adopted by the other studios, including Paramount, Universal, Warner Bros. and MGM, in the thirties and forties.

THREE STRIP SUCCESSIVE EXPOSURE TECHNICOLOR FEATURES

35mm dye transfer features derived from b&w successive exposure negative (Post–1950 features printed on safety base film. All pre–1950 nitrate features were reissued on Safety Base except for *Victory through Air Power.*)

Flowers and Trees (first three-strip short) (Disney/RKO, 1932)
Snow White and the Seven Dwarfs (Disney/RKO, 1938)
Gulliver's Travels (Par, 1939)
Fantasia (Disney/RKO, 1940)
Pinocchio (Disney/RKO, 1940)
Dumbo (Disney/RKO, 1941)
Mr. Bug Goes to Town (Par, 1941)
Bambi (Disney/RKO, 1942)
Saludos Amigos (Disney/RKO, 1943)
Victory through Air Power (UA, 1943)
Make Mine Music (Disney/RKO, 1946)
Melody Time (Disney/RKO, 1948)
Adventures of Ichabod and Mr. Toad (Disney/RKO, 1949)
Cinderella (Disney/RKO, 1949)
Alice in Wonderland (Disney/RKO, 1951)
Johnny, the Giant Killer (Lippert, 1953)
Peter Pan (Disney/RKO, 1953)
Animal Farm (Ind, 1954)
Hansel and Gretel (Ind, 1954)
1001 Arabian Nights (Col, 1960)
One Hundred and One Dalmations (BV, 1961)
Gay Puree (WB, 1962)
Sword and the Stone (BV, 1963)
Jungle Book (BV, 1967)
The Aristocats (BV, 1970)
Robin Hood (BV, 1973)

LIVE ACTION PHOTOGRAPHY

While Disney continued to perfect the successive exposure method, Kalmus made a deal with finacier Jock Whitney to produce

the first live action Technicolor film. Whitney founded Pioneer Pictures as his corporate entity, with RKO handling the distribution. To protect their investment, Whitney and his cousin, Sonny, purchased a large block of Technicolor stock.

Before they committed to a full length feature, a two reel short subject, *La Cucaracha,* was made as a test and released in 1934 by RKO (16mm dye transfer reprints were made of this film in 1972 for archival reference prior to the plant shutdown). A large sum, $65,000 (most shorts were only $15,000), was spent on the production, which was a big success. Critics and audiences were impressed with the full range of colors. The second three strip film also won an Academy Award, this time for Best Comedy Short Subject of 1934. Three strip Technicolor was off to a good start.

The black and white negatives used in the three strip cameras were very slow, requiring a great deal of light to get an exposure and making shooting conditions even more uncomfortable than the two strip productions of the twenties. However, the results were so impressive it was worth the effort.

Following the short, *Becky Sharp,* starring Miriam Hopkins and directed by Rouben Mamoulian, went into production. With her college art background, Natalie Kalmus, Herbert's wife, became an influential figure at the company in her role as the color consultant for most of the three strip productions.

Since the color blue was not present in the earlier two strip process, it was emphasized in *Becky Sharp.* Red was the most vibrant color and tended to be used dramatically. Indeed, a whole article could be written about the creative use of the color red in Technicolor films from 1934 through 1974. This unique rendering of the red hue could not be replicated in any other color process (although Kodachrome came close).

The combination of saturated, vibrant primary colors with rich contrast and pure blacks gave the three strip dye transfer prints excellent "apparent" sharpness, little "apparent" grain and a three dimensional appearance. The projected image was "solid," as if the audience was looking out a window, except that the world looked more colorful and far more beautiful than reality. It was this unique look that inspired advertisers to label the process as "Glorious Technicolor" (fig. 8).

Other features that used three strip Technicolor sequences included the last reel of *Kid Millions* (the ice cream factory fantasy)

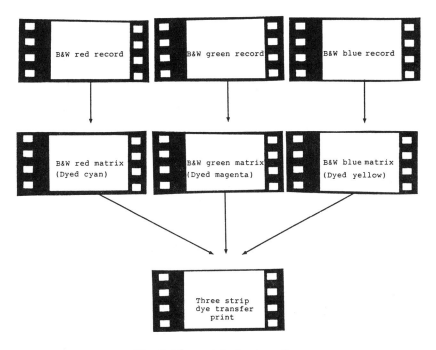

Fig. 8. Three strip dye transfer.

in 1934 and a sequence in *House of Rothschild,* produced by Fox the same year.

THE THREE STRIP CAMERA, 1932–1955

The three strip camera, used until the advent of color negative in the 1950s, was a huge and cumbersome machine usually bolted to a crane or dolly on wheels. The noisy machine was encased in a "Blimp" (outer covering) to quiet it. J. Arthur Ball, a student of Kalmus's at MIT, along with George Mitchell and a German mechanic, Henry Prouch, were involved with the actual design and construction.

Three black and white negatives were threaded into the camera with two of them bipacked emulsion to emulsion (fig. 9). The three negatives were exposed through a prism that split the light coming through the lens. The prism had a gold-flecked surface, which split the light into two beams. The straight-through beam (light coming

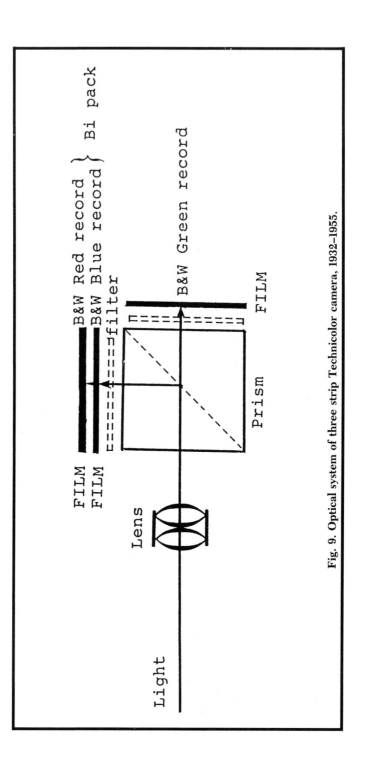

Fig. 9. Optical system of three strip Technicolor camera, 1932–1955.

through the lens not being reflected) was exposed through a green transmitting filter onto one roll of black and white negative through the emulsion. Therefore, the green black-and-white record (which received direct light) was the sharpest.

The gold-flecked prism reflected the same beam of light at a right angle to the two bipacked negatives (which were emulsion to emulsion), through a magenta filter transmitting blue and red light. The front negative was blue sensitive and contained a red-orange dye that absorbed the blue light, letting the red light pass through to the rear film of the bipack, which was red and blue sensitive. The sensitizing dyes in the black and white negatives were washed away during development, leaving only the black and white image.

The gold-flecked prism was used on all three-strip productions of the thirties. In the forties, Technicolor developed a silver reflected prism. The coating of the prism was eventually changed, toward the end of the three strip era, to dielectric materials that controlled which colors were reflected through the prism more effectively and allowed more light to reach the negatives. In the early fifties, a new prism was developed that split the light three ways, eliminating the bipack negatives, but was never used, since color negatives replaced this method for principal photography. The exception was animated films, which continued to use the successive exposure technique.

THREE STRIP MATRICES

A change in threading up negatives for matrix manufacture was necessary because the cyan record was exposed through the base. Therefore, the yellow and magenta records were threaded base to light (as in the two strip method), and the cyan record emulsion to light.

Since the registration of the three negatives that were exposed through a prism was not always precise, the matrix printer had a register glass that could be tilted in two axes to shift the image as much as plus or minus 0.0004 degrees from normal until they matched. After the switch to color negative in the fifties, this kind of matrix adjustment was not necessary, since matrices derived from single strip preprint did not have registration problems. (When Technicolor three strip films are converted to Eastmancolor today, however, few facilities have the capability of making these precise adjustments, and some registration problems occur.)

THE GRAY PRINTER

As previously mentioned, the green record in two strip productions was occasionally printed onto the blank first in a halftone image, which helped to fine-tune the shadow detail and contrast of the final dye transfer print. Although this also applied to three strip productions, there was another reason to expose and develop a gray black-and-white image under the dyes. The bipack records (which received reflected light) were not as sharp as the green record, which received direct light. By exposing the green record in a halftone black and white key image on the blank, apparent sharpness was increased.

The Type 19 Gray Printers were Bell and Howell Moel D machines that used an intermittent contact movement with a rotating drum shutter. The contact-printed gray image of the green record was manufactured in very close registration tolerance so there would be no fringing. The gray component can be thought of as a black and white print of the green record that is half the density (or darkness) of a normal black and white print. If the green record was exposed as a standard black and white positive, the final dye transfer release print would have been too dark, thus the halftone gray exposure. After the advent of the color negative, the gray exposure was eliminated, with the exception of an occasional feature that used it for effect. *Moby Dick* (1956) used a halftone gray exposure to desaturate the colors.

COLOR TIMING

Scene to scene and shot to shot color correction in the three strip process (referred to as color timing) was difficult. Generally speaking, the cameraman had to take a crash course with the lab to learn the ins and outs of color photography as dictated by Kalmus and staff. Since Technicolor supplied the equipment and handled all aspects of the process from negative developing through release printing, the terms were tough. Studios were required to hire a color consultant, who influenced if not dictated what colors would be used and how they would be rendered in the final dye transfer release print. This may sound unreasonable, but Kalmus was a shrewd businessman and wanted to protect his interests. The film industry was

always bogged down in litigation over patent infringements, and he wanted to protect those aspects of his process that were covered. He also had a reputation to maintain as "The Greatest Name in Color."

Since Technicolor technicians were always present on the set, exposure tended to be very consistent from shot to shot within the same scene, alleviating later problems of making shots match. For dailies, matrices and dye transfer "rush" prints of selected shots from a scene would be made so the director could get an idea of what the final print would look like. These test prints were very important as a reference, and the color timing information was eventually recorded on a three faced white card called a "lilly," which gave information on the gamma of each black and white negative strip and the correct lights they were to be printed under.

For editing purposes, a black and white positive copy of the green record was made (referred to as a workprint) that had the negative edge numbers printed onto the side of the sprockets. Once a final cut workprint was assembled, these edge numbers were matched to the green record in a synchronizer, which had the red and blue records threaded up. All three negatives were then matched shot by shot into the final cut three strip master and readied for matrix manufacture. It should be noted that after the lillies were used as a reference, each black and white negative had to be timed and printed as a separate entity for exposure in the matrix printer.

If this sounds complicated, it was. In the midthirties it took a lot of trial and error before a usable matrix could be made. Eventually, the staff (which was divided into departments on each floor of the plant) became experts at color correcting the three strips of negative. No one could deny that the dye transfer release prints were truly beautiful and that the words "Color by Technicolor" often increased box office revenue by 30 percent. Technicolor justifiably shared top billing with the stars on screen and in advertisements.

OPTICALS

Fades, dissolves, superimpositions and titles all had to be made on each separate record and spliced into the final cut negative. They were made on an optical printer which rephotographed the desired effect onto a fine grain black and white duplicate negative stock. This was the same method used on black and white films except that it had

to be done on each shot three times for Technicolor pictures. (Silent films had to be hand cranked back and forth to expose the optical effect directly onto the camera negative since no acceptable duplicating stock existed in the twenties.)

There was one important difference. In black and white films the opticals were so grainy that the editors cut back to the camera negative after the effect, creating a visual "pop" on screen. For example, if a character walked out of a room and the scene dissolved to another location, the image would appear very sharp until the start of the effect and then suddenly get grainy and contrasty, all within the same shot.

Theoretically, this would apply to dye transfer features as well, but the opticals were not as noticeably grainy. Three strip productions used a vast amount of light during principal photography, which generated a good exposure and very dense, fine grain negatives. Because the records were so finely grained, the duplicate negatives used for the opticals were not as obviously grainy as in standard black and white features. As a result, for Technicolor opticals the entire shot, rather than just a portion of it would be duped off and incorporated into the final negative. The vivid dyes and contrast in the release prints also drew attention away from the optical effects.

RECLAIM BLANK

With all of the expense involved in making three strip Technicolor prints, the lab did have two methods of saving money. Both involved the blank film as their source.

During soundtrack and gray halftone exposure, a great deal of silver was washed off the blank stock and reclaimed. In the 1950s, no gray image was used on dye transfer prints derived from Eastmancolor negatives, and even more silver was collected and resold. Technicians used to joke that Technicolor had a silver mine in its lab.

The blank film was also reusable if it did not come out. If the color components had not been applied at the proper ratio, the dyes were washed off and retransferred.

"Dummy" blanks (blanks with no soundtrack that were used for Technicolor dailies) were also used over and over in this capacity although not for release printing, since the optical track was never exposed.

Color Consultant

As mentioned earlier, part of the deal imposed on studios for every Technicolor production in this era was the presence of a color consultant. The director in this function was Kalmus's former wife, Natalie, whose name appears in the credits on most Technicolor films in the thirties and forties.

With her art background, Natalie Kalmus was the obvious choice, although her department had more than one run-in with the studio cinematographers. The history of this end of the company is interesting. In 1921, Natalie and Herbert divorced but kept it a secret from their staff and continued to live together for many years, an unusual relationship for the time.

Part of the divorce settlement was to make her head of this department. She became a powerful figure in the company during the three-strip years. Her staff included Henri Jaffa and William Fritzche. Natalie had specific likes and dislikes when it came to color, which often put her and the other color consultants in conflict with the directors and cinematographers. Filmmakers like Alfred Hitchcock and David O. Selznick liked to experiment with unusual color effects and had to fight it out with the color consultants to get what they wanted.

Natalie preferred picture postcard beauty, which was the style of black and white productions as well, rather than realism or a stylistic use of color. One can imagine what she thought of Selznick's exaggerated skies tinted weird colors, one of his trademarks. After the introduction of color negative in the early fifties, the color consultants became less influential, since Technicolor began making dye transfer release prints of features developed at other labs. For example, the *Giant* color negative was processed at WarnerColor, while release prints were made at Technicolor. In these cases, color consultants had no input during production.

Monopack

In 1939, the Technicolor research department, in collaboration with Eastman Kodak, developed a Monopack stock to be used in certain shooting conditions that were too difficult for the three strip unit to handle.

Monopack was essentially a low contrast Kodachrome type of positive stock that had been available in the 16mm format in the 1920s and was developed by Technicolor staff member Dr. Leonard Troland. Principal photography could be done with a standard black and white camera.

The Monopack stock contained silver halides which were exposed through thin layers of filters during principal photography. The filters allowed light to pass through each layer to generate a black and white latent image of the red, green and blue records. During development, the film went through three bleaches that contained "dye couplers." Dye couplers were tiny color globules which replicated the latent silver image of each record. After the dyes were "coupled" with the latent silver image of each layer, the silver was washed away. The end result was a three color positive image with each hue represented by a thin layer of dye couplers. (Dye coupler technology was later modified into the Eastmancolor negative/positive process in 1949.)

From this 35mm positive color image, Technicolor made black and white negatives of each dye coupler record by reprinting the Monopack through color filters on an optical printer that transmitted light of sympathetic frequencies. The three negatives were then treated as standard three strip records and cut into the final camera negatives to be used for matrix printing.

The aerial shots in *Dive Bomber* (1941) and *Captains of the Clouds* (1942) were the first films to use the Monopack for sequences. The fire scenes in *The Forest Rangers* (1942) and all exterior scenes in *Lassie Come Home* (1943) also used the process. In 1944, both interiors and exteriors for *Thunderhead, Son of Flicka* were shot with the Monopack, and it was used for the African exteriors in *King Solomon's Mines* in 1950 and for sequences in *Stars and Stripes Forever* in 1952. Several early 3-D features used the Monopack process during 1953–54.

Scenes and features using the Monopack were grainier than those shot with the three strip camera because Monopack positives had to be separated into black white negatives, resulting in a generation loss (the farther removed a copy is from the camera negative, the grainier it is). Since matrices were made directly from the three strip negatives, the duplicate negative footage derived from the Monopack was not as good. The quality difference is evident in *King Solomon's Mines*. The footage with the stars (shot with the three strip cameras)

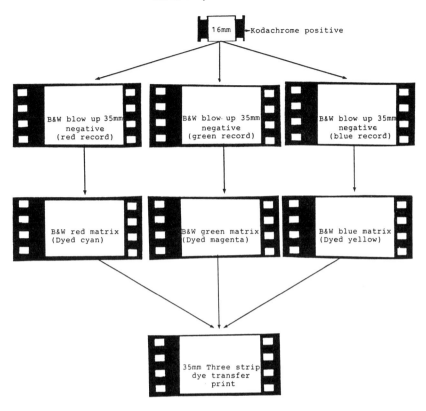

Fig. 10. Kodachrome blowup dye transfer.

was very sharp; the African location footage (shot with the Mono-pack) was grainy.

True Life Adventures

The Walt Disney company introduced a variation of the Monopack process in their True Life Adventures series. Principal photography was shot on 16mm Kodachrome stock rather than on 35mm Monopack film. Kodachrome was developed in the same fashion as the Monopack. After developing, the 16mm image was enlarged (also known as a "blowup") in an optical printer to the same 35mm three strip black and white separation negatives used in the Monopack system. Matrices were then made from the three 35mm negatives in the conventional manner (fig. 10).

The first film shot in this method was a short entitled *Seal Island* in 1949, which won the Academy Award as Best Short Subject, thus launching the series. Between 1950 and 1960, more than a dozen shorts were produced. The first feature in this format was *The Living Desert* in 1953.

Although the nature photography was quite beautiful, the 35mm dye transfer release prints were even grainier than the Monopack films due to the addition of a blowup enlargement of the tiny 16mm frame. The animated introductions of some True Life films were shot in the 35mm successive exposure method, and the quality difference was noticeable. Given the difficult location shooting, however, this was the only method available to capture the animals in their natural habitats.

BLUE TRACK TECHNICOLOR

An attempt was made by the research department in the 1940s to develop a method of transferring the optical soundtrack with the dyes rather than exposing it on the blank prior to imbibition. A light blue dye was used, and the soundtrack was transferred onto the receiver stock. Blue track Technicolor prints had inferior sound to the gray tracks, and their use was limited to the 16mm format in the 1940s. Further development with soundtrack transfer was initiated but never implemented by Technicolor in the late sixties and early seventies.

16MM DYE TRANSFER PRINTS

The Technicolor research department developed two methods for making 16mm dye transfer release prints for nontheatrical markets, including the armed services and universities. The two techniques were known as double rank and single rank dye transfer printing.

The double rank method used 35mm blank stock with smaller 16mm sprockets perforated on both sides of the film. A special pin belt was developed that also had smaller 16mm pins to hold the matrix and blank together as the dyes were transferred. The three strip negatives were reduced in an optical printer to the smaller 16mm

frame and transferred twice on the same 35mm blank, with one side imbibed head to tail and the other side tail to head. The result was a 35mm print that contained smaller 16mm sprockets and two dye transfer images side by side. The film was slit down the middle, making two 16mm dye transfer copies ready for screening. In the 1940s, most of the 16mm prints contained blue tracks, and the sound was transferred along with the three dyes. By the early fifties, blue track transfers were phased out, and all 16mm Technicolor prints had reduced size gray tracks exposed onto the blank prior to transfer. Double rank 16mm dye transfer prints could be identified by the clear sprockets.

The second method was the single rank process. In this case, reduction matrices in 16mm were made and transferred onto 16mm blank stock. Since 16mm sound prints only had one set of sprockets (the opposite side contained the optical soundtrack), single rank copies occasionally had registration problems because only one set of pins was used to hold the matrix and blank in place during the transfer of dyes. Single rank Technicolor prints could be identified by the black colored sprockets. Thus, the double rank method was the better system.

The quality control of 16mm nontheatrical Technicolor prints never matched the level of 35mm release copies, which was usually superb. The 16mm dye transfer prints could be quite beautiful, although many were plagued with problems that included color fringing, registration defects (in single rank copies), poor timing and reels that did not match. In the 1950s it was possible for universities to purchase some Technicolor titles for their own screenings; thus many film collectors legally own 16mm dye transfer copies of classics like the *Adventures of Robin Hood*. The 16mm prints were always made on the nonflammable safety base, unlike the 35mm professional films, which continued to use the dangerous nitrate base until 1950. A properly made 16mm dye transfer print is considered to be a rare collectible item, and titles like *The Wizard of Oz* are sold privately for thousands of dollars.

THE BRITISH LAB

Throughout the thirties, the Hollywood plant expanded to accommodate the growing interest in the three strip process and soon

became the central location for the Technicolor company. Kalmus retained the Boston test facility to continue research and development of the technology and set up offices in New York City for East Coast operations.

The popularity of three strip dye transfer printing soon intrigued Europeans, and Kalmus opened a British Technicolor lab in London, which became operational in 1938. Three strip cameras had been shipped to England in 1937 for use in their first Technicolor feature, *Wings of the Morning*. Although photographed and developed overseas, it was release printed at the Hollywood plant.

The Divorce of Lady X and *Drums* were among the first features to be photographed and release printed in the London dye transfer facility. In 1940, Alexander Korda's *Thief of Bagdad* became the first foreign Technicolor production to win an Academy Award for Best Color Cinematography.

Michael Powell's productions of *Black Narcissus* (1947) and *The Red Shoes* (1948) proved that the British could more than match the Americans in visual beauty and creative use of color. For imports and exports, matrices were shipped back and forth between Hollywood and London while the negatives remained in the facility that developed them.

Circa 1960, the British developed an interesting lacquering system never adopted in the United States. The lacquer would be applied after the dyes were transferred. Although it gave a rainbow hue when examined by the naked eye, the lacquer was not visible during projection and prevented scratches on the emulsion from showing up, since it was protected with this varnish. The lacquer had no smell and did not damage the film, unlike the foul smelling "rejuvenation" chemicals used by U.S. distributors, which removed the scratches but also caused both prints and negatives treated with the solutions to warp beyond usage. Conversely, lacquered British dye transfer prints displayed less shrinkage and warpage than did domestic Technicolor copies.

THE TECHNICOLOR PACKAGE

The Technicolor package involved a deal between the studio and Technicolor for the rental of the equipment and a minimum release print order. The larger the order, the cheaper the copies because

the cost of the matrices were amortized over the run. Since the majors usually had a three hundred release print run and the minor distributors a one hundred copy run, few independents could afford to use Technicolor. This problem later resulted in governmental interference when the smaller studios complained about being left out of the color field. Technicolor did all the developing, "rush" printing (for dye transfer dailies), black and white work printing (derived from the green record), negative matching and color timing. Studios would be obligated to hire Technicolor technicians, to supervise the equipment, and color consultants.

After the cut negative was prepared from the edited workprint, matrices were made based on the lillies (timing card reference), then flashed and developed to the desired density and contrast. Simultaneously, the blank was prepared by first exposing the silver soundtrack and then running it through the gray printer for the half-tone key image and 1.33×1 silver framelines. The blank was processed and unused silver was washed off (which was reclaimed and resold) and went to the dye transfer machines. Matrices were dyed their complementary colors (yellow, cyan and magenta) and transferred (imbibed) layer by layer onto the blank stock via the pin belt, which kept the matrix and blank in registration. The matrices traveled on overhead rollers in a continuous loop, bolted together with clips, while the blank traveled on large rolls that were cut into separate thousand foot sections as they came off the line. Throughout the thirties and forties, each two thousand foot projection reel was done in two parts and spliced together to make one composite reel. For example, all three hundred copies of reel #2A of *The Wizard of Oz* were transferred. Then the matrices and blanks for all three hundred copies of reel #2B were threaded up, transferred and spliced together into a composite reel #2, ready for shipment. In essence, the photomechanical process was similar to lithography.

In between the layers, the matrices went through a "washback," which rinsed off excess dye prior to transfer and was also a tool for fine-tuning the density and contrast of individual colors. In most cases, the color was enhanced during washback, making the release copies more saturated than other processes. (Since color enhancement in this fashion is impossible in the Eastmancolor process, no new positive copy of a film designed for dye transfer printing can accurately be called a "restoration," since the latter contained more dye in the release copy.)

TECHNICOLOR FILMS IN THE THIRTIES AND FORTIES

Although the major studios each adopted their own Technicolor "look," there were certain consistencies among the releases. One thing all productions featured was vivid amber fleshtones. Sometimes referred to as the "Technicolor tan," it made the actors look very attractive. The effect was achieved with a combination of makeup and "bastard amber" gels on the lights.

The vividness of fleshtones varied during the years. In the thirties and forties, it was very saturated. In the fifties, a more realistic fleshtone was used, although it was still "warm." In the seventies, a more desaturated fleshtone was adopted, with the exception of the tones in the *Godfather* films. It should be noted that other processes like CineColor and Eastmancolor also adopted this look as they were introduced in the forties and fifties.

After the demise of the dye transfer process in 1975, fleshtones gradually changed to the "cold" look currently in vogue. (Today, actors' fleshtones often have a blue or green bias, which does not do them justice.)

David O. Selznick attempted a sepiatone look for two of his productions in the 1930s. In *The Adventures of Tom Sawyer*, released in 1937, the entire feature was printed with a saturated sepia hue that utilized few primary colors. This was partly due to the fact that the film had been designed as a black and white production, and the decision to shoot in color was an afterthought.

For *Gone with the Wind*, a similar sepia look was used in the early sequences of the prewar South. After the Civil War broke out, the yellows and reds were emphasized during the burning of Atlanta scenes. Fleshtones were richly tanned and saturated throughout. (The 1988 Eastmancolor "restoration" was completely inaccurate in this respect and was printed with "cold" desaturated fleshtones, distorting Selznick's look.)

Fox Technicolor films in the forties featured a garish, overly colorful look that was very entertaining. In 1971, archivist Eric Spilker arranged to have Busby Berkeley's musical *The Gang's All Here* (1943) reprinted in the dye transfer process. The wildly exaggerated colors made the film a cult hit, and prints still occasionally turn up in revival theaters. Especially notable were the vibrant primary colors in the Carmen Miranda number "The Lady in the Tutti-Frutti Hat," which were so saturated they were almost hallucinatory.

M-G-MAGIC!
GERSHWIN SONGS!
TECHNICOLOR
GLORIES!

Until you see with your own eyes the spectacular beauty of the Beaux Arts Ball, until you dream with these lovers, until you live and laugh among the garrets, in the cafés, in the music halls of Paris you cannot truly know the joy and excitement, the tenderness and drama of this remarkable entertainment with wonderful Gershwin score.

M-G-M Presents
"AN AMERICAN
IN PARIS"
In The Music Of
GEORGE GERSHWIN

GENE KELLY

LESLIE CARON
OSCAR · GEORGES
LEVANT · GUETARY
NINA FOCH
COLOR by TECHNICOLOR

Directed by VINCENTE MINNELLI
Produced by ARTHUR FREED

Here comes the "SHOW BOAT"
THE "GONE WITH THE WIND" OF MUSICALS!

A year ago it was M-G-M's "Annie Get Your Gun" that enthralled the nation. This year "Show Boat" comes with Technicolor banners flying to excite and delight with its wonderful American story and its timeless songs. A mighty production in cast, spectacle, heart-thrill!

M-G-M Presents
"SHOW BOAT"
STARRING
KATHRYN · AVA · HOWARD
GRAYSON · GARDNER · KEEL
WITH JOE E. BROWN · MARGE and GOWER CHAMPION
ROBERT · MOOREHEAD
STERLING · TECHNICOLOR

Directed by GEORGE SIDNEY
Produced by ARTHUR FREED

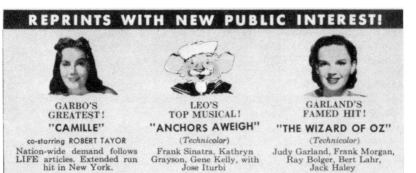

No one could forget Judy Garland opening the door from the sepia tinted Kansas to reveal Oz in its full Technicolor glory. Although earlier features had used the combination of black and white and color scenes, this was the first time it was used for artistic effect. Musicals were especially suited for this look. Among the notable features were *Meet Me in St. Louis* (1944), *State Fair* (1945), and *The Jolson Story* (1946).

THREE STRIP TECHNICOLOR FEATURES

35mm dye transfer features derived from black and white three strip negatives (all features printed on nitrate base)

The Cat and the Fiddle (sequences) (MGM, 1934)

La Cucaracha (first three-strip short) (RKO, 1934)

Hollywood Party (sequences) (MGM, 1934)

House of Rothschild (sequence) (Fox, 1934)

Kid Millions (last reel) (Goldwyn/ UA, 1934)

Kliou (Ind, 1934)

Becky Sharp (RKO, 1935)

Le Gong: The Dance of the Virgins (Ind, 1935)

The Little Colonel (sequence) (Fox, 1935)

The Dancing Pirate (RKO, 1936)

The Garden of Allah (Selznick/UA, 1936)

Ramona (Fox, 1936)

Trail of the Lonesome Pine (Par, 1936)

Coronation Film (British, Ind, 1937)

Ebb Tide (Par, 1937)

God's Country and the Women (WB,1937)

Nothing Sacred (Selznick/UAQ, 1937)

A Star Is Born (Selznick/UA, 1937)

Victoria the Great (sequences) (British, RKO, 1937)

Vogues of 1938 (UA, 1938)

When's Your Birthday? (sequences) (RKO, 1937)

Wings of the Morning (British, Fox, 1937)

Adventures of Robin Hood (WB, 1938)

Adventures of Tom Sawyer (Selznick/UA, 1938)

Drums (British, UA, 1938)

Gold Is Where You Find It (WB, 1938)

The Goldwyn Follies (UA, 1938)
Heart of the North (WB, 1938)
Her Jungle Love (Par, 1938)
Jezebel (sequences) (WB, 1938)
Kentucky (WB, 1938)
Men with Wings (Par, 1938)
Sixty Glorious Years (British, RKO, 1938)
Sweethearts (MGM, 1938)
Valley of the Giants (WB, 1938)
Dodge City (WB, 1939)
Drums Along the Mohawk (Fox, 1939)
Four Feathers (British, UA, 1939)
Gone with the Wind (MGM, 1939)
Hollywood Cavalcade (Fox, 1939)
Ice Follies of 1939 (sequences) (MGM, 1939)
Jesse James (Fox, 1939)
Land of Liberty (sequences) (MGM, 1939)
The Little Princess (Fox, 1939)
The Mikado (British, U, 1939)
The Private Lives of Elizabeth and Essex (WB, 1939)
The Wizard of Oz (MGM, 1939)
The Women (sequence) (MGM, 1939)
Bittersweet (Fox, 1940)
The Blue Bird (Fox, 1940)
Chad Hanna (Par, 1940)
Doctor Cyclops (Par, 1940)
Down Argentine Way (Fox, 1940)
Irene (sequence) (RKO, 1940)
Maryland (Fox, 1940)
Northwest Mounted Police (Par, 1940)
Over the Moon (British, UA, 1940)
Return of Frank James (Fox, 1940)
Swanee River (Fox, 1940)
Thief of Bagdad (UA, 1940)
Typhoon (Par, 1940)
Untamed (Par, 1940)
Aloma of the South Seas (Par, 1941)
Belle Star (Fox, 1941)
Billy the Kid (MGM, 1941)
Blood and Sand (Fox, 1941)
Blossoms in the Dust (MGM, 1941)
Dive Bomber (Monopack sequences) (WB, 1941)
Fiesta (UA, 1941)

Louisiana Purchase (Par,1941)
Moon over Miami (Fox, 1941)
Reluctant Dragon (part successive exposure) (Disney/RKO, 1941)
Shepherd of the Hills (Par, 1941)
Smilin' Through (Par, 1941)
That Night in Rio (Fox, 1941)
Virginia (Par, 1941)
Week-End in Havana (Fox, 1941)
Western Union (Fox, 1941)
Arabian Nights (U, 1942)
Bahama Passage (Par, 1942)
Beyond the Blue Horizon (Par, 1942)
The Black Swan (Fox, 1942)
Captains of the Clouds (Monopack sequences) (WB, 1942
The Forest Rangers (Monopack sequences) (Par, 1942)
Jungle Book (UA, 1942)
Moon and Sixpence (sequence) (UA, 1942)
My Gal Sal (Fox, 1942)
Reap the Wild Wind (Par, 1942)
Song of the Islands (Fox, 1942)
Springtime in the Rockies (Fox, 1942)
Thunder Birds (Fox,1942)
To the Shores of Tripoli (Fox, 1942)
Best Foot Forward (MGM, 1943)
Cobra Woman (U, 1943)
Coney Island (Fox, 1943)
Crash Dive (Fox, 1943)
The Desperados (Col, 1943)
Dixie (Par, 1943)
DuBarry Was a Lady (MGM, 1943)
For Whom the Bell Tolls (Par, 1943)
The Gang's All Here (Fox, 1943)
The Great Mr. Handel (Ind, 1943)
Happy Go Lucky (Par, 1943)
Heaven Can Wait (Fox, 1943)
Hello, Frisco, Hello (Fox, 1943)
Lassie Come Home (Monopack) (MGM, 1943)
My Friend Flicka (Fox, 1943)
Phantom of the Opera (U, 1943)
Report from the Aleutians (Ind, 1943)
Riding High (Par, 1943)

Salute to the Marines (MGM, 1943)
Sweet Rosie O'Grady (Fox, 1943)
This Is the Army (WB, 1943)
Thousands Cheer (MGM, 1943)
White Savage (U, 1943)
Ali Baba and the Forty Thieves (U, 1944)
An American Romance (MGM, 1944)
Bathing Beauty (MGM, 1944)
Broadway Rhythm (MGM, 1944)
Buffalo Bill (Fox, 1944)
Can't Help Singing (U, 1944)
The Climax (U, 1944)
Cover Girl, (Co, 1944)
The Desert Song (WB, 1944)
Greenwich Village (Fox, 1944)
Gypsy Wildcat (U, 1944)
Home in Indiana (Fox, 1944)
Irish Eyes Are Smiling (Fox, 1944)
Kisenga, Man of Africa (Ind, 1944)
Kismet (MGM, 1944)
Lady in the Dark (Par, 1944)
Meet Me in St. Louis (MGM, 1944)
Pin Up Girl (Fox, 1944)
The Princess and the Pirate (RKO, 1944)
Rainbow Island (Par, 1944)
Shine on Harvest Moon (sequence) (WB, 1944)
Something for the Boys (Fox, 1944)
The Story of Dr. Wassell (Par, 1944)
Up in Arms (RKO, 1944)
Wilson (Fox, 1944)
Anchors Aweigh (MGM, 1945)
Belle of the Ukon (RKO, 1945)
Billy Rose's Diamond Horseshoe (Fox, 1945)
Blithe Spirit (British, UA, 1945)
Bring on the Girls (Par, 1945)
The Dolly Sisters (Fox, 1945)
The Fighting Lady (Fox, 1945)
Frenchman's Creek (Par, 1945)
Frontier Gal (U, 1945)
Incendiary Blonde (Par, 1945)
It's a Pleasure (RKO, 1945)
Leave Her to Heaven (Fox, 1945)
The Life and Death of Colonel Blimp (British, UA, 1945)
National Velvet (MGM, 1945)

Nob Hill (Fox, 1945)
The Picture of Dorian Gray (sequences) (MGM, 1945)
Salome, Where She Danced (U, 1945)
San Antonio (WB, 1945)
Son of Lassie (MGM, 1945)
A Song to Remember (Col, 1945)
The Spanish Main (RKO, 1945)
State Fair (Fox, 1945)
Sudan (U, 1945)
The Three Caballeros (part successive exposure) (Disney/RKO, 1945)
A Thousand and One Nights (Col, 1945)
Thrill of a Romance (MGM, 1945)
Thunderhead, Son of Flicka (Monopack) (Fox, 1945)
Tonight and Every Night (Col, 1945)
Where Do We Go from Here? (Fox, 1945)
Wonder Man (RKO, 1945)
Yolanda and the Thief (MGM, 1945)
The Bandit of Sherwood Forest (Col, 1946)
Blue Skies (Par, 1946)
Caesar and Cleopatra (British, UA, 1946)
Canyon Passage (U, 1946)
Courage of Lassie (MGM, 1946)
Do You Love Me? (Fox, 1946)
Easy to Wed (MGM, 1946)
The Harvey Girls (MGM, 1946)
Holiday in Mexico (MGM, 1946)
I've Always Loved You (Republic, 1946)
The Jolson Story (Col, 1946)
The Kid from Brooklyn (RKO, 1946)
Laughing Lady (British, Ind, 1946)
Margie (Fox, 1946)
Night and Day (WB, 1946)
Night in Paradise (U, 1946)
The Raider (British, Ind, 1946)
Renegades (Col, 1946)
Smoky (Fox, 1946)
Song of the South (part successive exposure) (Disney/RKO, 1946)

Stairway to Heaven (British, U, 1946)
Three Little Girls in Blue (Fox, 1946)
Till the Clouds Roll By (MGM, 1946)
The Time, the Place and the Girl (WB, 1946)
The Virginian (Par, 1946)
Wake Up and Dream (Fox, 1946)
The Yearling (MGM, 1946)
Ziegfeld Follies (MGM, 1946)
Black Narcissus (U, 1947)
California (Par, 1947)
Captain from Castile (Fox, 1947)
Carnival in Costa Rica (Fox, 1947)
Desert Fury (Par, 1947)
Down to Earth (Col, 1947)
Duel in the Sun (SRO, 1947)
Fiesta (MGM, 1947)
Forever Amber (Fox, 1947)
Fun and Fancy Free (part successive exposure) (Disney/RKO, 1947)
Good News (MGM, 1947)
Gunfighters (Col, 1947)
The Homestretch (Fox, 1947)
I Wonder Who's Kissing Her Now? (Fox, 1947)
Life with Father (WB, 1947)
Mother Wore Tights (WB, 1947)
My Heart Goes Crazy (also known as London Town) (Ind, 1947)
My Wild Irish Rose (WB, 1947)
The Perils of Pauline (Par, 1947)
Pirates of Monterey (U, 1947)
Private Affairs of Bel Ami (sequences) UA, 1947)
Secret Life of Walter Mitty (RKO, 1947)
Shocking Miss Pilgram (Fox, 1947)
Sinbad the Sailor (RKO, 1947)
Slave Girl (U, 1947)
Song of Scheherazade (U, 1947)
The Swordsman (Col, 1947)
This Happy Breed (U, 1947)
This Time for Keeps (MGM, 1947)
Thunder in the Valley (also known as Bob, Son of Battle) (Fox, 1947)
Tycoon (RKO, 1947)

Unconquered (Par, 1947)
The Unfinished Dance (MGM, 1947)
Apartment for Peggy (Fox, 1948)
Black Bart (U, 1948)
Blanche Fury (EL, 1948)
The Boy with Green Hair (RKO, 1948)
A Date with Judy (MGM, 1948)
Easter Parade (MGM, 1948)
The Emperor Waltz (Par, 1948)
Fighter Squadron (WB, 1948)
The Gallant Blade (Col, 1948)
Give My Regards to Broadway (Fox, 1948)
Green Grass of Wyoming (Fox, 1948)
Hills of Home (MGM, 1948)
An Ideal Husband (Fox, 1948)
Jassy (U, 1948)
Joan of Arc (RKO, 1948)
The Kissing Bandit (MGM, 1948)
Loves of Carmen (Col, 1948)
Luxury Liner (MGM, 1948)
Man from Colorado (Col, 1948)
On an Island with You (MGM, 1948)
One Sunday Afternoon (WB, 1948)
The Paleface (Par, 1948)
The Pirate (MGM, 1948)
The Red Shoes (British, EL, 1948)
Relentless (Col, 1948)
Return of October (Col, 1948)
River Lady (U, 1948)
Romance on the High Seas (WB, 1948)
Rope (WB, 1948)
Scudda Hoo, Scudda Hay (Fox, 1948)
Secret Land (MGM, 1948)
Smugglers (British, EL, 1948)
A Song Is Born (RKO, 1948)
Summer Holiday (MGM, 1948)
Tale of the Navajos (MGM, 1948)
Tap Roots (U, 1948)
Task Force (sequences) (WB, 1948)
That Lady in Ermine (Fox, 1948)
Three Daring Daughters (MGM, 1948)
Three Godfathers (MGM, 1948)
Three Musketeers (MGM, 1948)
Two Guys from Texas (WB, 1948)

The Untamed Breed (Col, 1948)
When My Baby Smiles at Me (Fox, 1948)
Words and Music (MGM, 1948)
Adventures of Don Juan (WB, 1949)
Bagdad (U, 1949)
Barkleys of Broadway (MGM, 1949)
Beautiful Blonde from Bashful Bend (Fox, 1949)
Big Cat (British, EL, 1949)
Blue Lagoon (U, 1949)
Calamity Jane and Sam Bass (U, 1949)
Christopher Columbus (U, 1949)
A Connecticut Yankee in King Arthur's Court (Par, 1949)
Dancing in the Dark (Fox, 1949)
The Gal Who Took the West (MGM, 1949)
The Inspector General (WB, 1949)
It's a Great Feeling (WB, 1949)
Jolson Sings Again (Col, 1949)
Little Women (MGM, 1949)
Look for the Silver Lining (WB, 1949)
Mother Is a Freshman (Fox, 1949)
The Mutineers (Col, 1949)
My Dream Is Yours (WB, 1949)
Neptune's Daughter (MGM, 1949)
Oh, You Beautiful Doll (Fox, 1949)

On the Town (MGM, 1949)
Red Canyon (U, 1949)
The Red Pony (Republic, 1949)
Samson and Delilah (Par, 1949)
Sand (Fox, 1949)
Saraband (British, EL, 1949)
Scott of the Antarctic (British, EL, 1949)
The Secret Garden (sequences) (MGM, 1949)
She Wore a Yellow Ribbon (RKO, 1949)
So Dear to My Heart (part successive exposure) (Disney/RKO)
Some of the Best (sequences) (MGM, 1949)
South of St. Louis (WB, 1949)
Story of Seabiscuit (WB, 1949)
Streets of Laredo (Par, 1949)
Sun Comes Up (MGM, 1949)
Take Me Out to the Ball Game (MGM, 1949)
That Forsythe Woman (MGM, 1949)
That Midnight Kiss (MGM, 1949)
Tulsa (British, EL, 1949)
Under Capricorn (WB, 1949)
Yes, Sir, That's My Baby (U, 1949)
The Younger Brothers (WB, 1949)
You're My Everything (Fox, 1949)

THREE STRIP TECHNICOLOR FEATURES

35mm dye transfer features derived from black and white
three strip negatives (starting in 1950, all dye transfer
features were printed on safety base film)

An American Guerrilla in the Philippines (Fox, 1950)
Annie Get Your Gun (MGM, 1950)
Barricade (WB, 1950)
Black Rose (Fox, 1950)
Blue Lamp (British, EL, 1950)
Broken Arrow (Fox, 1950)
Buccaneer's Girl (U, 1950)
Challenge to Lassie (MGM, 1950)
Cheaper by the Dozen (Fox, 1950)
Colt .45 (WB, 1950)
Comanche Territory (U, 1950)

Copper Canyon (Par, 1950)
Curtain Call at Cactus Creek (U, 1950)
Daughter of Rosie O'Grady (WB, 1950)
Desert Hawk (U, 1950)
Destination Moon (British, EL, 1950)
Duchess of Idaho (MGM, 1950)
Eagle and the Hawk (Par, 1950)
Fancy Pants (Par, 1950)
Fighting Pimpernell (Ind, 1950)

Flame and the Arrow (WB, 1950)
Happy Years (MGM, 1950)
High Lonesome (British, EL, 1950)
I'll Get By (British, EL, 1950)
Kid from Texas (U, 1950)
Kim (MGM, 1950)
King Solomon's Mines (Monopack sequences) (MGM, 1950)
Let's Dance (Par, 1950)
Montana (Fox, 1950)
My Blue Heaven (Fox, 1950)
Nancy Goes to Rio (MGM, 1950)
Outriders (MGM, 1950)
Pagan Love Song (MGM, 1950)
Palomino (Col, 1950)
Peggy (U, 1950)
Pretty Girl (Col, 1950)
Return of the Frontiersman (WB, 1950)
Saddle Tramp (U, 1950)
Sierra (U, 1950)
Summer Stock (MGM, 1950)
Sundowners (British, EL, 1950)
Tea for Two (WB, 1950)
Three Little Words (MGM, 1950)
A Ticket to Tomahawk (Fox, 1950)
The Toast of New Orleans (MGM, 1950)
Treasure Island (Disney/RKO, 1950)
Tripoli (RKO, 1950)
Two Weeks with Love (MGM, 1950)
Wabash Avenue (Fox, 1950)
The White Tower (RKO, 1950)
Wyoming Mail (U, 1950)
Across the Wide Missouri (MGM, 1951)
The African Queen (UA, 1951)
Al Jennings of Oklahoma (Col, 1951)
An American in Paris (MGM, 1951)
Anne of the Indies (Fox, 1951)
Apache Drums (U, 1951)
Best of the Badmen (RKO, 1951)
Bird of Paradise (Fox, 1951)
Branded (Par, 1951)
Call Me Mister (Fox, 1951)
Captain Horatio Hornblower (WB, 1951)
Cattle Drive (U, 1951)
Cave of Outlaws (U, 1951)
Cimarron Kid (U, 1951)

Crosswinds (U, 1951)
Dallas (WB, 1951)
David and Bathsheba (Fox, 1951)
Distant Drums (WB, 1951)
Double Crossbones (U, 1951)
Excuse My Dust (MGM, 1951)
Flame of Araby (U, 1951)
Flaming Feather (Par, 1951)
Flying Leathernecks (RKO, 1951)
Forth Worth (WB, 1951)
Frenchie (U, 1951)
Golden Girl (Fox, 1951)
Golden Horde (U, 1951)
Great Caruso (MGM, 1951)
Great Missouri Raid (Par, 1951)
Half Angel (Fox, 1951)
Halls of Montezuma (Fox, 1951)
Happy Go Lovely (RKO, 1951)
I'd Climb the Highest Mountain (Fox, 1951)
I'll Never Forget You (Fox, 1951)
Kansas Raider (U, 1951)
Lady from Texas (U, 1951)
Last Outpost (Par, 1951)
Little Egypt (U, 1951)
Lorna Doone (Col, 1951)
Lullaby of Broadway (WB, 1951)
Man in the Saddle (Col, 1951)
Mark of the Renegade (U, 1951)
Mark of the Avenger (C, 1951)
Meet Me after the Show (Fox, 1951)
Mr. Imperium (MGM, 1951)
On Moonlight Bay (WB, 1951)
On the Riviera (Fox, 1951)
The Painted Hills (MGM, 1951)
Painting the Clouds with Sunshine (WB, 1951)
Pandora and the Flying Dutchman (MGM, 1951)
Passage West (Par, 1951)
Prince Who Was a Thief (U, 1951)
Quebec (Par, 1951)
Quo Vadis (MGM, 1951)
Red Mountain (Par, 1951)
Rick, Young and Pretty (MGM, 1951)
The River (UA, 1951)
Royal Wedding (MGM, 1951)
Santa Fe (Col, 1951)
Show Boat (MGM, 1951)

Silver City (Par, 1951)
Smuggler's Island (U, 1951)
Stage to Tucson (Col, 1951)
Sugarfoot (WB, 1951)
Take Care of My Little Girl (Fox, 1951)
Tales of Hoffman (L, 1951)
Ten Tall Men (Col, 1951)
Texas Carnival (MGM, 1951)
Tomahawk (U, 1951)
Two Tickets to Broadway (RKO, 1951)
Valentino (Col, 1951)
Vengeance Valley (MGM, 1951)
Warpath (Par, 1951)
When Worlds Collide (Par, 1951)
Aaron Slick from Punkin Crick (Par, 1952)
About Face (WB, 1952)
Against All Flags (U, 1952)
All Ashore (Col, 1952)
Ambush at Tomahawk Gap (Col, 1952)
At Sword's Point (RKO, 1952)
Battle of Apache Pass (U, 1952)
Because You're Mine (MGM, 1952)
Belle of New York (MGM, 1952)
Bells on Their Toes (Fox, 1952)
Bend of the River (U, 1952)
La Bergère et le Ramoneur (Ind, 1952)
The Big Trees (WB, 1952)
Blackbeard the Pirate (RKO, 1952)
Blazing Forest (Par, 1952)
Bloodhounds of Broadway (Fox, 1952)
Bonnie Prince Charlie (UA, 1952)
Brave Warrior (Col, 1952)
Brigand (Col, 1952)
Bronco Buster (U, 1952)
Bugles in the Afternoon (WB, 1952)
California Conquest (Col, 1952)
Captain Pirate (Col, 1952)
Caribbean (Par, 1952)
Crimson Pirate (WB, 1952)
Cripple Creek (Col, 1952)
Denver and the Rio Grande (Par, 1952)
Dual at Silver Creek (Par, 1952)
Dupont Story (Ind, 1952)

Everything I Have Is Yours (MGM, 1952)
The Firebird (UA, 1952)
Girls of Pleasure Island (Par, 1952)
Golden Hawk (Col, 1952)
Greatest Show on Earth (Par, 1952)
Half Breed (RKO, 1952)
Hangman's Knot (Col, 1952)
Hans Christian Andersen (RKO, 1952)
Has Anybody Seen My Gal? (U, 1952)
Hong Kong (Par, 1952)
Horizon's West (U, 1952)
Hurricane Smith (Par, 1952)
Importance of Being Ernest (U, 1952)
Iron Mistress (WB, 1952)
Island of Desire (UA, 1952)
Ivanhoe (MGM, 1952)
Ivory Hunter (also known as Where No Vultures Fly) (U, 1952)
Just for You (Par, 1952)
Kangaroo (Fox, 1952)
Lovely to Look At (MGM, 1952)
Lure of the Wilderness (Fox, 1952)
Lutuko (Ind, 1952)
Lydia Bailey (Fox, 1952)
Magic Box (Ind, 1952)
Maytime in Mayfair (Ind, 1952)
Merry Widow (MGM, 1952)
Million Dollar Mermaid (MGM, 1952)
Montana Territory (Col, 1952)
Montemartre (Ind, 1952)
Moulin Rouge (UA, 1952)
Mutiny (UA, 1952)
Naked Spur (MGM, 1952)
Plymouth Adventure (MGM, 1952)
Pony Soldier (Fox, 1952)
Powder River (Fox, 1952)
Prisoner of Zenda (MGM, 1952)
The Quiet Man (R, 1952)
The Raiders (U, 1952)
Rainbow 'Round My Shoulder (Col, 1952)
Ramble in Erin (Ind, 1952)
Rancho Notorious (RKO, 1952)
Red Skies of Montana (also known as Smoke Jumpers) (Fox, 1952)

The Savage (Par, 1952)
Scaramouche (MGM, 1952)
Scarlet Angel (U, 1952)
She's Working Her Way through
College (WB, 1952)
Singing' in the Rain (MGM, 1952)
Skirts Ahoy (MGM, 1952)
Snows of Kilimanjaro (Fox, 1952)
Somebody Loves Me (Par, 1952)
Son of Paleface (Par, 1952)
Stars and Stripes Forever (Fox,
1952)
Steel Town (U, 1952)
Story of Robin Hood (RKO, 1952)
Thief of Damascus (Col, 1952)
Tropic Zone (Par, 1952)
Untamed Frontier (U, 1952)
Wait Till the Sun Shines, Nellie
(Fox, 1952)
Way of a Goucho (Fox, 1952)
What Price Glory (Fox, 1952)
Where's Charley? (WB, 1952)
Wild Heart (RKO, 1952)
With a Song in My Heart (Fox, 1952)
World in His Arms (U, 1952)
Yankee Buccaneer (U, 1952)
Aan (UA, 1953)
Affair in Monte Carlo (AA, 1953)
All Ashore (Col, 1953)
All the Brothers Were Valiant
(MGM, 1953)
Ambush at Tomahawk Gap (Col,
1953)
April in Paris (WB, 1953)
Appointment in Honduras (RKO,
1953)
Arrowhead (Par, 1953)
Back to God's Country (U, 1953)
The Band Wagon (MGM, 1953)
Beggar's Opera (WB, 1953)
Below the Sahara (RKO, 1953)
Bonjour Paris (Ind, 1953)
Botany Bay (Par, 1953)
By the Light of the Silvery Moon
(WB, 1953)
Calamity Jane (WB, 1953)
Call Me Madam (Fox, 1953)
Captain Scarlet (UA, 1953)
Caroling Cherie (Ind, 1953)
City Beneath the Sea (U, 1953)

City of Bad Men (Fox, 1953)
Column South (U, 1953)
Conquest of Cochise (Col, 1953)
Conquest of Everest (UA, 1953)
Cruisin' Down the Everest (UA,
1953)
Dangerous When Wet (MGM, 1953)
Decameron Nights (RKO,1953)
Desert Legion (U, 1953)
Destination Gobi (Fox, 1953)
Down Among the Sheltering Palms
(Fox, 1953)
East of Sumatra (U, 1953)
Easy to Love (MGM, 1953)
Eddie Cantor Story (WB, 1953)
Farmer Takes a Wife (Fox, 1953)
Father's Doing Fine (Ind, 1953)
5000 Fingers of Dr.T (Col, 1953)
Flame of Calcutta (Col, 1953)
Gentlemen Prefer Blondes (Fox,
1953)
Gilbert and Sullivan (UA, 1953)
Girl Next Door (Fox, 1953)
Give a Girl a Break (MGM, 1953)
Golden Blade (U, 1953)
Great Sioux Uprising (U, 1953)
Gun Belt (UA, 1953)
Gunsmoke (U, 1953)
Here Come the Girls (Par, 1953)
Houdini (Par, 1953)
The "I Don't Care" Girl (Fox, 1953)
I Love Melvin (MGM, 1953)
It Started in Paradise (Ind, 1953)
Jack McCall, Desperado (Col, 1953)
Jamaica Run (Col, 1953)
The Jazz Singer (WB, 1953)
Last of the Comanches (Col, 1953)
Latin Lovers (MGM, 1953)
Law and Order (U, 1953)
Let's Do It Again (Col, 1953)
Lili (MGM, 1953)
A Lion Is in the Streets (WB, 1953)
Lone Hand (U, 1953)
Lucretia Borgia (Ind, 1953)
Man Behind the Gun (WB, 1953)
Man from the Alamo (U, 1953)
Master of Ballantrae (WB, 1953)
Meet Me at the Fair (U, 1953)
Melba (UA, 1953)
Mississippi Gambler (U, 1953)

Mogambo (MGM, 1953)
Monsoon (UA, 1953)
Naked Spur (MGM, 1953)
Niagara (Fox, 1953)
Paris Express (Ind, 1953)
The Pathfinder (Col, 1953)
Pony Express (Par, 1953)
Powder River (Fox, 1953)
Prince of Pirates (Col, 1953)
Prisoners of the Casbah (Col, 1953)
Puccini (Ind, 1953)
A Queen Is Crowned (U, 1953)
Raiders of the Seven Seas (UA, 1953)
Redhead from Wyoming (U, 1953)
Return to Paradise (UA, 1953)
Road to Bali (Par, 1953)
Saadia (MGM, 1953)
Salome (Col, 1953)
Scandal at Scourie (MGM, 1953)
Sea Around Us (RKO, 1953)
Sea Devils (RKO, 1953)
Seminole (U, 1953)
Serpent of the Nile (Col, 1953)
Shane (Par, 1953)
Siren of Bagdad (Col, 1953)
Slaves of Babylon (Col, 1953)
Small Town Girl (MGM, 1953)
So This Is Love (WB, 1953)
Sombrero (MGM, 1953)
Stand at Apache River (U, 1953)
Stars Are Singing (Par, 1953)
Story of Three Loves (MGM, 1953)
Sword and the Rose (RKO, 1953)
Take Me to Town (U, 1953)
Three Sailors and a Gal (WB, 1953)
ThunderBay (U, 1953)
Titfield Thunderbolt (Ind, 1953)
Tonight at 8:30 (Ind, 1953)
Tonight We Sing (Fox, 1953)
Torch Song (MGM, 1953)
Treasure of the Golden Condor (Fox, 1953)
Tropic Zone (Par, 1953)
Tumbleweed (U, 1953)
The Vanquished (Par, 1953)
Veils of Bagdad (U, 1953)
Walking My Baby Back Home (U, 1953)

War Arrow (U, 1953)
War of the Worlds (Par, 1953)
White Witch Doctor (Fox, 1953)
Young Bess (MGM, 1953)
Annapurna (Ind, 1954)
Apache (UA, 1954)
Arrow in the Dust (AA, 1954)
Battle of Rogue River (Col, 1954)
Beachcomber (UA, 1954)
Beachhead (UA, 1954)
Beau Brummel (MGM, 1954)
Bengal Brigade (U, 1954)
Black Dakotas (Col, 1954)
Black Horse Canyon (U, 1954)
Black Night (Col, 1954)
Border River (U, 1954)
A Bullet Is Waiting (Col, 1954)
Caine Mutiny (Col, 1954)
Casanova's Big Night (Par, 1954)
Charge of the Lancers (Col, 1954)
Conquest of Everest (Ind, 1954)
Dawn at Socorro (U, 1954)
Demetrius and the Gladiators (Fox, 1954)
Destry (U, 1954)
Drums Across the River (U, 1954)
Duel in the Jungle (WB, 1954)
Elephant Walk (Par, 1954)
Fire over Africa (Col, 1954)
Flame and the Flesh (MGM, 1954)
Four Guns to the Border (U, 1954)
Gambler from Natchez (Fox, 1954)
Genevieve (U, 1954)
Glen Miller Story (U, 1954)
Golden Coach (Ind, 1954)
Golden Mask (UA, 1954)
Golden Mistress (UA, 1954)
Hell Below Zero (Col, 1954)
His Majesty O'Keefe (WB, 1954)
Iron Glove (Col, 1954)
Jesse James' Women (UA, 1954)
Johnny Dark (U, 1954)
King of the Khyber Rifles (Fox, 1954)
Knock on Wood (Par, 1954)
Last Time I Saw Paris (MGM, 1954)
Laughing Anne (R, 1954)
Law vs. Billy the Kid (Col, 1954)
Living It Up (Par, 1954)
Mad About Men (Ind, 1954)

Magnificent Obsession (U, 1954)
Man with a Million (UA, 1954)
Masterson of Kansas (Col, 1954)
Men of the Fighting Lady (MGM, 1954)
Naked Jungle (Par, 1954)
Night People (Fox, 1954)
Out of this World (Ind, 1954)
Outlaw Stallion (Col, 1954)
Passion (RKO, 1954)
Puccini (Ind, 1954)
Purple Plain (UA, 1954)
Raid (Fox, 1954)
Rails into Laramie (UA, 1954)
Rainbow Jacket (Ind, 1954)
Red and the Black (Ind, 1954)
Red Garters (Par, 1954)
Rhapsody (MGM, 1954)
Ride Clear of Diablo (U, 1954)
Romeo and Juliet (UA, 1954)
Saracen Blade (Col, 1954)
Saskatchewan (U, 1954)
Scarlet Spear (UA, 1954)
Secret of the Incas (Par, 1954)
Siege at Red River (Fox, 1954)
Silver Lode (RKO, 1954)
Sixth Continent (Ind, 1954)
Stormy, the Thoroughbred (BV, 1954)
Susan Slept Here (RKO, 1954)
Tanganyika (U, 1954)
They Rode West (Col, 1954)
This Is Your Army (Ind, 1954)
Three Hours to Kill (Col, 1954)
Three Young Texans (Fox, 1954)
Tonight's the Night (British, AA, 1954)
War Arrow (U, 1954)
Yankee Pasha (U, 1954)
Yellow Mountain (U, 1954)
Ain't Misbehavin' (U, 1955)
The Americano (RKO, 1955)
The Annapolis Story (AA, 1955)
Attila (Ind, 1955)
Benny Goodman Story (U, 1955)
Bridges at Toko-Ri (Par, 1955)
Bring Your Smile Along (Col, 1955)

Cattle Queen of Montana (RKO, 1955)
Conquest of Space (Par, 1955)
Contraband Spain (Ind, 1955)
Davy Crockett, King of the Wild Frontier (BV, 1955)
Davy Crockett and the River Pirates (BV, 1955)
Doctor in the House (R, 1955)
Duel on the Mississippi (Col, 1955)
Far Country (U, 1955)
Footsteps in the Fog (Col, 1955)
Fort Yuma (UA, 1955)
Foxfire (U, 1955)
Gun That Won the West, (Col, 1955)
Invitation to the Dance (MGM, 1955)
Kiss of Fire (U, 1955)
Lady Godiva (U, 1955)
A Lawless Street (Col, 1955)
Littlest Outlaw (BV, 1955)
Man Without a Star (U, 1955)
The Naked Dawn (U, 1955)
One Desire (U, 1955)
Pirates of Tripoli (Col, 1955)
A Prize of Gold (Col, 1955)
The Purple Mask (U, 1955)
Raising a Riot (Ind, 1955)
Rawhide Years (U, 1955)
Sabaka (UA, 1955)
Seminole Uprising (Col, 1955)
Shotgun (AA, 1955)
Simon and Laura (U, 1955)
Smoke Signal (U, 1955)
So This Is Paris (U, 1955)
The Spoilers (U, 1955)
Ten Wanted Men (Col, 1955)
To Paris with Love (Ind, 1955)
Touch and Go (U, 1955)
Treasure of Pancho Villa (RKO, 1955)
Value for Money (Ind, 1955)
Wakumba! (RKO, 1955)
Warriors (AA, 1955)
Wee Geordie (British, Ind, 1955)
Woman for Joe (Ind, 1955)
Wyoming Renegades (Col, 1955)
You Know What Sailors Are (Ind, 1955)

KODACHROME BLOWUP DYE TRANSFER FEATURES

35mm dye transfer features derived from 16mm Kodachrome positive

Living Desert (RKO, 1953)
Vanishing Prarie (RKO, 1954)

African Lion (BV, 1955)

THREE STRIP TECHNICOLOR REISSUES FEATURES

35mm dye transfer features derived from black and white
nitrate three strip negatives reissued on safety base
during the years 1950–74

Trail of the Lonesome Pine (Par, 1936)
Adventures of Robin Hood (WB, 1938)
Adventures of Tom Sawyer (Selznick/UA, 1938)
Divorce of Lady X (British, UA, 1938)
Drums (British, UA 1938)
Kentucky (Fox, 1938)
Sweethearts (MGM, 1938)
Four Feathers (British, UA, 1939)
Gone with the Wind (MGM, 1939)
Jesse James (Fox, 1939)
The Private Lives of Elizabeth and Essex (WB, 1939)
The Wizard of Oz (MGM, 1939)
Bittersweet (Box, 1940)
Northwest Passage (MGM, 1940)
Thief of Bagdad (UA, 1940) British
The Black Swan (Fox, 1942)
Jungle Book (British, UA, 1942)
Reap the Wild Wind (Par, 1942)
The Gang's All Here (Fox, 1943)
Meet Me in St. Louis (MGM, 1944)

Anchors Aweigh (MGM, 1945)
National Velvet (MGM, 1945)
Salome, Where She Dance (U, 1945)
The Three Caballeros (BV, 1945)
Henry V (UA, 1946)
The Jolson Story (Col, 1946)
Smoky (Fox, 1946)
Song of the South (BV, 1946)
The Yearling (MGM, 1946)
Black Narcissus (U, 1947)
Duel in the Sun (SRO, 1947)*
Fun and Fancy Free (BV, 1947)
Easter Parade (MGM, 1948)
The Paleface (Par, 1948)
The Red Shoes (EL, 1948)
Words and Music (MGM, 1948)
Jolson Sings Again (Col, 1949)
On the Town (MGM, 1949)
Samson and Delilah (Par, 1949)
So Dear to My Heart (BV, 1949)
Under Capricorn (WB, 1949)

The Beijing Film Lab did a test of reel #4A in the dye transfer process using Chinese matrix and blank stock in 1993.

Consent Decree

In the late forties, four events happened simultaneously that would change the direction of both the Technicolor company and the film industry at large: the 1948 consent decree that separated distribution from exhibition; an antitrust suit against Technicolor that accused them of monopolizing the color field; the introduction of Eastmancolor negative; and competition from a new medium, television.

All four events would have long-term effects that are still being felt. Let's take a look at each event and how it influenced the Technicolor company.

DISTRIBUTION VERSUS EXHIBITION

Since the early days of cinema, the studios which produced and distributed motion pictures tried to swallow up as many theater chains (and often each other) as possible to guarantee outlets for their product. In some cases the exhibitors owned the distributors, as in the case of Loews theater circuit, which controlled MGM. In other cases, the studios owned a large number of houses, as did Warner Bros. and Fox.

This left the independent studios (e.g., Republic, Monogram) in the precarious position of trying to secure bookings around the major's schedules. Needless to say, the studio-owned theaters negotiated brutal terms with the "indies." There were also many independent theaters throughout the country, but here again, the smaller studios were at their mercy.

For years, the indies complained about the major studios' monopolization of distribution and exhibition, until the government

NOW IN RELEASE ALAN LADD in "**PARATROOPER**"

also starring LEO GENN · Screenplay by RICHARD MAIBAUM and FRANK NUGENT. Story by Hilary St.
George Saunders, adapted from his book, "The Red Beret." Directed by TERENCE YOUNG.

NOW IN RELEASE ALAN LADD in "**HELL BELOW ZERO**"

with JOAN TETZEL · Screenplay by ALEC COPPEL and MAX TRELL. Adaptation by RICHARD MAIBAUM.
Based on the novel, "The White South" by Hammond Innes. Directed by MARK ROBSON.

ALAN LADD NOW IN RELEASE MAY RELEASE RICHARD WIDMARK

"**The BLACK** "**PRIZE OF**
KNIGHT**" GOLD**"

co-starring PATRICIA MEDINA co-starring MAI ZETTERLING

Story and screenplay by ALEC COPPEL Screenplay by ROBERT BUCKNER and
Directed by TAY GARNETT JOHN PAXTON From the novel by Max Catto
 Directed by MARK ROBSON

"**COCKLESHELL HEROES**"
To be directed by and starring JOSE FERRER in CINEMASCOPE

"**SAFARI**" in CINEMASCOPE
To be filmed on location in Africa. Original screenplay by ROBERT BUCKNER

COLOR BY TECHNICOLOR

The 1948 Consent Decree that separated distribution from exhibition opened
the doors for more independent product.

stepped in and issued a series of decrees separating the two entities. It took years before the complete divorce took place, and regardless of the decrees, the majors still had enough clout to force exhibitors to give their product top priority.The decrees at least opened up the doors for independent producers and films that would have had a difficult time getting booked prior to 1948.

The long term effects can be seen today. After the television competition of the fifties had been alleviated, theatrical exhibition began a slow decline that resulted in the "shoebox" mulplexes common throughout the United States. While the studios controlled their own houses or had some competition from other mediums, exhibition tended to be quite spectacular. After exhibition became a separate entity, the bottom liners ultimately took over. The fact that presentation was substandard did not adversely affect the distributors because they had no say in the matter.

Prior to the decline, theatrical exhibition reached a new height of showmanship in the 1950s, designed to compete with the usurping television medium.

The Government versus Technicolor

While the indies fought the majors for theater space, they also complained about being left out of the color field. The bulk of the three strip Technicolor productions were made by studios like MGM, Paramount and Warner Bros., and only a handful by the minors like Republic. It was difficult to secure the cameras, and the extra expense of Technicolor technicians and color consultants was too costly for them.

To be fair to Kalmus and company, it is easy to understand why he preferred to rent his cameras to MGM. The release print run of the average Loews feature was three hundred copies. For a company like Republic, it was only one hundred copies. It was good business to cater to the studio that would order the most release prints.

In 1947, the United States Department of Justice filed an antitrust suit against Technicolor which implicated Kodak. At the time, Kodak was the only stock manufacturer that supplied matrix and blank stock to Kalmus, who was their largest customer. (The relationship between Technicolor and Kodak would soon change, once the latter introduced their proprietary Eastmancolor process.)

Kalmus argued that competing color processes were available to studios who did not like Technicolor's tough terms. The Justice Department would not accept this defense, since the other systems, like CineColor and Trucolor, offered only the two color range and were inferior to the dye transfer three color process.

The suit dragged on for three years, until a consent decree was finally issued in 1950. The 1951 issue of *Film Daily Yearbook* summarized the results:

> GOVERNMENT VS. INDUSTRY. The Government's antitrust suit against Technicolor finally came to an end on Feb. 28 with the signing in Hollywood of a consent decree which ended various contracts and arrangements between Technicolor and motion picture producers.
>
> The judgment gave producers the option to cancel contracts which had required them to use only Technicolor cameras and services in the making of motion pictures in color and to take advantage of any other decrees. Additionally, the judgment requires Technicolor to license 92 patents on a royalty free basis while 12 additional patents, 48 patent applications and all patents Technicolor acquires or applies for up until Nov. 28, 1953, are also made available to producers on a reasonable royalty basis.
>
> Moreover, Technicolor is required up until Jan. 1, 1957, to furnish "knowhow" to all licensees who pay a reasonable royalty. Finally, the judgment requires Technicolor to furnish at nominal charge the detailed specifications, prints and plans of Technicolor three strip cameras to all applicants desiring to manufacture cameras and to have the cameras and accessories available at reasonable rentals.*

What exactly did this mean? It meant that Technicolor would have to allow competing labs to set up their own dye transfer printing machines as well as to manufacture their own three strip cameras. A certain number of cameras would be set aside for whoever wanted to rent them, including tiny companies like PRC and Monogram (imagine the Bowery Boys in Technicolor!). As it turned out, this decree was rendered insignificant when the acceptance of color negative made the three strip cameras obsolete and the dye transfer process was adapted and substantially improved using this new medium for principal photography.

There was an interesting sidelight to this decree. For a few months in 1953, negotiations were under way between Technicolor and the DeLuxe lab to set up a dye transfer line in the latter. A

*Film Daily Yearbook of Motion Pictures, 1951 *(New York: Wid's Film and Film Fol, 1929–70)*, p. 63.

handful of 35mm imbibition prints were made of *How to Marry a Millionaire* and *Beneath the 12-Mile Reef* that contained the credits "Color by Technicolor-DeLuxe." The DeLuxe executives changed their minds and decided to go with the Eastmancolor contact printing system for most of their future 35mm releases, although many of their nontheatrical 16mm prints were made in the dye transfer process. (In some cases, 16mm IB prints are the only DeLuxe titles that still have color, since the majority of the 35mm color negatives and prints developed at that facility display severe fading problems.) Had DeLuxe or some other color lab taken advantage of the decree, we might still have dye transfer printing in the United States.

EASTMANCOLOR NEGATIVE

Circa 1949, Kodak introduced its first 35mm color negative stock, 5247. Color negative contained the same dye couplers used in the Monopack and Kodachrome processes with an important difference: the couplers were contained in the emulsion and developed into a color negative image rather than being bleached into a color positive image in separate baths.

To make a release copy, the negative was contact printed with Kodak positive stock 5381, which also contained dye couplers. Light was exposed through the emulsion of the negative onto the emulsion of the print stock, and the latter was developed, fixed and washed into a color positive image.

What did the color positive look like compared to a dye transfer print? There were many notable differences. On the up side, color positives were technically sharper than imbibition prints derived from the three strip negatives. This is not to suggest that Technicolor prints didn't look sharp. The rich contrast and vivid dyes combined with the high key lighting gave them excellent "apparent" sharpness. The only way an audience would have seen any difference in the sharpness is if viewers screened a positive print and an imbibition copy side by side. Nevertheless, the sharpness problem bothered Kalmus, and he put his research department to work on it. By the midfifties, dye transfer prints had comparable apparent sharpness to positive prints.

Unfortunately, there were many down sides to the process, which came to be known as Eastmancolor. Positive prints lacked the

intense colors of dye transfer copies. Although the primary color rendition was adequate, the dye couplers did not "glow" from the screen in a three dimensional depth as the dyes used in imbibition process did. There was no way of replicating the vibrant, saturated primary colors of a Technicolor print on Eastmancolor positive stock. The "pure" blacks of a dye transfer print that gave them their rich contrast and grain free appearance were also absent in positive prints. Eastmancolor had weaker contrast and transparent blacks, which made grain more apparent in dark scenes that used low lighting.

In the best case scenario, Eastmancolor positives looked good, providing the lab work was exacting (which was not always the case) and the negatives were fully exposed (as they generally were prior to the 1970s), but not "glorious." While the sharpness of the image somewhat offset the weak contrast and colors, there was no way of mass-producing the prints with the same quality control available with the dye transfer method. From the distributor's point of view, this was not as important as the fact that Eastmancolor provided a cost-efficient method of running an in-house film lab. Positive prints were cheaper to make in small numbers because most were struck directly from the camera negative. This eliminated the necessity of additional preprint, which in the case of the Technicolor process was the cost of making matrices. Unfortunately, mass-producing positive prints from the camera negatives wore them out quickly. Negatives used in the dye transfer process were used only for matrix manufacture, so they remained in better condition. For print orders exceeding one hundred copies, the dye transfer process was less expensive than Eastmancolor.

There was another major flaw in the Eastmancolor process that was ignored by the industry at the time but later resulted in an archival crisis: dye couplers were chemically unstable and would fade. The rate of fading was determined by a number of factors, not the least of which were the quality of the original labwork and storage conditions. An unsubstantiated though interesting story was repeated by many insiders in the research for this book: When Kodak offered their negative/positive process to the studio owned labs, they gave specific instructions on how to develop, fix and wash the film. If these specifications were not followed, quality control and image stability would suffer. The labs quickly discovered that an acceptable image could be generated while cutting corners in certain areas, like washing the film after fixing. Improper washing resulted in image deterioration,

since residue hypo and other chemicals left on the emulsion of both prints and negatives acted as a corrosive and made the dye couplers fade. As the story went, Kodak told these facilities that if they weren't going to process the film correctly, they should use their own trade names rather than Eastmancolor. Thus, Pathé Color, WarnerColor and others were formed.

This story may well have validity, since dye coupler fading varies greatly per lab. Whereas positive prints all faded rapidly (the organic dye couplers could not withstand the heat of the carbon arcs), the negatives deteriorated slowly at Metrocolor, which had better than average quality control, and very quickly at labs like Pathé Color, where corners were cut. Bill O'Connell detailed the problems of one of the facilities in *Film Comment* magazine: "Many archivists accuse DeLuxe of processing Fox films too quickly and sloppily, and insist that improper 'washing' of the developing chemicals from the prints and original negatives as well as mediocre quality control have contributed to Fox's current preservation problems."*

To cover themselves, the stock manufacturers offering dye coupler materials put a disclaimer on their cans of film, stating that they would not warrant against any change in color. This disclaimer is still on all motion picture and still film. In fairness to the stock manufacturers, it should be acknowledged that the fact that dye transfer prints did not fade was probably not intentional. The earlier cement positive Technicolor prints faded to orange, and no one seemed to care. The stability of the acid based dyes combined with photomechanical rather than photochemical printing just happened to be one of the assets that made it foolproof in terms of preservation.

It's a shame that none of the competing facilities attempted to become "The Greatest Name in Eastmancolor." Had at last one of them offered the consistant quality control of Technicolor, the reputation of facilities like Pathé Color and WarnerColor would not be so tarnished. It would appear that most of them merely offered a "cheap" alternative to Technicolor's undisputed reputation as "The Greatest Name in Color."

Eastmancolor was not generally adopted for professional use until 1952–53, although it was available in 1949. One of the problems for the first three years of its development was the lack of quality duplicating color stock. If producers wanted an optical effect like a

*October 1979, p. 13.

fade or dissolve, they were out of luck. This was impractical for feature productions. Circa 1952, Kodak devised a method of incorporating opticals into their process. A set of black and white panchromatic separation positives (type 5216) would be derived from the color negative of the sequence. From these separations, the optical effects would be reprinted onto color internegative stock (type 5243) and spliced into the original camera negative.

Although this enabled the color negative/positive process to be used for feature productions, the quality of the internegative optical effects was extremely grainy and poor. Editors cut back to the camera negative after the effect in the same way they did in black and white films. Thus early Eastmancolor productions had the same visual "pop" whenever a fade or dissolve appeared.

The black and white panchromatic separation stock had another function. By making black and white separations of the entire color negative, the studios had a protection master against the dye coupler fading that would eventually render early Eastmancolor materials unusable. Separations were not automatically made on all features shot with color negatives. Studios like MGM and Disney made them on their product, while others like Columbia, Warner Bros. and United Artists separated only selective titles. Academy Award winner *Tom Jones* never had black and white separations manufactured, and new prints derived from the faded camera negative are a distortion of the original color. Part of the reluctance might have been attributed to the poor color intermediate stock available at the time. Making separations in the fifties was based on the assumption that they could be used to restore the color some day in the future but not at the time of manufacture. Kodak eventually offered quality color internegative stock that was used in this capacity.

Although encumbered with image stability and quality control problems, the Eastmancolor process improved throughout the fifties. When the color negatives were later adapted for use in the dye transfer process, release printing reached a zenith it would never hit again.

OTHER COLOR PROCESSES

The late forties and early fifties also saw other color processes trying to find a place in the industry. As previously mentioned, the Cine-Color and Trucolor two strip methods had been around throughout

the forties but offered only a limited color range on double emulsion stock. Both used black and white bipack negatives for principal photography and a variation of imbibition that dyed the two colors on either side of the film. The colors purple, lavender and pink could not be reproduced in CineColor or Trucolor processes. The companies attempted to upgrade their processes into the full three color range in the early fifties. Super CineColor was introduced circa 1952. Kodak Eastmancolor negatives were used for principal photography. The negative was then separated into black and white three strip negatives, similar to those used in the Technicolor process. A variation of imbibition was used that dyed two colors on one side of the film and the third color on the opposite side. The end result was a full color print that was very saturated and somewhat resembled a dye transfer Technicolor print but was grainier. The grain was caused by the generation loss of separating a color negative. Although the Super CineColor prints had excellent image stability, they were inferior to both Technicolor and Eastmancolor positives and were phased out in the midfifties. Upon the dissolution of the company, Kalmus bought the CineColor building and made it into an extension of his research department. (It was rumored that Kalmus was involved with the elimination of Super CineColor to avoid the competition.)

Trucolor switched over to the negative/positive process to offer the three color range. Kodak color negatives were used for principal photography and then separated into black and white preprint. Du Pont positive stock (type 875) was used for release printing. This stock had a Monopack structure that used synthetic polymer rather than gelatin as a color former. Shortly afterward, Du Pont left the film business and Trucolor was phased out.

Two foreign companies, Agfa color and Fujicolor, developed their own color negative and positive stock. Neither was used much in the United States until the 1960s. While both Agfa and Fuji stock lacked the resolution of Kodak stock at the time, they had two slight advantages. Both were cheaper — which is why they were used extensively by the independents — and each had better image stability. Many Agfa color prints from the sixties still maintain their color intact, and Fujicolor prints also faded slowly, although they were subject to a phenomenon known as "Fujirot." Colored dots would appear all over the emulsion during exhibition, the cause of which was unknown, since not all prints were affected.

The other notable three color process was Ansco Color, sponsored

by MGM in the late forties. Ansco was originally a Monopack/Koda-chrome type of 35mm stock used during principal photography. For release prints, reversal Kodachrome prints would be made from the Kodachrome master. Since reversal positives were derived from Kodachrome positives, the prints had substandard resolution and apparent grain.

In the early fifties, Ansco offered their own color negative and color positive stock in the dye coupler process. Ansco color negatives lacked the resolution and sharpness of Kodak color negatives. In 1956, MGM shot their last feature with Ansco color stock, *Lust for Life*, thereafter switching to Kodak negative/positive film and retitling their lab Metrocolor, which is now defunct.

SAFETY BASE FILM

One of the most significant developments in film stock was the implementation of 35mm triacetate "safety" base professional film in 1948. Film deterioration problems must be broken down into two components: image deterioration and base deterioration. In the case of pre–1950 dye transfer prints, CineColor and Trucolor copies and black and white films, the image was stable but the nitrate base they were printed on was flammable and subject to decomposition and explosion in bad storage conditions. In the early Eastmancolor films printed on the upgraded safety stock, the base had better stability but the image deteriorated.

If properly processed and stored, nitrate film could last a long time. Since Technicolor had the greatest quality control in the business, the nitrate three strip negatives have still not decomposed in most cases. Nitrate negatives and prints developed at other labs deteriorated more rapidly because some of the facilities cut corners in processing and storage.

Even carefully processed, nitrate film was a fire hazard. Kodak offered 16mm safety film as early as the 1920s, and Agfa sold biacetate 35mm safety base film in 1929. During World War II, 35mm safety film was used by the armed services. Unfortunately, stock manufacturers were irresponsible about the dangers associated with their professional film, and it was not until 1948 that they began to phase out their nitrate film and switch to an upgraded triacetate safety stock. Some Technicolor films still used the nitrate stock. For example,

the *Show Boat* three strip negatives were photographed on the nitrate base, while the optical effects were on safety film. It took another 20 years before the studios began to transfer their nitrate negatives to the more durable safety film, and even then did so only after the American Film Institute and other archival institutions put considerable pressure on them.

How "safe" was the safety film used from 1948 through the present? It was certainly an improvement over the nitrate base. The deterioration problems of the latter resulted in the loss of over 50 percent of the pre–1950 titles.

As it turned out, safety base film also had deterioration problems which were attributed to bad lab work and storage. Improperly developed and washed triacetate black and white and Eastmancolor film stored in hot, humid Los Angeles vaults (which were common in Hollywood) were subject to a phenomenon known as "vinegar syndrome." Residue hypo and other chemicals left on the emulsion combining with moisture and heat caused the base to go through a humidity inversion, shriveling the film while giving it the smell of vinegar (which was really acetic acid). Although archivists have not found vinegar syndrome to be as widespread as nitrate decomposition, they are now examining negatives developed at the competing labs that did not have the quality control of Technicolor. Thus far, properly developed and stored safety film seems to be reasonably stable. It is interesting to note that few dye transfer prints have been affected. Based on the evidence, a valid argument could be made that Technicolor was the *only* facility that consistently offered archival quality processing and release printing through the 1970s.

TELEVISION

The years 1948 through 1952 were critical for the film industry. It was in a state of panic, and television was the culprit. Although there were broadcasts as early as 1930, and Du Mont had attempted to introduce television to consumers in 1939, it wasn't until after World War II that the medium caught on.

During the years 1946–48, television gained in popularity. There were originally four networks — CBS, ABC, NBC, and Du Mont — in addition to hundreds of independent stations throughout the country. The early sets could be bought in two shapes, oval and square.

Twenty-five inch screens were available as early as 1950. At the time, most broadcasts were in black and white (although experimentation was going on with color), and the television screen replicated the motion picture theatrical ratio of 3:4.

From its inception, there was a debate about whether TV should be "free" (albeit inundated with annoying commercials) or paid for by consumers, like today's cable, which at the time was referred to as "toll TV." There were even some attempts to project television signals in movie theaters, but the results were so poor, it was quickly abandoned.

Broadcasts were either live or on film, depending on the show. Both "The Honeymooners" and "I Love Lucy" were shot in 35mm for network airing. Reduction prints made in 16mm were used for syndication. Movies were broadcast via a "film chain" system that involved a projector aimed into a modified television camera using a lower light source.

Some shows, such as "The Show of Shows" and "The Colgate Comedy Hour," were broadcast live and "kinescoped" for later reruns. A 16mm black and white camera was adapted to the video scan and photographed the performance off a television monitor. Kinescopes were very poor quality, but they were the only method available at the time of saving a live performance. Upon the advent of professional Two Inch videotape in the early sixties, kinescopes became obsolete. Unfortunately, videotape was an impermanent medium (as are all magnetic materials), subject to oxide flaking. Most kinescopes have survived in better condition than Two Inch videotapes from the sixties.

The free entertainment at home cut into theater attendance. *Film Daily Yearbook* of 1954 detailed the decline:

Average weekly attendance of U.S. film theaters
since 1922 (estimated)

1952	45 million	1941	85 million	1931	75 million
1951	54 million	1940	80 million	1930	90 million
1950	60 million	1939	85 million	1929	80 million
1949	70 million	1938	85 million	1928	65 million
1948	90 million	1937	88 million	1927	57 million
1947	90 million	1936	88 million	1926	50 million
1946	95 million	1935	80 million	1925	46 million
1945	85 million	1934	70 million	1924	46 million
1944	85 million	1933	60 million	1923	43 million
1943	85 million	1932	60 million	1922	40 million
1942	85 million				

Take it Easy!

Change TV Programs from your Easy Chair with the Amazing

Zenith "Lazy Bones"
REMOTE CONTROL

Not one knob to touch! That's right — you just hold the "Lazy Bones" control in your palm, anywhere in the room. To change programs one after another, just press lightly with your thumb. Absolutely nothing else to tune or re-tune. All the necessary adjustments are made for you — automatically. It's the far-ahead design and extraordinary stability of Zenith's Turret Tuner that make possible such miraculous remote control! You must try it yourself to believe it. Your Zenith Radio and Television Dealer invites you, today.

New Zenith® "Byron" TV Console. 19 inch (238 sq. in.) 2-in-1 Reflection-Proof screen, wider than a newspaper page! New "Super-Range" chassis. Pre-tuned built-in antenna. 18th Century cabinet in rich Mahogany veneers.

©1951

Only $30, on any new
Zenith TV Receiver

ZENITH
LONG DISTANCE RADIO and TELEVISION

THE ROYALTY OF RADIO AND TELEVISION

Zenith Radio Corporation, Chicago 39, Illinois • Also Makers of Fine Hearing Aids

First in development — When Dr. Du Mont started his research in 1931, the cathode ray tube was a laboratory curiosity. It was his development of this tube that made electronic television commercially practical.

First with home receivers — Du Mont built the first commercial home receivers in 1939. After the war, in 1946, Du Mont was first on the market with a line of fine receivers; first with the 20-inch and 30-inch tubes—the world's largest.

First in station equipment — Du Mont is a leading maker of high-fidelity, precision broadcasting equipment, and has planned, designed, and built many of the country's leading television stations.

20th year as pioneer

DU MONT

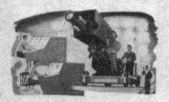

First in precision electronics — Du Mont is the world's foremost maker of scientific precision instruments utilizing the electronic cathode ray tube.

First in radar — In 1933, Dr. Du Mont filed a patent application which the army asked him to withdraw for security reasons. This idea, developed in secrecy, became radar.

DU MONT

20th YEAR AS PIONEER

first with the finest in Electronics

During the postwar years theater attendance peaked at a level that equaled the one reached with the introduction of sound (1927–30). The advent of television made attendance drop by fifty percent. The decline, combined with the effect of the consent decree separating distribution and exhibition, made many studios fear that the end of the motion picture industry was near.

Fortunately, television competition inspired a technological revolution that made the years 1952 through 1962 the most exciting decade in motion picture exhibition. Since most of the new formats used the superior dye transfer process for release printing, the fortunes of Technicolor also reached a peak in this era.

The Fabulous Fifties

Most writers who discuss the Technicolor process stop after the introduction of Eastmancolor and the demise of the three strip cameras. Actually, the zenith of the imbibition technique was during the years 1952 through 1962, when the color negative was adapted for use with the process. Television competition had resulted in an increase in three strip Technicolor productions in 1948–52. The research department came up with a method to supplement the three strip camera, known as stripping negative. Three differently sensitized layers of black and white emulsion were separated by soluble interlayers with suitable filtering dyes. After exposure in a modified black and white camera, the top two layers were individually transferred to new supports. The resulting three black and white negatives would then be used for making matrices in the conventional manner. The gaining popularity of the Kodak and Ansco single strip color negatives made the Technicolor staff abandon this technique and work on adapting these negatives to their imbibition process.

Around the same time, a young chemist named Richard Goldberg joined the research staff and eventually became the vice-president of the department. Goldberg's first contribution was the development of single component dyes. In the thirties and forties, the dyes used in the imbibition process contained multiple components and were difficult to manufacture. For example, the yellow dye had three components, and the cyan had five. According to Goldberg, there was even a time when oyster juice was used as one of the elements, and Technicolor technicians used to visit restaurants at the end of the day to collect it. Sometimes the dyes were not pure when received from the supplier and had to be treated with egg albumin and acetic acid and boiled, then vacuum filtered to remove the impurities.

The early multiple component dyes made quality control difficult for Technicolor reprints. For example, after one set of matrices wore out and was replaced for additional orders, it was difficult to duplicate the precise dye components used on the initial run. Pre–1950 dye transfer prints often had slightly different color renditions from each batch of dyes.

Goldberg was able to simplify the dyes so they came from one component each and were purified at the source. The American Cyanamid Company achieved this domestically and became the primary supplier of the era. The new single component dyes were somewhat different in look than the multiple component ones; the magenta was more brilliant, for instance. As a result, some of the three strip reprints of films like *Gone with the Wind* and *The Wizard of Oz,* both reissued in 1954, had more vibrant colors than when originally released. The single component dyes improved quality control and enabled reprints from new matrices to match the original colors more precisely.

TECHNICOLOR PROCESS NUMBER FIVE: THREE STRIP DYE TRANSFER PRINT DERIVED FROM COLOR NEGATIVE

In the early fifties, the Technicolor company expanded their facility to enable them to develop color negatives and make contact positive prints in the Eastmancolor process. The research department also modified their optical printer to enable them to derive matrices directly from a color negative. This was accomplished by placing a filter over the negative that transmitted light of sympathetic frequencies onto the matrix stock. Kodak developed a new panchromatic matrix stock for this application. This technique was referred to as Technicolor Process Number Five. This process encompassed various formats, which will be described below.

CINERAMA

The first innovation that made an impact in the rush to bring audiences back to the theater was the most spectacular and the strangest. Dubbed Cinerama, it was an entirely new method of filming and

projecting motion pictures. Fred Waller had developed a prototype system known as Vistarama, which was used to make films for a gunnery training in World War II. Lowell Thomas and Merian C. Cooper (coproducer of *King Kong*) formed a partnership with theatrical showman Michael Todd to develop the process for feature productions, and Hazard Reeves introduced the six channel magnetic stereophonic sound.

The Cinerama specifications were very complicated, which may, in part, have been an attempt to make the technology difficult for third parties to steal. (The Cinemiracle system, a near identical process, was developed in 1958 anyway.) Three interlocked 35mm cameras photographed the panoramic image on Kodak color negative (fig. 11). A six-sprocket high frame was exposed (sans optical track

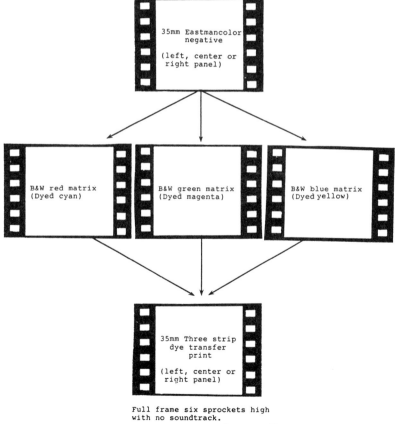

Fig. 11. Cinerama dye transfer.

area), which generated a wide 2.77 × 1 aspect ratio when projected. The 35mm magnetic fullcoat stock contained six discrete stereo tracks and was interlocked with the projectors and displayed on a curved screen. The "louvered" screen was made up of horizontal slats that resembled venetian blinds, which prevented light from the right and left panels from reflecting on one another.

The projection speed was increased to 26 frames per second, while the interlocked magnetic stereo track remained at 24. For the last two three-panel features, the speed was reduced to 24 frames per second.

The theaters that played Cinerama films had to be equipped with three booths, each of which projected one panel onto the curved screen. The Cinemiracle system, introduced with *Windjammer* in 1958, modified the format to include the three projectors in one booth to reflect the image to the appropriate part of the screen via mirrors. Cinerama bought out Cinemiracle and adapted the latter for the remaining three panel features. The final modification involved "jitters" inside the projectors, which blurred the frame lines that made up the three panel panorama.

The gamble paid off; *This Is Cinerama*, released on September 30, 1952, became one of the top grossing films of the year and generated $5 million of revenue. The picture was treated as a road show event, with reserved seats and a two dollar admission.

The film began with a standard black and white 35mm prologue, with Lowell Thomas giving an intentionally dull history of motion picture exhibition. Just as audiences were ready to walk out and demand their money back, Thomas exclaimed, "Ladies and Gentlemen, this is Cinerama!" The black and white 1.33 × 1 intro faded out and the three panel color image placed the viewer on a roller coaster ride. The remaining Cinerama films of the fifties all started in this fashion, with the changing aspect ratios used to "wow" the audience.

This Is Cinerama and the other five productions of the fifties were spectacular travelogues which took audiences on trips to Niagara Falls, the Grand Canyon, the South Seas and other sights. It wasn't until the process had run its course (and the company had run out of locations to photograph) that two narrative films were attempted in 1962, *How the West Was Won* and *The Wonderful World of the Brothers Grimm*. By then, single panel wide screen formats had caught on, and the three panel process was phased out.

The modified optical printer that enabled a set of matrices to be

derived from a color negative was not operational by the time *This Is Cinerama* was ready for release. Therefore, the 1952 three panel prints were made in the Eastmancolor process.

After the research department perfected their optical printer to enable matrices to be made from any size negative, *This Is Cinerama* was rereleased in the dye transfer process in 1962, with even more impressive results. The last two three-panel story features were also printed via imbibition. (Of the seven three-panel features, only *This Is Cinerama* and *How the West Was Won* exist in Technicolor, thanks to a film collector who saved dye transfer copies and has a working three panel projector set up in his house. No three panel IB print has survived on *The Wonderful World of the Brothers Grimm*. The remaining Cinerama titles of the fifties were all printed in Eastmancolor and have completely faded.)

CINERAMA FEATURES

35mm dye transfer features derived from Cinerama three
panel color negatives (all were interlocked with six or
seven channel magnetic stero fullcoats)

This Is Cinerama (Cinerama, 1962 reissue)
How the West Was Won (MGM/Cinerama, 1962)
Wonderful World of the Brothers Grimm (MGM/Cinerama, 1962)

3-D

Shortly after the premiere of *This Is Cinerama*, the public was bombarded with advertisements for another innovation that required new methods of filming and exhibition and was known as 3-D. Like most new formats of the fifties, 3-D had been available earlier but did not catch on. In the silent era, there was some experimentation with 3-D, including footage of Abel Gance's *Napoleon* in 1925, although it was not used in the final release print.

Pete Smith made two novelty short subjects entitled *Audioscopiks* (1936) and *The Third Dimension Murder* (1941), both released by MGM. They were essentially gimmick films that showed objects thrown at the audience with little or no connecting plot. Both used the Anaglyphic system of 3-D. Anaglyphic entailed shooting with two

interlocked 35mm cameras that photographed the action at slightly different angles, which replicated how the two human eyes see things. For release printing, the two negatives were printed onto one strip of film at Technicolor, which imbibed the two tints.

Glasses were worn by the audience that contained the same tinted filters reversed, with the left eye receiving the red tint and the right eye the blue tint. The brain did the rest of the trick: the filters canceled each other out and the viewer perceived the image in three dimensional depth. Unfortunately, the red and blue glasses caused eyestrain.

A more sensible method, known as Polarized 3-D, was developed in Italy and Germany in the 1930s. The same method was used in principal photography, with two interlocked cameras photographing the action at slightly different perspectives. For projection, the two prints were shown through two different polarizing filters. The same filters were reversed in the audience's glasses, and the three dimensional illusion was achieved with less eyestrain since these filters merely darkened the image rather than tinted it. A silver screen was required to project 3-D to reflect the light and brighten the image. The Polarized system enabled films to be shot in color, an impossibility in the Anaglyphic method. (Anaglyphic color 3-D was tried on broadcast television in the 1980s with poor results.)

Low budget producer Arch Obler dusted off this process and reintroduced it on November 24, 1952, with his 3-D feature *Bwana Devil*, photographed and printed on Ansco color stock. Interlocked with the 3-D prints was a four track magnetic stereo 35mm fullcoat on a sound dubber. The movie received terrible reviews, but the process was a hit with viewers who wanted "lion in their lap." Actually, 3-D worked best when the effect was used subtly. Whenever something was thrown at the audience, the viewer went crosseyed trying to merge the two images. When used to create a sense of distance between foreground and background, it was more effective.

Technicolor adapted its three strip cameras with "selsyn" interlock motors to enable them to photograph the dual strip image for dye transfer 3-D prints. They also made dye transfer dual strip 3-D prints on features shot with color negatives and with Monopack positives.

Dye transfer 3-D (as well as standard 2-D features) derived from color negatives did not have halftone key images printed under the

dyes because they did not require registration adjustments, as did matrices derived from three strip negatives. In addition, the sharpness was increased since the matrices were made from a single element.

Although color fringing was alleviated, grain increased, which bothered Kalmus. He put his research department to work on an emergency basis, and the grain problem was resolved by 1954–55. Thereafter, dye transfer prints derived from color negatives had a grain-free appearance that surpassed Eastmancolor positives.

RKO used the Monopack stock for their 3-D color films. Two of the best 3-D films of the fifties were both shot with color negatives — *Kiss Me, Kate* (Ansco Color negative) and *Dial M for Murder* (Kodak color negative). In both cases, other labs did the negative processing, and Technicolor's involvement was limited to the production of the dye transfer release prints; they had no input during the production. Many of the features were interlocked with four channel magnetic stereophonic soundtracks, although all were printed with optical tracks.

The Technicolor 3-D prints of the fifties really did give the illusion of depth. The fact that dye transfer prints generated a three dimensional appearance anyway helped the process. The popularity of 3-D wore out quickly, since only a few of the features used what audiences considered "A" material. Most were "B" films that relied on arrows, rocks and other objects thrown at the audience — entertaining to first time viewers but tiresome in the long run. The most creative use of the process was in the previously mentioned *Dial M for Murder,* but by then it was too late. By the end of 1954, 3-D has fizzled out, and other processes like CinemaScope and VistaVision attracted more attention.

It's a pity the process did not last long enough to introduce the Vectograph 3-D system, which was developed by Technicolor and Polaroid. A specially prepared blank stock was created that had emulsion on both sides and the appropriate polarizing tints. The right eye color image was transferred onto one side of the film and the left eye image on the opposite side. Both images were thus contained, with the polarized tints, on one strip of film, and the system required only one projector. The process could be resurrected some day by the Polaroid company and Beijing Film Lab.

3-D FEATURES

35mm dye transfer dual system 3-D features derived from
three strip, Monopack, Kodak or Ansco Color negatives

House of Wax (WarnerColor) (WB, 1953)*
Fort Ti (Col, 1953)*
Sangaree (Par, 1953)
Arena (Ansco Color) (MGM, 1953)*
Second Chance (RKO, 1953)*
Inferno (Fox, 1953)*
Stranger Wore a Gun (Col, 1953)*
Devil's Canyon (RKO, 1953)
Wings of the Hawk (U, 1953)*
Those Redheads from Seattle (Par, 1953)
Flight to Tangier (Par, 1953)
Kiss Me, Kate (MGM, 1953)*

Gun Fury (Col, 1953)*
The Nebraskan (Col, 1953)*
Miss Sadie Thompson (Col, 1953)*
Drums of Tahiti (Col, 1954)*
Money from Home (Par, 1954)
The French Line (RKO, 1954)
Jesse James vs. the Daltons (Col, 1954)*
Dangerous Mission (RKO, 1954)
Jivaro (Par, 1954)
Dial M for Murder (WarnerColor) (WB, 1954)
Gorilla at Large (Fox, 1954)*
Son of Sinbad (RKO, 1954)
Taza, Son of Cochise (U, 1954)*

Interlocked with four track magnetic stereo fullcoats.

CinemaScope

After the success of Cinerama, 20th Century–Fox purchased the rights of the Hypergonar process credited to Professor Henri Chretien, who developed it in 1927. The Hypergonar process involved an anamorphic lens attachment screwed onto a standard 35mm prime lens. The anamorphic attachment compressed ("squeezed") the image vertically during principal photography. A similar lens attached to the projector "unsqueezed" the image horizontally into a wide 2.66×1 aspect ratio. Fox dubbed the process CinemaScope and came up with an attractive logo.

The first feature film released in the format was *The Robe* in October 1953. Although the release prints contained a 2×1 compression and unsqueezed 2.66×1 image area, a slight cropping of the frame resulted from the thin magnetic oxide stereo tracks applied to the base of the print inside and from the outside smaller, square sprockets, referred to as "Fox holes." The magnetic strips generated the four tracks of stereo sound used in the process (fig. 12). No backup optical track was printed onto the release copy, and the projected image included the area usually reserved for the soundtrack.

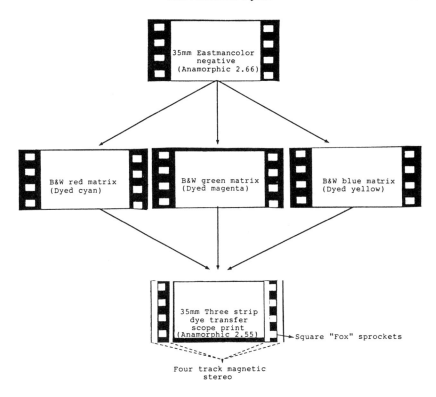

Fig. 12. CinemaScope dye transfer.

The process was a big hit and other studios, including MGM and Warner Bros., sublicensed the lens attachments from Fox. To play back the magnetic tracks a Pentouse adapter was necessary. A Penthouse was a small magnetic dubber attached to the top of the projector between the top magazine and gate. The film was threaded through the dubber, and the unit had four outputs that had to be wired to four amplifiers and speakers. This involved extensive theater modification, and exhibitors complained. It was one thing to get another lens attachment and a bigger screen but costly to rewire the entire sound system. Fox stuck to its guns and released magnetic only Cinema-Scope prints on many titles through 1956. Eventually, exhibitor pressure forced Fox to modify the release prints to contain both magnetic and optical tracks.

In the mag/optical format, the reduced sized sprockets were retained but both magnetic and optical tracks were included on the

Magnetic stereo Penthouse adapter bolted to the top of the projector beneath the top magazine.

CinemaScope release print. Theaters had the choice of playing the magnetic stereo tracks or a mono optical soundtrack. All CinemaScope films made after 1956 were distributed in this method, eliminating the magnetic only format. Since the optical track cropped the image slightly, the aspect ratio was permanently reduced to 2.35 × 1.

The first dye transfer prints of *The Robe* were a disaster. Whereas the new panchromatic matrix stock was acceptable for "flat," non-anamorphic films (e.g., MGM's *Athena*), stretching out the image increased grain and distortion. The latter was not entirely due to the matrix stock. The CinemaScope lens attachments cut down on the amount of light transmitted to the color negative and also tended to distort closeups, since the image was being photographed through so much glass.

Kalmus rushed out backup Eastmancolor positive prints to replace the dye transfer copies in circulation, even though the credits contained the "Color by Technicolor" logo. A "flat" 1.33 × 1 version was shot simultaneously with the scope version, and dye transfer prints were made from this negative and shipped to theaters not equipped to play the CinemaScope format. These prints did not have the grain problem because the image was not being stretched out.

Kalmus and Goldberg called an emergency meeting with Kodak to request an improved panchromatic matrix stock that would work with CinemaScope color negatives. According to Goldberg, Kodak showed interest in promoting their Eastmancolor process and suggested that Technicolor abandon the dye transfer format and switch to positive printing.

Kalmus and company felt they had a unique product with superior color, contrast and quality control to Eastmancolor and went to other stock manufacturers for the solution. A deal was struck with Du Pont to make upgraded dye transfer materials which were used on a number of 1953–56 features. Some of the VistaVision films used Du Pont materials, which were an improvement over the early Kodak panchromatic stock. Dye transfer prints made on Du Pont stock displayed less apparent grain and contained the identification on the sprockets.

With the upgraded Du Pont materials, Kalmus went to Kodak and asked them to match it or lose their business. Since Technicolor was still their largest client, Kodak took a more enlightened attitude and improved their dye transfer matrix and blank stock, which

MIGHTY IN SCOPE

...mighty as this man whose conquests changed the face of the world!

HOWARD HUGHES presents

JOHN WAYNE · SUSAN HAYWARD

THE CONQUEROR

IN TECHNICOLOR · CinemaScope

co-starring PEDRO ARMENDARIZ · AGNES MOOREHEAD · with THOMAS GOMEZ · JOHN HOYT · WILLIAM CONRAD · TED de CORSIA

A DICK POWELL Production · Written b OSCAR MILLARD · Produced and Directed by DICK POWELL

RKO RADIO

eventually surpassed the quality of the Du Pont stock. The remaining Du Pont inventory was used through 1956 and then discontinued.

A new generation of Kodak matrix and blank stock, which replaced the earlier panchromatic films, was introduced in 1954 and again in 1956. A separate color sensitive matrix was developed that improved the resolution. The yellow matrix stock was sensitive to blue and ultraviolet light; the cyan was sensitive to red, blue and ultra violet, and somewhat sensitive in the green; and the magenta stock was sensitive to green, blue ultraviolet and a little to the red. Appropriate filters placed over the Kodak or Ansco color negatives provided the desired separation in the optical printer.

One could see the improvements from the 1953 scope IBs of *The Robe*. In the 1983 Radio City Music Hall screening of *A Star Is Born* (1954), an original dye transfer copy printed on Kodak stock was shown that had excellent sharpness and little apparent grain, even on the enormous screen.

CinemaScope's popularity continued to grow throughout the fifties and was later improved with the introduction of anamorphic prime lenses by the Panavision company in 1957. Technicolor also made optical only dye transfer CinemaScope prints that had no mag tracks. This was accomplished by recentering the 2.66 × 1 negative in the optical printer and equally cropping approximately 0.050 inches on either side of the image while manufacturing matrices in the 2.35 × 1 format. The final scope dye transfer release copy had a slight edge cropping but retained the correct center of the frame and widescreen composition.

The competing Eastmancolor labs did not have this capability, since they were using the contact printing system, which did not allow for any adjustments. When a 2.66 × 1 negative was printed with an optical track, the left side of the image was randomly cropped, leaving the entire Eastmancolor release print off center. (This can be seen during the split screen sequences in the letterbox laserdisc of *It's Always Fair Weather*.) The flexibility of the dye transfer process allowed the optical printer to crop the frame to any format required. For example, Technicolor was able to derive a masked 1.85 × 1 release print from a 2.66 × 1 negative for theaters not equipped with wide screens. A "flat" print of *Wichita* (1956) exists in a private film collection that has the 1.85 × 1 masking.

CINEMASCOPE FEATURES

35mm dye transfer features derived from CinemaScope negative
(All features released in four track magnetic only format. Some
titles may have been printed in optical mono format for
theaters not equipped with Penthouse adapters. Other titles were
developed at competing labs and release printed at Technicolor.)

The Robe (Fox, 1953)*
How to Marry a Millionaire (Fox, 1953)
Beneath the 12-Mile Reef (Fox, 1953)
Black Shield of Falworth (UA, 1953)*
Brigadoon (Ansco Color) (MGM, 1953)*
Sign of the Pagan (U, 1954)
The Silver Chalice (WarnerColor) (WB, 1954)
A Star Is Born (WB, 1954)
Three Coins in the Fountain (DeLuxe) (Fox, 1954)
20,000 Leagues Under the Sea (BV, 1954)
Demetrius and the Gladiators (Fox, 1954)
Garden of Evil (Fox, 1954)
Hell and High Water (Fox, 1954)
Prince Valiant (Fox, 1954)
River of No Return (Fox, 1954)
Seven Brides for Seven Brothers (Ansco Color) (MGM, 1954)

Woman's World (Fox, 1954)
Captain Lightfoot (U, 1955)
Chief Crazy Horse (U, 1955)
Count Three and Pray (Col, 1955)
East of Eden (WarnerColor) (WB, 1955)
Gentlemen Marry Brunettes (UA, 1955)
The Indian Fighter (UA, 1955)
The Kentuckian (UA, 1955)
Lady and the Tramp (successive exposure) (BV, 1955)
The Last Frontier (Col, 1955)
The Long Grey Line (Col, 1955)
Man from Laramie (Col, 1955)
My Sister Eileen (Col, 1955)
Picnic (Col, 1955)
Three for the Show (Col, 1955)
To Hell and Back (U, 1955)
The Violent Men (Col, 1955)
White Feather (Fox, 1955)
Wichita (AA, 1955)
Oklahoma (Magna, 1955)

*Flat 1.33 × 1 version shot simultaneously and released in dye transfer process.

CINEMASCOPE FEATURES

35mm dye transfer features derived from CinemaScope negative

Alexander the Great (UA, 1956)*
The Ambassador's Daughter (UA, 1956)
Bigger than Life (Fox, 1956)*
The Brave One (RKO, 1956)*
Cockleshell Heroes (Col, 1956)
The Conqueror (RKO, 1956)*
Eddy Duchin Story (Col, 1956)*
First Texan (AA, 1956)
Great Locomotive Chase (BV, 1956)
Hot Blood (Col, 1956)

Jubal (Col, 1956)
Pillars of the Sky (U, 1956)
Safari (Col, 1956)
The Sharkfighters (UA, 1956)
Storm over the Nile (Col, 1956)
Walk the Proud Land (U, 1956)
Westward Ho the Wagons (BV, 1956)
World Without End (AA, 1956)
You Can't Run Away from It (Col, 1956)

Bridge on the River Kwai (Col, 1957)
Fire Down Below (Col, 1957)
Interlude (U, 1957)
Istanbul (U, 1957)
Joe Butterfly (U, 1957)
Kelly and Me (U, 1957)
Miller's Beautiful Wife (Ind, 1957)
The Oklahoman (AA, 1957)
Secrets of Life (BV, 1957)
Tammy and the Bachelor (U, 1957)
Bonjour Tristesse (Col, 1958)
Gigi (British prints only) (Metrocolor) (MGM, 1958)

Gunman's Walk (Col, 1958)
Tank Force (also known as No Time to Die) (Col, 1959)
This Earth Is Mine (U, 1959)
Guns of Navarone (Col, 1961)*
Damn the Defiant (Col, 1962)
The Singer Not the Song (WB, 1962)
Summer Holiday (AIP, 1963)
Gold for the Caesars (MGM, 1964)
The Son of Captain Blood (Par, 1964)
Great Sioux Massacre (Col, 1965)

**Released in both mag/optical and optical mono formats.*

VistaVision

Paramount got into the widescreen craze and introduced Vista-Vision in 1954. Although VistaVision was not really a widescreen process, it was adaptable to this kind of presentation. It entailed shooting with a large format negative, which improved the resolution of both contact positive and dye transfer release prints.

A standard 35mm negative was exposed horizontally during principal photography, using the equivalent image area of two frames. The uncropped aspect ratio was 1.50×1, with an eight sprocket width. If this sounds familiar, it's because it was the same format used in 35mm still photography.

From this horizontal negative, 35mm reduction matrices were made in a specially designed optical printer that enabled an eight sprocket intermittent movement. The soundtrack often contained a Perspecta sound, a method of encoding a standard mono optical track with subaudio tones of 30 cycles for the left channel, 35 cycles for the center channel and 40 cycles for the right channel. When decoded, the mono signal was sent through three front speakers to generate directional pseudostereophonic sound. Exhibitors liked it because the Perspecta tracks could also be played as a standard mono signal, with the tones inaudible to the audience.

A 35mm projector was turned onto its side and adapted to the eight sprocket intermittent movement (referred to as "lazy eight" projectors) for special large format Eastmancolor Roadshow prints. General release copies were dye transfer reduction prints in the

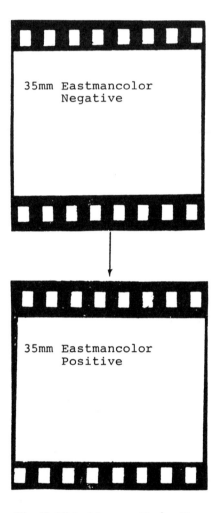

Fig. 13. Vistavision negative/positive.

standard 35mm format. *White Christmas* was the first VistaVision film given both horizontal Eastmancolor as well as dye transfer reduction 35mm presentations.

The tag line for VistaVision was "Motion Picture High Fidelity," which indeed it was. Radio City Music Hall in New York City was one of the movie palaces set up to project in this format. Paramount suggested cropping the image to 1.85×1 for VistaVision features, although publicity surrounding the process claimed the cropping

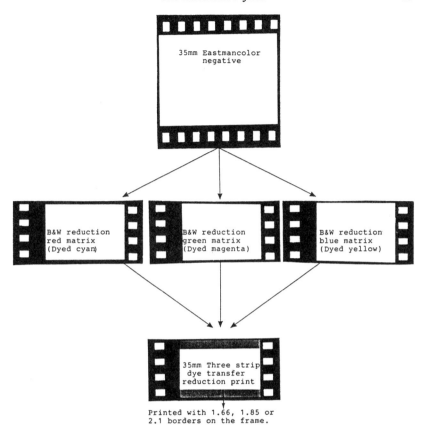

Fig. 14. VistaVision reduction dye transfer.

could vary between 1.66×1 to 2×1 (fig. 14). It is uncertain whether Technicolor ever manufactured 35mm horizontal eight sprocket dye transfer prints.

The major advantage to the process was a dramatic improvement in the conventional 35mm dye transfer prints. By reduction printing a large negative to a conventional 35mm size set of matrices, the grain structure was shrunk, which resulted in an ultrasharp IB print. The fine grain image could be cropped and enlarged for the CinemaScope screens without a loss of quality. When standard 35mm dye transfer prints were cropped and enlarged, apparent grain was increased, since so little of the available frame was being projected. VistaVision retained a fine grain image when given this kind presentation. It was the sharpest "flat" Technicolor process.

will glorify the motion picture
that the whole world is waiting for:

Cecil B. DeMille's
The Ten
Commandments

Color by TECHNICOLOR

with the greatest cast ever assembled . . .

The general release VistaVision prints were so impressive, Paramount eventually phased out large format horizontal positive prints by 1957 and used the process exclusively for dye transfer reduction printing. Technicolor had a series of masks they used for the latter, although most were reduction printed with a 1.66 ratio and projected in a cropped 1.85 format. White frame-line markings were contained on the first shot of each reel.

Alfred Hitchock used this process with impressive results on many of his films of the fifties, including, *The Trouble with Harry* (1955), *To Catch a Thief* (1955), *The Man Who Knew Too Much* (1956), *Vertigo* (1958) and *North by Northwest* (1959). Original 35mm dye transfer prints of these titles were true works of art and vastly superior to the Eastmancolor reissues of the eighties.

VISTAVISION FEATURES

35mm dye transfer features derived from VistaVision color negatives (Most of the Paramount VistaVision titles, with the exception of some Hitchcock titles, contained a Perspecta encoding on the optical soundtracks. Many of the early films were given large format presentations. All were reduction printed to standard 35mm Technicolor.)

Three Ring Circus (Par, 1954)
White Christmas (Par, 1954)
Artists and Models (Par, 1955)
The Far Horizons (Par, 1955)
The Girl Rush (Par, 1955)
Hell's Island (also known as South Seas Fury) (Par, 1955)
Lucy Gallant (Par, 1955)
Run for Cover (Par, 1955)
Seven Little Foys (Par, 1955)
Strategic Air Command (Par, 1955)
To Catch a Thief (Par, 1955)
The Trouble with Harry (Par, 1955)
We're No Angels (Par, 1955)
You're Never Too Young (Par, 1955)
Anything Goes (Par, 1956)
Away All Boats (U, 1956)
The Birds and the Bees (Par, 1956)
High Society (MGM, 1956)
Hollywood or Bust (Par, 1956)
The Man Who Knew Too Much (Par, 1956)
The Mountain (Par, 1956)
Pardners (Par, 1956)

The Rainmaker (Par, 1956)
Richard III (Lopert, 1956)
The Searchers (WB, 1956)
The Ten Commandments (Par, 1956)
That Certain Feeling (Par, 1956)
The Vagabond King (Par, 1956)
War and Peace (Par, 1956)
Beau James (Par, 1957)
The Devil's Hairpin (Par, 1957)
Doctor at Large (U, 1957)
Funny Face (Par, 1957)
Gunfight at the O.K. Corral (Par, 1957)
Loving You (Par, 1967)
Omar Khayyam (Par, 1957)
The Pride and the Passion (UA, 1957)
Pursuit of the Graf Spee (Rank, 1957)
The Spanish Gardener (Rank, 1957)
Triple Deception (Rank, 1957)
The Buccaneer (Par, 1958)
The Geisha Boy (Par, 1958)

Night Ambush (Rank, 1958) 1959)
Rock-a-Bye Baby (Par, 1958) L'il Abner (Par, 1959)
Spanish Affair (Par, 1958) North by Northwest (MGM,
Vertigo (Par, 1958) 1959)
The Five Pennies (Par, 1959) One-Eyed Jacks (Par, 1961)
The Jayhawkers (Par, 1959) My Six Loves (Par, 1963)
Last Train from Gun Hill (Par,

WIDESCREEN "FLAT" FILMS

Universal was one of the few studios that did not sponsor a new process in the fifties, although they sublicensed other studio's systems. They did advocate a "cheap" method of generating a wide image, simply by making a projector plate that cropped a standard 1.33 × 1 print to 1.85 × 1. Other studios adopted their own cropped ratios. A 1.66 × 1 masking was used by MGM for their "flat" films (including reissues of *The Wizard of Oz* and *Gone with the Wind*, which were designed for 1.33 × 1). The Walt Disney company used a 1.75 × 1 masking for their releases, although most were projected in 1.85.

One of the first features to use this projector cropping was Universal's 3-D production *It Came from Outer Space* (1953), presented in a 1.85 × 1 ratio. Later releases, like *Thunder Bay* (1953), advertised as presented in Wide Vision, compensated for the cropping during principal photography so the heads and feet of the actors would not be chopped off, as they were when standard 1.33 × 1 films were shown this way (e.g., *Gone with the Wind*).

As previously mentioned, apparent grain was increased and sharpness decreased when films were cropped and enlarged in this manner, since only a portion of the available image was projected. Dye transfer prints held up better than Eastmancolor prints because the rich colors and superior contrast of the former drew attention away from the problems. VistaVision dye transfer reduction prints were best suited for this kind of presentation (fig. 15).

FIRST GENERATION OPTICALS

In 1956, the Technicolor research department developed a method of A and B rolling of the negatives of films processed there. Each reel of the negative was assembled onto two rolls so that when

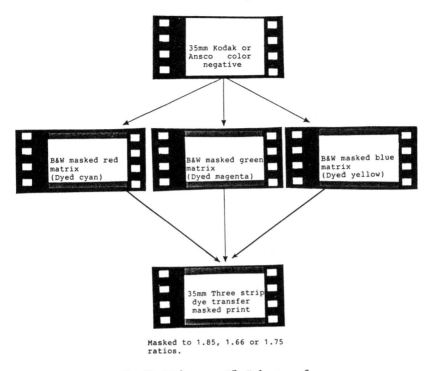

Fig. 15. Widescreen "flat" dye transfer.

a fade or dissolve was required, the effect could be incorporated directly into the matrix and the use of the grainy color internegative stock could be avoided. After 1956, most dye transfer prints had sharp opticals, and Eastmancolor prints grainy opticals.

THE WET GATE OPTICAL PRINTER

Another major development from the research department was the Wet Gate Optical Printer, implemented in 1956. The printing gate contained a solution that had a refractive index similar to that of celluloid and that filled in scratches on the base of the preprint with the liquid so that light rays traveled at a consistent angle through the base. In simpler terms, the liquid gate "filled in" base scratches on the negative so they would not show up on the matrices or release print. The other color labs did not have this technology and often displayed scratches and cinch marks on their release copies.

The superior color combined with the first generation opticals and scratch free image did not go unnoticed by the competing color labs. Throughout the fifties, many labs sent negatives processed at their facility to Technicolor for dye transfer release printing. It was not uncommon to see credits that stated "Color by Ansco Color, print by Technicolor" (e.g., *Kiss Me, Kate*), a somewhat misleading statement, since the quality of the color was a result of the dye transfer process, not Ansco Color's negative developing. Many WarnerColor features and some DeLuxe color titles were printed in the dye transfer process. In some cases, no mention was made in the credits of Technicolor's release printing, a poor marketing strategy by Kalmus that led audiences to assume there was no quality difference between the labs. Perhaps the consent decree combined with the huge profits Technicolor was generating by doing other facilities' release printing prevented him from pressing the issue.

What follows is a reference list of "flat" dye transfer releases from 1953 through 1974, including many films developed at other facilities. Some titles were printed in the dye transfer process only in London. There may be more features developed at other labs and printed at Technicolor not included in this list, since no printing records survive for defunct facilities like Warner Color or Ansco Color. Much of this list was compiled by film collectors who have preserved the bulk of the Technicolor release print output. Few prints exist at the distribution companies — some cannot find their negatives!

WIDESCREEN "FLAT" FILMS FEATURES

35mm dye transfer features derived from Eastmancolor color
negatives and cropped to various aspect ratios (e.g., 1.85, 1.66, 1.75)

Athena (Eastmancolor) (MGM, 1954)
Rear Window (U, 1954)
Fabulous India (Ind, 1955)
House of Ricordi (Ind, 1955)
Ludwig II (Ind, 1955)
Madame Butterfly (Ind, 1955)
Maddalena (Ind, 1955)
Only the French Can (French Can Can) (Ind, 1955)
Tam Tam Mayumbre (Ind, 1955)
The Tiger and the Flame (Ind, 1955)

Ulysses (Par, 1955)
All for Mary (Ind, 1956)
All That Heaven Allows (U, 1956)
An Alligator Named Daisy (Ind, 1956)
Animal World (WB, 1956)
At Gunpoint (AA, 1956)
Backlash (U, 1956)
The Black Tent (R, 1956)
Bundle of Joy (RKO, 1956)
Congo Crossing (UI, 1956)
Court Jester (Par, 1956)

A Day of Fury (U, 1956)
Don Juan (Ind, 1956)
The Feminine Touch (Ind, 1956)
First Traveling Saleslady (RKO, 1956)
Great Locomotive Chase (BV, 1956)
He Laughed Last (Col, 1956)
House of Secrets (Ind, 1956)
It's a Great Life (Ind, 1956)
It's a Wonderful World (Ind, 1956)
Ladykillers (Ind, 1956)
Madame Butterfly (Ind, 1956)
Marie Antoinette (Ind, 1956)
Moby Dick (WB, 1956)
Odongo (Col, 1956)
Oh, Roslinda! (Ind, 1956)
Point Afrique (Col, 1956)
Raw Edge (U, 1956)
The Red Balloon (Ind, 1956)
Red Sundown (U, 1956)
Reprisal (Col, 1956)
Run for the Sun (U, 1956)
Second Greatest Sex (U, 1956)
Secrets of Life (BV, 1956)
7th Calvary (Col, 1956)
Showdown at Abilene (U, 1956)
Smiley (Fox, 1956)
Solid Gold Cadillac (sequence) (Col, 1956)
Star in the Dust (U, 1956)
Star of India (UA, 1956)
Tension at Table Rock (RKO, 1956)
Toy Tiger (U, 1956)
Zarak (Col, 1956)
Admirable Crichton (Col, 1957)
Adventures of Arsene Lupin (Ind, 1957)
All Mine to Give (U, 1957)
Les Aventures de Till L'Espiègle (Ind, 1957)
Battle Hymn (U, 1957)
Beyond Mombasa (Col, 1957)
The Blob (DeLuxe) (1957)
Casino de Paris (Ind, 1957)
Decision at Sundown (Col, 1957)
Folies-Bergere (Ind, 1957)
Four Girls in Town (U, 1957)
The Girl Most Likely (RKO, 1957)
Good Companions (Ind, 1957)
Guns of Fort Petticoat (Col, 1957)

Hard Man (Col, 1957)
Immortal Garrison (U, 1957)
Iron Petticoat (MGM, 1957)
It Happened in Rome (Ind, 1957)
Johnny Tremain (BV, 1957)
Old Yeller (BV, 1957)
Pajama Game (WarnerColor) (WB, 1957)
Pal Joey (Col, 1957)
Paris Does Strange Things (WB, 1957)
Parson and the Outlaw (Col, 1957)
Le Pays d'Où Je Viens (Ind, 1957)
Perri (BV, 1957)
Prince and the Showgirl (WB, 1957)
Public Pigeon No. 1 (U, 1957)
Story of Mankind (WB, 1957)
The Tall "T" (Col, 1957)
Tarzan and the Lost Safari (MGM, 1957)
Three Violent People (Par, 1957)
Typhon a Nagazaki (Ind, 1957)
Woman of the River (Col, 1957)
Written on the Wind (U, 1957)
Bell, Book and Candle (Col, 1958)
Big Money (Ind, 1958)
Cowboy (Col, 1957)
Damn Yankees (WB, 1958)
Davy (Ind, 1958)
Enchanted Island (WB, 1958)
Flute and the Arrow (Ind, 1958)
From the Earth to the Moon (WB, 1958)
Gideon of Scotland Yard (Col, 1958)
Horror of Dracula (U, 1958)
Horse's Mouth (L, 1958)
Houseboat (Par, 1958)
Indiscreet (WB, 1958)
Light in the Forest (BV, 1958)
Mark of the Hawk (U, 1958)
Les Miserables (Ind, 1958)
Missouri Traveler (BV, 1958)
Moonraker (Ind, 1958)
Mother India (Ind, 1958)
No Time to Die (Col, 1958)
Proud Rebel (BV, 1958)
La Ragazza del Palio (Ind, 1958)
Return to Warbow (Col, 1958)
Revenge of Frankenstein (Col, 1958)

Seventh Voyage of Sinbad (Col, 1958)
Stage Struck (BV, 1958)
Story of Vickie (BV, 1958)
Tonka (BV, 1958)
Le Triporteur (Ind, 1958)
Une le Parisienne (UA, 1958)
The Unholy Wife (U, 1958)
Wind Across the Everglade (WB, 1958)
Bridal Path (Ind, 1959)
F.B.I. Story (WB, 1959)
Handful of Grain (Ind, 1959)
Hanging Tree (WB, 1959)
Hound of the Baskervilles (UA, 1959)
Invitation to Monte Carlo (Ind, 1959)
Man Who Could Cheat Death (Par, 1959)
The Mummy (U, 1959)
Nun's Story (WB, 1959)
1001 Arabian Nights (Col, 1959)
Rio Bravo (WB, 1959)
Serenade of a Great Love (Ind, 1959)
A Summer Place (WB, 1959)
Sword and the Dragon (Ind, 1959)
Third Man on the Mountain (WB, 1959)
Thunder in the Sun (Par, 1959)
The Trap (Par, 1959)
Watusi (MGM, 1959)
Wonderful Country (UA, 1959)
Young Land (Ind, 1959)
Bramble Bush (WB, 1960)
Brides of Dracula (U, 1960)
Cash McCall (WB, 1960)
Crowded Sky (WB, 1960)
Crowning Experience (Ind, 1960)
Dark at the Top of the Stairs (WB, 1960)
Doctor in Love (WB, 1960)
G.I. Blues (WB, 1960)
Guns of the Timberland (WB, 1960)
Heller in Pink Tights (Par, 1960)
Hound that Thought He Was a Racoon (BV, 1960)
Ice Palace (WB, 1960)
It Started in Naples (Par, 1960)

Jungle Cat (BV, 1960)
Kidnapped (BV, 1960)
Once More with Feeling (Col, 1960)
One, Two, Three, Four (Ind, 1960)
Pollyanna (BV, 1960)
Rat Race (Par, 1960)
Sergeant Rutledge (WB, 1960)
Sundowners (WB, 1960)
Sunrise at Campobello (WB, 1960)
Ten Who Dared (BV, 1960)
Tunes of Glory (L, 1960)
Toby Tyler (BV, 1960)
Two Faces of Dr. Jekyll (Col, 1960)
World of Susie Wong (Par, 1960)
All in a Night's Work (Par, 1961)
Babes in Toyland (BV, 1961)
Breakfast at Tiffany's (Par, 1961)
Call Me Genius (Ind, 1961)
Fanny (WB, 1961)
Ghosts in Rome (Ind, 1961)
Gorgo (MGM, 1961)
Greyfriar's Bobby (BV, 1961)
Honeymoon Machine (MGM, 1961)
Ladies' Man (Par, 1961)
Nikki, Wild Dog of the North (BV, 1961)
Parent Trap (BV, 1961)
Parrish (WB, 1961)
Pleasure of His Company (Par, 1961)
Queen's Guards (Fox, 1961)
Raising the Wind (Ind, 1961)
Roman Spring of Mrs. Stone (WB, 1961)
Romanoff and Juliet (U, 1961)
Rommel's Treasure (Ind, 1961)
Sins of Rachel Cade (WB, 1961)
Splendor in the Grass (WB, 1961)
Steel Claw (WB, 1961)
Susan Slade (WB, 1961)
Vanina Vanini (Ind, 1961)
Almost Angels (BV, 1962)
Big Red (BV, 1962)
Boccaccio '70 (Emb, 1962)
Bon Voyage (BV, 1962)
Chapman Report (WB, 1962)
Counterfeit Traitor (Par, 1962)
Dr. No (UA, 1962)
Escape from Zahrain (Par, 1962)
A Family Diary (MGM, 1962)
First Spaceship on Venus (Ind, 1962)

Forever My Love (Par, 1962)
Girls! Girls! Girls! (Par, 1962)
Hatari! (WB, 1962)
In Search of the Castaways (BV, 1962)
Jessica (UA, 1962)
Lad: A Dog (WB, 1962)
Lafayette (Ind, 1962)
Legend of Lobo (BV, 1962)
Madame Sans-Gene (Ind, 1962)
A Majority of One (WB, 1962)
Mondo Cane (Ind, 1962)
Moon Pilot (BV, 1962)
Phantom of the Opera (U, 1962)
Rome Adventure (WB, 1962)
Der Rosenkavalier (Ind, 1962)
Samar (WB, 1962)
The Birds (U, 1963)
Captain Sinbad (MGM, 1963)
Charade (U, 1963)
Diary of a Madman (UA, 1963)
Doctor in Distress (Ind, 1963)
Donovan's Reef (Par, 1963)
Fast Lady (Ind, 1963)
From Russia with Love (UA, 1963)
From Saturday to Monday (Ind, 1963)
Fun in Acapulco (Par, 1963)
Ghost at Noon (Ind, 1963)
Gudrun (Ind, 1963)
Imperial Venus (Ind, 1963)
Incredible Journey (Ind, 1963)
Island of Love (WB, 1963)
MacBeth (Ind, 1963)
Man's Paradise (Ind, 1963)
Mary, Mary (WB, 1963)
Miracle of the White Stallions (BV, 1963)
A New Kind of Love (Par, 1963)
The Nutty Professor (Par, 1963)
Palm Springs Weekend (WB, 1963)
Papa's Delicate Condition (Par, 1963)
Rampage (WB, 1963)
Savage Sam (BV, 1963)
Seige of the Saxons (Col, 1963)
Summer Magic (BV, 1963)
Three Lives of Thomasina (BV, 1963)
Threepenny Opera (Ind, 1963)

Tommy the Toreador (7A, 1963)
Twice Told Tales (UA, 1963)
Who's Minding the Store? (Par, 1963)
Women of the World (Emb, 1963)
Bargee (Ind, 1964)
Castle (Ind, 1964)
Chalk Garden (U, 1964)
Code 7, Victim 5 (Ind, 1964)
Crooks in Cloisters (Ind, 1964)
Curse of the Mummy's Tomb (Ind, 1964)
Dark Purpose (U, 1964)
Disorderly Orderly (Par, 1964)
Emil and the Detectives (BV, 1964)
An Evening with the Royal Ballet (Ind, 1964)
Father Goose (U, 1964)
Finest Hours (Col, 1964)
Four for Texas (WB, 1964)
Germany Greets Kennedy (Ind, 1964)
Goldfinger (UA, 1964)
Gorgon (Ind, 1964)
Incredible Mr. Limpet (WB, 1964)
Lydia (Ind, 1964)
Mail Order Bride (MGM, 1964)
Man From Rio (Ind, 1964)
Man's Favorite Sport? (U, 1964)
Marnie (U, 1964)
Mary Poppins (part successive exposure) (BV, 1964)
Midadventures of Merlin Jones (BV, 1964)
Mondo Cane No. 2 (Ind, 1964)
Moon Spinners (BV, 1964)
Nasty Rabbit (Ind, 1964)
Paris When It Sizzles (Par,1964)
Patsy (Par, 1964)
The Prize (MGM, 1964)
Quick Gun (Col, 1964)
Red Desert (Ind, 1964)
Send Me No Flowers (U, 1964)
Sex and the Single Girl (WB, 1964)
The Soldier's Tale (Ind, 1964)
Strange Bedfellows (U, 1964)
Taggert (U, 1964)
Those Calloways (BV, 1964)
Three Nights of Love (Ind, 1964)
A Tiger Walks (BV, 1964)

Voice of the Hurricane (Ind, 1964)
White Voice (Ind, 1964)
Wonderful Live (Ind, 1964)
Yesterday, Today and Tomorrow
 (Emb, 1964)
An American Wife (Ind, 1965)
Art of Love (U, 1965)
Beach Ball (U, 1965)
Blood and Black Lace (AA, 1965)
Boeing Boeing (Par, 1965)
La Boheme (WB, 1965)
Brigand of Kandahar (Ind, 1965)
Casanova '70 (Ind, 1965)
The Collector (Col, 1965)
Crack in the World (Par, 1965)
Dingaka (Emb, 1965)
Dr. Who and the Daleks (Ind, 1965)
Ecco! (Ind, 1965)
Family Jewels (Par, 1965)
Git! (Ind, 1965)
I'll Take Sweden (UA, 1965)
I've Gotta Horse (Ind, 1965)
Love and Kisses (U, 1965)
Love Goddess (sequence) (Ind,
 1965)
Merry Wives of Windsor (Ind, 1965)
Monkey's Uncle (BV, 1965)
Oil Prince (Ind, 1965)
One Million Dollars (UA, 1965)
A Pistol for Ringo (Ind, 1965)
Red Line 7000 (Par, 1965)
Seven Guns for the MacGregors
 (Col, 1965)
Shenandoah (U, 1965)
Slalom (Ind, 1965)
Taboos of the World (Ind, 1965)
Tenth Victim (Ind, 1965)
That Darn Cat (BV, 1965)
That Funny Feeling (U, 1965)
Three Faces of a Woman (Ind,
 1965)
Truth About Spring (U, 1965)
Ugly Dachshund (BV, 1965)
Up Jumped a Swagman (Ind, 1965)
A Very Special Favor (U, 1965)
What (Ind, 1965)
Wild Wild Winter (U, 1965)
After the Fox (British prints only)
 (UA, 1966)
An American Dream (WB, 1966)

And Now Miguel (U, 1966)
Any Wednesday (WB, 1966)
A Big Hand for the Little Lady
 (WB, 1966)
The Big T-N-T Show (AIP, 1966)
Chamber of Horrors (WB, 1966)
The Countess from Hong Kong (U,
 1966)
Every Day Is a Holiday (Ind, 1966)
Fahrenheit 451 (U, 1966)
The Fighting Prince of Donegal
 (BV, 1966)
A Fine Madness (WB, 1966)
Follow Me, Boys! (BV, 1966)
For Love and Gold (Ind, 1966)
Frankie and Johnny (UA, 1966)
Goal! World Cup of 1966 (Ind,
 1966)
Gunpoint (U, 1966)
The Hostage (Ind, 1966)
Johnny Tiger (U, 1966)
Juliet of the Spirits (Ind, 1966)
Kaleidoscope (WB, 1966)
Kill or Be Killed (Ind, 1966)
Kiss the Girls and Make Them Die
 (Col, 1966)
The Last of the Secret Agents? (Par,
 1966)
Let's Kill Uncle (U, 1966)
Lt. Robinson Caruso U.S.N. (BV,
 1966)
Madame X (U, 1966)
A Man for All Seasons (Col, 1966)
A Matter of Honor (Ind, 1966)
Maya (MGM, 1966)
Moment to Moment (U, 1966)
Munster Go Home (U, 1966)
Murderer's Row (Col, 1966)
Nashville Rebel (AIP, 1966)
Not with My Wife, You Don't (WB,
 1966)
One Million Years B.C. (British
 prints only) (Fox, 1966)
Othello (WB, 1966)
Out of Sight (U, 1966)
The Pad (U, 1966)
Paradise, Hawaiian Style (Par,
 1966)
Promise Her Anything (Par, 1966)
Rings Around the World (Col, 1966)

Secret Agent Super Dragon (Ind, 1966)

Seven Golden Men Strike Again (Ind, 1966)

Stop the World, I Want to Get Off (WB, 1966)

The Sultans (Par, 1966)

Taking of Power by Louis XIV (Ind, 1966)

Thank You Very Much (Ind, 1966)

Thunderbirds Are Go (UA, 1966)

Tobruk (U, 1966)

Torn Curtain (U, 1966)

Two Kouney Lemels (Ind, 1966)

Up the MacGregors (Col, 1966)

A Virgin for the Prince (Ind, 1966)

Warning Shot (Par, 1966)

White, Red, Yellow, Pink (sequence) (Ind, 1966)

The Wrong Box (Col, 1966)

Young Cassidy (British prints only) (Ind, 1966)

Adventures of Bullwhip Griffin (BV, 1967)

After You, Comrade (Ind, 1967)

Ambushers (Col, 1967)

Berserk (Col, 1967)

Birds, the Bees and the Italians (WB, 1967)

The Bobo (WB, 1967)

Bonditis (Ind, 1967)

Bonnie and Clyde (WB, 1967)

A Bullet for the General (Emb, 1967)

Charlie, the Lonesome Cougar (BV, 1967)

The Corrupt Ones (WB, 1967)

A Covenant with Death (Col, 1967)

The Deadly Affair (Col, 1967)

Divorce, Italian Style (Col, 1967)

Don't Lose Your Head (Ind, 1967)

Easy Come, Easy Go (Par, 1967)

El Dorado (Par, 1967)

The Family Way (WB, 1967)

Follow that Camel (Par, 1967)

Frank's Greatest Adventure (Ind, 1967)

The Gnome Mobile (BV, 1967)

Gunfire in Abilene (U, 1967)

Gunn (Par, 1967)

Half a Sixpence (Par, 1967)

The Happening (Col, 1967)

The Happiest Millionaire (BV, 1967)

Hell on Wheels (Ind, 1967)

The Hippie Revolt (Ind, 1967)

The Honey Pot (UA, 1967)

Hotel (WB, 1967)

I'll Never Forget What's 'is Name (Ind, 1967)

It! (WB, 1967)

The Jokers (U, 1967)

King's Pirate (U, 1967)

Knives of the Avenger (Ind, 1967)

The Last Safari (WB, 1967)

The Mikado (WB, 1967)

Misunderstood (Ind, 1967)

Monkeys, Go Home (BV, 1967)

Oedipus Rex (Ind, 1967)

Oh, Dad, Poor Dad, Mama's Hung You in the Closet and I'm Feeling So Sad (Par, 1967)

The 1,000,000 Eyes of Su-Muru (AIP, 1967)

Privilege (U, 1967)

Red Dragon (Ind, 1967)

The Reluctant Astronaut (U, 1967)

The Ride to Hangman's Tree (U, 1967)

A Rose for Everyone (Ind, 1967)

The Savage Eye (Ind, 1967)

The Spirit Is Willing (Par, 1967)

Thoroughly Modern Millie (U, 1967)

To Each His Own (Ind, 1967)

To Sir, with Love (Col, 1967)

Triple Cross (WB, 1967)

Up the Down Staircase (WB, 1967)

Valley of Mystery (U, 1967)

Wait Until Dark (WB, 1967)

War — Italian Style (AIP, 1967)

The Wild Rebels (Ind, 1967)

The Young Girls of Rochefort (WB, 1967)

Ace High (Par, 1968)

And There Came a Man (Ind, 1968)

Battle Beneath the Earth (MGM, 1968)

Benjamin (Ind, 1968)

Better a Widow (U, 1968)

The Big Gundown (Ind, 1968)

Birds in Peru (U, 1968)

The Birthday Party (Ind, 1968)
Blackbeard's Ghost (BV, 1968)
The Bliss of Mrs. Blossom (Par, 1968)
Bofors Gun (U, 1968)
Bullitt (WB, 1968)
Bye Bye Braverman (WB, 1968)
Candy (CRC, 1968)
Charlie Bubbles (U, 1968)
The Cobra (Ind, 1968)
Coogan's Bluff (U, 1968)
Corruption (Col, 1968)
The Counterfeit Killer (U, 1968)
Danger: Diabolik (Par, 1968)
Devil in Love (WB, 1968)
Devil's Bride (Fox, 1968)
Doctor Faustus (Col, 1968)
Don't Raise the River, Lower the Bridge (Col, 1968)
The Double Man (WB, 1968)
Duffy (Col, 1968)
Five Card Stud (Par, 1968)
Ghosts—Italian Style (Ind, 1968)
The Girl on a Motorcycle (also known as Naked Under Leather) (WB, 1968)
Great Catherine (WB, 1968)
Head (Col, 1968)
Heart Is a Lonely Hunter (WB, 1968)
Heidi (WB, 1968)
Here We Go Round the Mulberry Bush (Ind, 1968)
Horse in the Gray Flannel Suit (BV, 1968)
The Hostage (Ind, 1968)
House of 1000 Dolls (AIP, 1968)
How Sweet It Is! (NG, 1968)
I Love You, Alice B. Toklas (WB, 1968)
Interlude (Col, 1968)
Isabel (Par, 1968)
Island of the Doomed (Ind, 1968)
Jigsaw (U, 1968)
Kona Coast (WB, 1968)
Listen, Let's Make Love (7A, 1968)
A Maiden for the Prince (Ind, 1968)
The Murder Clinic (Ind, 1968)
Negatives (Ind, 1968)
Never a Dull Moment (BV, 1968)

No Way to Treat a Lady (Par, 1968)
Oedipus the King (U, 1968)
The One and Only, Genuine, Original Family Band (BV, 1968)
Petulia (WB, 1968)
A Place for Lovers (MGM, 1968)
Poor Cow (NG, 1968)
Private Navy of Sgt. O'Farrell (UA, 1968)
Project X (Par, 1968)
Rachel, Rachel (WB, 1968)
Rosemary's Baby (Par, 1968)
Rosie (U, 1968)
Romeo and Juliet (Par, 1968)
Run Like a Thief (Ind, 1968)
Sergeant Ryker (U, 1968)
Sebastian (Par, 1968)
Secret Ceremony (U, 1968)
The Sea Gull (WB, 1968)
The Shuttered Room (WB, 1968)
Sky Over Holland (WB, 1968)
The Strange Affair (Par, 1968)
Sweet November (WB, 1968)
The Swimmer (Col, 1968)
30 Is a Dangerous Age, Cynthia (Col, 1968)
Three Guns for Texas (U, 1968)
Torture Garden (Col, 1968)
Track of Thunder (UA, 1968)
La Traviata (Ind, 1968)
Uptight (Par, 1968)
The Vengeance of She (Fox, 1968)
Will Penny (Par, 1968)
The Adding Machines (U, 1969)
All Heat in Black Stockings (NG, 1969)
Angel in My Pocket (U, 1969)
Assassination Bureau (Par, 1969)
Before Winter (Col, 1969)
Bob & Carol & Ted & Alice (Col, 1969)
The Brotherhood (Par, 1969)
Buona Sera, Mrs. Campbell (UA, 1969)
Can Hieronymus Merkin Ever Forget Mercy Humppe and Find True Happiness? (U, 1969)
A Challenge for Robin Hood (Fox, 1969)
A Change of Habit (U, 1969)

Daddy's Gone-a-Hunting (Ind, 1969)
Death of a Gunfighter (U, 1969)
Easy Rider (WB, 1969)
80 Steps to Jonah (WB, 1969)
Eye of the Cat (U, 1969)
Fraulein Doktar (Par, 1969)
Goodbye, Columbus (Par, 1969)
Hell's Angels 69 (Ind, 1969)
Hook, Line and Sinker (Col, 1969)
How to Commit Marriage (CRC, 1969)
The Love Bug (BV, 1969)
The Loves of Isadora (also released in longer version as Isadora) (U, 1969)
A Man Called Gannon (U, 1969)
Mayerling (MGM, 1969)
Medium Cool (Par, 1969)
Midas Run (CRC, 1969)
Midnight Cowboy (British prints only) (UA, 1969)
Mission Batangas (Ind, 1969)
Night of the Following Day (U, 1969)
On My Way to the Crusades, I Met a Girl Who . . . (WB, 1969)
Otley (Col, 1969)
Pendulum (Col, 1969)
Rain People (WB, 1969)
Ring of Bright Water (CRC, 1969)
Riot (Par, 1969)
Run Wild, Run Free (Col, 1969)
The Sergeant (WB, 1969)
Seven Golden Men (WB, 1969)
Shock Troops (UA, 1969)
The Sterile Cuckoo (Par, 1969)
Take the Money and Run (CRC, 1969)
True Grit (Par, 1969)
Trygon Factor (WB, 1969)
Twisted Nerve (NG, 1969)
2000 Years Later (WB, 1969)
Valley of Gwangi (WB, 1969)
Wrecking Crew (Col, 1969)
Young Americans (Col, 1969)
Act of the Heart (U, 1970)
Adam at 6 A.M. (NG, 1970
Africa, Blood and Guts (Ind, 1970)
All the Way Up (Ind, 1970)
And Soon the Darkness (WB, 1970)

The Babymaker (NG, 1970)
Ballad of Cable Hogue (WB, 1970)
Boatnicks (BV, 1970)
The Body (MGM, 1970)
Buttercup Chain (Col, 1970)
Cannibals (Ind, 1970)
Cockeyed Cowboys of Calico County (U, 1970)
El Condor (NG, 1970)
The Conformist (Par, 1970)
The Damned (WB, 1970)
Darker Than Amber (NG, 1970)
Detective Belli (Ind, 1970)
Diary of a Mad Housewife (U, 1970)
Eyewitness (MGM, 1970)
Frankenstein Must Be Destroyed (WB, 1970)
Giant (WarnerColor, reissue) (WB, 1970)
Grasshopper (NG, 1970)
Hoffman (WB, 1970)
Homer (NG, 1970)
Horror of Frankenstein (MGM, 1970)
I Love My Wife (U, 1970)
Imago (Ind, 1970)
In Search of Gregory (U, 1970)
Just Another War (Ind, 1970)
Kemek (Ind, 1970)
King of the Grizzlies (BV, 1970)
Last of the Mobile Hot Shots (WB, 1970)
Let It Be (16mm blowup) (UA, 1970)
Man Who Haunted Himself (WB, 1970)
Mind of Mister Soames (Col, 1970)
Moon Zero Two (WB, 1970)
Most Beautiful Wife (Ind, 1970)
Night of Counting the Years (Ind, 1970)
Norwood (Par, 1970)
Out-of-Towners (Par, 1970)
Performance (WB, 1970)
The Phynx (WB, 1970)
Pufnstuf (U, 1970)
Rabbit, Run (WB, 1970)
Railway Children (U, 1970)
Rio Lobo (NG, 1970)
Rise and Fall of Michael Rimmer (WB, 1970)

Scars of Dracula (MGM, 1970)
Spider's Strategy (Ind, 1970)
Spring and Port Wine (WB, 1970)
Start the Revolution without Me
 (WB, 1970)
Story of a Citizen Above All Suspi-
 cion (Ind, 1970)
Story of a Woman (U, 1970)
Strogoff (Ind, 1970)
Sunflower (Emb, 1970)
Take a Girl Like You (Col, 1970)
Taste the Blood of Dracula (WB,
 1970)
Tell Me That You Love Me, Junie
 Moon (Par, 1970)
Tomorrow (R, 1970)
Trog (WB, 1970)
Twinky (R, 1970)
Undercover Rogue (Ind, 1970)
Upon This Rock (Ind, 1970)
The Vampire Lovers (MGM, 1970)
Which Way to the Front? (WB,
 1970)
Barefoot Executive (BV, 1971)
Bedknobs and Broomsticks (part
 successive exposure) (BV, 1971)
The Beguiled (U, 1971)
Bless the Beasts and the Children
 (Col, 1971)
The Body (MGM, 1971)
Bora, Bora (AIP, 1971)
Captain Apache (Ind, 1971)
The Clowns (Ind, 1971)
Conformist (Par, 1971)
Creatures the World Forgot (Col,
 1971)
Decameron (UA, 1971)
$ (Col, 1971)
Dusty and Sweets McGee (WB,
 1971)
Five Bloody Graves (Ind, 1971)
Fragment of Fear (Col, 1971)
Friends (Par, 1971)
Get to Know Your Rabbit (WB,
 1971)
Glory Boy (also known as My Old
 Man's Place) (CRC, 1971)
Go-Between (Col, 1971)
A Gunfight (Par, 1971)
Harold and Maude (Par, 1971)

Hired Hand (U, 1971)
How to Frame a Figg (U, 1971)
Invincible Six (Ind, 1971)
Last Movie (U, 1971)
Last Rebel (Col, 1971)
Long Ago, Tomorrow (Ind, 1971)
Lust for a Vampire (Ind, 1971)
Maddalena (Ind, 1971)
Malcolm X (WB, 1971)
Man Who Haunted Himself (Ind,
 1971)
Million Dollar Duck (BV, 1971)
Minnie and Moskowitz (U, 1971)
Nana (NG, 1971)
Narco Men (Ind, 1971)
On Any Sunday (Ind, 1971)
One More Train to Rob (U, 1971)
Percy (MGM, 1971)
Peter Rabbit and Tales of Beatrix
 Potter (MGM, 1971)
Play Misty for Me (U, 1971)
Plaza Suite (Par, 1971)
Priest's Wife (WB, 1971)
Punishment Park (Ind, 1971)
Puzzle of a Downfall Child (U, 1971)
Raid on Rommel (U, 1971)
The Reckoning (Col, 1971)
Red Sky at Morning (U, 1971)
Romance of a Horsethief (AA, 1971)
Sacco and Vanzetti (Ind, 1971)
A Safe Place (Col, 1971)
A Severed Head (Col, 1971)
Shoot Out (U, 1971)
The Ski Bum (Emb, 1971)
Story of a Woman (U, 1971)
Sudden Terror (NG, 1971)
Summer of '42 (WB, 1971)
A Town Called Hell (Ind, 1971)
T. R. Baskin (Par, 1971)
200 Motels (shot on video) (UA,
 1971)
Two-Lane Blacktop (U, 1971)
The Vampire Lovers (AIP, 1971)
Villain (MGM, 1971)
When Dinosaurs Ruled the Earth
 (WB, 1971)
The Wild Country (BV, 1971)
Willy Wonka and the Chocolate
 Factory (Par, 1971)
The Animals (Ind, 1972)

Assassination of Trotsky (CRC, 1972)
Bad Company (Par, 1972)
Baron Blood (AIP, 1972)
Battle of Neretva (Ind, 1972)
Blood from the Mummy's Tomb
(AIP, 1972)
Bluebeard (CRC, 1972)
Born to Boogie (Ind, 1972)
Cabaret (AA, 1972)
Cancel My Reservation (WB, 1972)
The Candidate (WB, 1972)
Chato's Land (UA, 1972)
Come Back, Charleston Blue (WB,
1972)
Crescendo (WB, 1972)
Cross and the Switchblade (Ind,
1972)
Dirty Outlaws (Ind, 1972)
Dr. Jekyll and Sister Hyde (AIP,
1972)
Dracula A.D. 1972 (WB, 1972)
Dulcima (Ind, 1972)
Emigrants (WB, 1972)
Fellini's Roma (UA, 1972)
Fillmore (Fox, 1972)
The Godfather (Par, 1972)
The Great Northfield, Minnesota,
Raid (U, 1972)
Hands of the Ripper (U, 1972)
Here Comes Every Body (Ind, 1972)
Last of the Red Hot Lovers (Par,
1972)
Last Tango in Paris (UA, 1972)
Legend of Boggy Creek (Ind, 1972)
Limbo (U, 1972)
The Little Ark (NG, 1972)
Lizard in a Woman's Skin (also
known as Schizoid) (AIP, 1972)
Lola (AIP, 1972)
Napoleon and Samantha (BV, 1972)
Night Evelyn Came Out of the
Grave (Ind, 1972)
The Nightcomers (Emb, 1972)
No Drums, No Bugles (CRC, 1972)
Now You See Him, Now You Don't
(BV, 1972)
Outback (UA, 1972)
Play It Again, Sam (Par, 1972)
Pocket Money (NG, 1972)
Puppet on a Chain (CRC, 1972)

Red Sun (NG, 1972)
Silent Running (U, 1972)
Snoopy, Come Home (NG, 1972)
Snowball Express (BV, 1972)
Something Big (NG, 1972)
Sometimes a Great Notion (U, 1972)
Super Fly (WB, 1972)
Ten Days' Wonder (Ind, 1972)
Trick Baby (U, 1972)
Up the Sandbox (NG, 1972)
The Valachi Papers (Col, 1972)
War Between Men and Women
(NG, 1972)
Wednesday's Child (Ind, 1972)
What's Up, Doc? (WB, 1972)
You'll Like My Mother (U, 1972)
Alfredo, Alfredo (Par, 1973)
Alpha Beta (Ind, 1973)
Ash Wednesday (Par, 1973)
Assassin of Rome (Col, 1973)
Battle of the Amazons (AIP, 1973)
Baxter (NG, 1973)
Blume in Love (WB, 1973)
Boy Who Cried Werewolf (U, 1973)
Breezy (U, 1973)
Brother Sun, Sister Moon (Par,
1973)
Charley and the Angel (BV, 1973)
Charley Varrick (U, 1973)
Contact (Ind, 1973)
Day of the Jackal (U, 1973)
Deadly Trackers (WB, 1973)
Deaf Smith and Johnny Ears (MGM,
1973)
Diary of a Cloistered Nun (Ind,
1973)
The Don Is Dead (U, 1973)
Don't Look Now (BL, 1973)
Enter the Dragon (WB, 1973)
Friends of Eddie Coyle (Par, 1973)
Giordano Bruno (Ind, 1973)
Girls Are for Loving (Ind, 1973)
The Iceman Cometh (AFT, 1973)
I Did It (WB, 1973)
Jimi Hendrix (WB, 1973)
Last of Sheila (WB, 1973)
Lialeh (Ind, 1973)
Loveland (Ind, 1973)
Lucky Luciano (Ind, 1973)
Man Called Noon (NG, 1973)

Massacre in Rome (Ind, 1973)
Maurie (NG, 1973)
Naked Ape (U, 1973)
Number One (Ind, 1973)
Nuns of Sant 'Arcangelo (Ind, 1973)
O Lucky Man! (Col, 1973)
One Little Indian (BV, 1973)
Sacred Knives of Vengeance (WB, 1973)
Scalaway (Par, 1973)
Serpico (Par, 1973)
Sssssss (U, 1973)
The Sting (U, 1973)
Stone Killer (Col, 1973)
Summer Wishes, Winter Dreams (Col, 1973)
Teresa the Thief (Ind, 1973)
That Man Bolt (U, 1973)
That'll Be the Day (Ind, 1973)
Two People (U, 1973)
Visions of Eight (C5, 1973)
A Warm December (NG, 1973)
Whatever Happened to Miss September (Ind, 1973)
World's Greatest Athlete (BV, 1973)
Abdication (WB, 1974)
Alicia (Ind, 1974)
Always a New Beginning (Ind, 1974)
Amarcord (WB, 1974)
Arabian Nights (UA, 1974)
Bears and I (BV, 1974)
Beast (WB, 1974)
Beast Must Die (CRC, 1974)
Beautiful People (WB, 1974)
Black Eye (WB, 1974)
Black Sampson (WB, 1974)
Castaway Cowboy (BV, 1974)
Conversation (Par, 1974)
Coonskin (Par, 1974)
Craze (WB, 1974)
Dakota (Ind, 1974)
Death Wish (Par, 1974)
Digby, the Biggest Dog in the World (CRC, 1974)
La Faro da Padre (Ind, 1974)

Girl from Petrovka (U, 1974)
The Godfather II (Par, 1974)
Herbie Rides Again (BV, 1974)
How Long Can You Fall? (Inc, 1974)
Island at the Top of the World (BV, 1974)
It's Alive (WB, 1974)
The Klansman (Par, 1974)
Li'l Scratch (Inc, 1974)
Little Prince (Par, 1974)
Longest Yard (Par, 1974)
Lords of Flatbush (16mm blowup) (Col, 1974)
Lost in the Stars (AFT, 1974)
Mahler (Ind, 1974)
Man on a Swing (Par, 1974)
Murder on the Orient Express (Par, 1974)
Mutation (Col, 1974)
My Way (Ind, 1974)
Newman's Law (U, 1974)
Night Porter (UA, 1974)
Our Time (WB, 1974)
Paul and Michelle (Par, 1974)
Phase IV (Par, 1974)
Return of the Dragon (Ind, 1974)
Sonny and Jed (Ind, 1974)
Star Dust (Ind, 1974)
Superdad (BV, 1974)
Swallow and Amazona (Ind, 1974)
Terminal Man (WB, 1974)
That Midnight Man (U, 1974)
Three Tough Guys (Par, 1974)
Torso (Ind, 1974)
Truck Stop Women (Ind, 1974)
Uptown Saturday Night (WB, 1974)
Venial Sin (Ind, 1974)
Verdi (Ind, 1974)
A Very Natural Thing (Ind, 1974)
Wicker Man (British) (WB, 1974)
Willie Dynamite (U, 1974)
Zandy's Bride (WB, 1974)
Space Avenger (Chinese dye transfer) (New Wave, 1989)

THRILLARAMA

In 1956, Albert H. Reynolds and Dowlen Russell of Texas tried to re-create the Cinerama process using two rather than three cameras. Thrillarama involved two interlocked 35mm cameras exposing the full silent ratio aperture (four sprockets rather than Cinerama's six sprocket frame). When two interlocked projectors played the two prints, a 2.66 × 1 widescreen image, similar to the CinemaScope ratio, was generated. Whereas the Cinerama panel divisions were on the edge of a viewer's peripheral vision, the Thrillarama panel divisions were right down the center.

Only one feature was made in the process, *Thrillarama Adventure*, which played for one week in Houston, Texas, then closed. Both panels were printed in the dye transfer process, with the left panel in the mag only format with fox sprockets, and the right panel silent with conventional sprockets. One complete print exists in a private collection.

THRILLARAMA FEATURES

35mm dye transfer feature derived from
Thrillarama two panel color negatives

Thrillarama Adventure (Ind, 1956)

CINEMASCOPE 55

In 1956, Fox tried to upgrade their CinemaScope process by adapting it for use with a large format negative. Kodak manufactured a special 55mm color negative and print film which was processed at DeLuxe. They named the process CinemaScope 55. It used the same anamorphic compression as the 35mm format, retaining the 2.55 × 1 ratio, reduced size sprockets and four track magnetic only release print. Since a larger negative was used, sharpness and resolution were increased. Another development was the use of anamorphic prime lenses rather than attachments. A series of lenses was created with different focal lengths that had the squeeze built in which had foreshadowed the Panavision anamorphic system.

Fox noticed the quality of the VistaVision reduction prints coming

out of Technicolor and had DeLuxe build them an optical printer to derive standard 35mm scope prints from the 55mm negative. The 35mm Eastmancolor scope reduction prints of the first feature, *Carousel*, were so sharp that it was never shown in the large format.

The second feature, *The King and I*, also made in 1956, reportedly played 55mm for some limited engagements. Although better than standard 35mm scope positives, reduction printing in Eastmancolor did not work as well as it did in the dye transfer process. For the 1961 reissue, Fox sent the reduction 35mm internegative to Technicolor and had 35mm dye transfer prints made in a cropped 2.35 × 1 ratio, with more impressive results. Both 55mm features were also printed in the 16mm dye transfer scope process as well.

Circa 1956, Fox bought a controlling interest in the Todd AO 70mm process and phased out the CinemaScope 55 format. Future large scale Fox films were shot in 65mm.

CINEMASCOPE 55 FEATURES

35mm dye transfer features derived from
CinemaScope 55mm negative

King and I (Fox, 1961, reissue)

SuperScope

In the rush to widescreen, Howard Hughes and his RKO company wanted to compete, but the billionaire had no intention of paying a franchise fee to Fox for use of their CinemaScope lens attachment. He made a deal with the Tushinsky brothers, equipment manufacturers, to develop a new anamorphic system known as SuperScope. All SuperScope entailed was the adaption of a standard 1.33 × 1 color negative into a scope image by cropping the tops and bottoms of the frame and having Technicolor add an anamorphic compression during matrix manufacture. Since the frame was being cropped and enlarged, the resulting dye transfer release prints were grainy and lacked sharpness.

The SuperScope prints were made in a 2 × 1 ratio by printing black borders on the sides of the image (fig. 16). A projector plate would crop the image, but a standard anamorphic lens could be used.

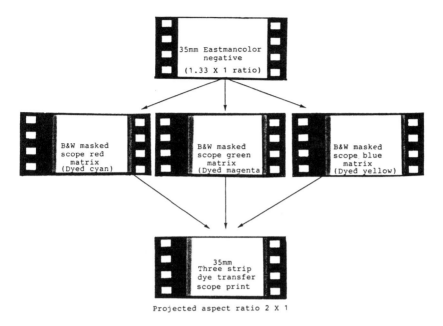

Fig. 16. Superscope dye transfer.

The Tushinskys also made a new kind of lens attachment that was really a box with two mirrors that gave a variable anamorphic compression, in the event future formats were introduced that did not use the standard 2×1 compression. The Tushinsky SuperScope projection attachments were difficult to adjust, and no matter how an operator turned the knob on top of the box to unsqueeze the image, it looked slightly distorted.

Since the same 2×1 ratio could be achieved by cropping a standard release print without adding anamorphic compression, and since the resulting print had less grain, SuperScope was a pretty worthless process and was quickly phased out after Hughes sold RKO to General Tire in 1957.

Several features that were originally released in 1.33 were reissued in the SuperScope format, including *Son of Sinbad* (shown in 3-D in 1954), *Henry V* (1945) and *Fantasia* (1940). The last was the most ridiculous; each animated sequence was given a different cropped aspect ratio, including an anamorphic squeeze in some that made the figures appear fat. The only interesting thing about this version was that it was the only dye transfer reissue that contained the

Fantasound stereo tracks in the magnetic only format. Future stereo reissues of *Fantasia* were in the Eastmancolor process and lacked the vibrant colors and rich contrast of the Technicolor originals.

SUPERSCOPE FEATURES

35mm dye transfer features derived from SuperScope negative

Vera Cruz (RKO, 1954)
Desert Sands (RKO, 1955)
Escape to Burma (RKO, 1955)
Pearl of the South Pacific (RKO, 1955)
Son of Sinbad (reissue) (RKO, 1955)
Tennessee's Partner (RKO, 1955)
Texas Lady (RKO, 1955)

Underwater (RKO, 1955)
Fantasia (reissued in magnetic stereo format) (RKO, 1956)
Glory (RKO, 1956)
Great Day in the Morning (RKO, 1956)
Henry V (reissue) (UA, 1956)
Slightly Scarlet (RKO, 1956)

TODD AO

One of the partners in the Cinerama company was veteran theatrical showman Michael Todd. He had supervised the European sequences of *This Is Cinerama*. Todd had reservations about the join lines that made up the widescreen image and the problems of keeping so many separate elements in synch. He sold off his interests in Cinerama and decided to develop his own proprietary format that would simulate the panoramic image without the join lines and contain the stereo tracks on the release copies.

Todd formed a partnership with Dr. Brian O'Brian, head of the Institute of Optics at the University of Rochester. A set of extremely wide angle lenses was developed that attempted to replicate the field of vision of Cinerama. They ranged from a huge "bug eye" 128 degree lens down to 64, 48 and 37 degree lenses. Todd had Kodak manufacture him a special 65mm negative stock for principal photography. For contact positive release prints, Kodak developed a 70mm stock. The extra 5mm was necessary for the six channels of magnetic strips applied to the base inside and outside the normal sized sprockets. The projected aspect ratio was 2.21 to 1. The speed of the film was also increased to 30 frames per second, which not only improved sound quality but also eliminated the "picket fence" distortion common in widescreen films when the camera panned past objects at the standard 24 frame rate (fig. 17).

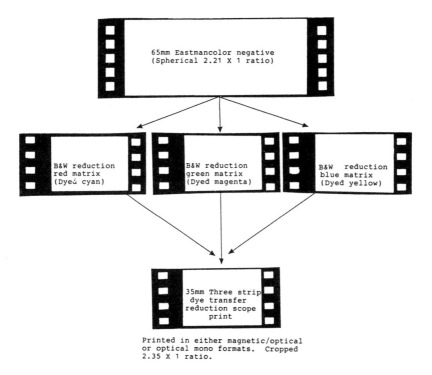

Fig. 17. Todd AO, Super Panavision, Panavision 70 dye transfer.

The Todd AO 70mm release prints, with their improved sharpness and resolution, represented the best quality available in the Eastmancolor process at the time. Since the wide frame was spherical rather than anamorphic, Todd AO prints displayed none of the distortion associated with the CinemaScope attachments. The only problem with the process was adapting it to 35mm for general release: There were no 35mm projectors in the U.S. that ran at the faster 30 frames per second rate.

The first Todd AO production, *Oklahoma!* (1955), was shot twice. During principal photography, the actors had to perform their roles for the 65mm cameras and then play the same scenes over to be shot in 35mm CinemaScope. Technicolor made the 35mm dye transfer magnetic only release prints in the full frame 2.55 × 1 ratio, while the C.F.I. lab manufactured the 70mm positives. It was obvious that the CinemaScope version was inferior to the 70mm version.

For his own production of *Around the World in 80 Days*, released

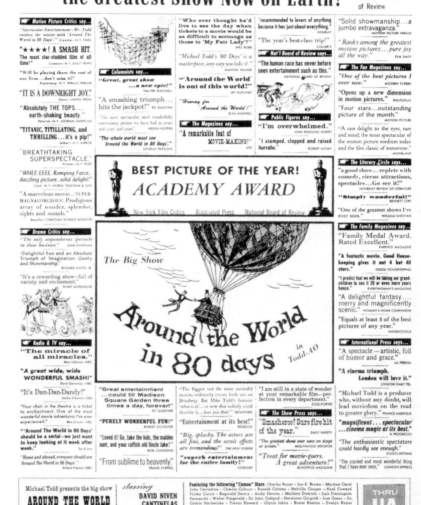

in 1957, Todd wanted the capability of making top-notch 35mm dye transfer general release copies as well as large format prints. His approach was both unusual and typical of the showmanship common in this era. Two 65mm negatives were exposed during principal photography. One ran at 30 frames per second for making optically derived 70mm prints (Technicolor A and B rolled the negative for first generation fades and dissolves), and the second 65mm negative ran at 24 frames per second for dye transfer "scope" reduction prints.

Reduction "scope" dye transfer prints looked as spectacular as the VistaVision "flat" reductions. The grain structure was finer, which increased apparent sharpness. VistaVision, Todd AO and other large negative printdowns represented the best color image possible on 35mm film.

The method of making the 35mm prints was similar to the VistaVision process. The 65mm negative would be reduced in an optical printer to 35mm by adding an anamorphic compression to the matrices. The three matrices were then transferred in a conventional manner.

Several different 35mm versions were made of *Around the World in 80 Days*. For four-track magnetic-only prints, the 24 frames per second 65mm color negative was reduction printed to full frame matrices (using the entire silent aperture ratio) with a lesser 1.75×1 anamorphic compression. When unsqueezed in a SuperScope variable anamorphic attachment, the 70mm aspect ration of 2.21×1 was retained. These unusual 35mm dye transfer prints also had a Perspecta encoding on the rear channel to direct the sound to three speakers in the back of the theater. This same version was released in England but transferred onto thinner 34mm blank stock (to get around the 35mm import fees) and derived from the 30 frames per second 65mm negative. Special motors had to be adapted to screen these 35mm Technicolor copies, referred to as Cinestage prints, at the faster 30 frames per second speed. No Cinestage copy seems to have survived.

For general release, the 24 frames per second 65mm negative was reduction printed to matrices with a conventional 2×1 squeeze and a projected aspect ratio of 2.35×1. This resulted in a slight cropping on the top and bottom of the 2.21×1 65mm frame, but it was not noticeable to audiences. General release Technicolor prints of *Around the World in 80 Days* were made with a Perspecta optical soundtrack. The picture was a tremendous hit and won the Academy

Award for Best Picture of 1957, although Todd had to sell off his interests in both Cinerama and Todd AO to finance the film. Sadly, he died in a plane crash while on a promotional tour, and the world lost a great showman. (After his death, the distribution of the film passed through two companies who proceeded to cut the negatives and allow them to deteriorate. The new Eastmancolor prints display serious negative fading and are 40 minutes shorter than the original Roadshow. Fortunately, a number of uncut 35mm Technicolor prints exist in archives and private collections.)

After Todd died, the Todd AO company decreased the speed to the standard 24 frames per second to make reduction printing easier. Most of the remaining Todd AO productions were released in the dye transfer process in 35mm, resulting in superior sharpness, albeit with a slight cropping on the top and bottom of the frame.

TODD AO FEATURES

35mm dye transfer features derived from Todd AO 65mm negative
(all titles released in both mag/optical and optical mono formats)

Around the World in 80 Days (UA, 1957)

South Pacific (British prints only) (Magna, 1958)

Porgy and Bess (Col, 1959)

The Alamo (UA, 1960)

Cleopatra (British prints only, short version) (Fox, 1963)

Sound of Music (Fox, 1967 reissue)

Airport (U, 1970)

The Last Valley (Cinerama, 1971)

TECHNIRAMA AND SUPER TECHNIRAMA 70

One way to make huge profits in the fifties was to own and sublicense a new widescreen process. Fox was raking in money by licensing their CinemaScope lenses. Paramount licensed their VistaVision process to MGM for *North by Northwest* (1959). Kalmus put his research department to work on creating their own proprietary widescreen method, which they called Technirama.

Technirama was a combination of VistaVision and CinemaScope. The research department devised a series of lenses that added a slight 1.5×1 anamorphic compression to a standard 35mm VistaVision horizontal negative. During matrix manufacture, the negative was given an additional compression as it was reduction printed to generate a standard 2.35×1 dye transfer release print (fig. 18).

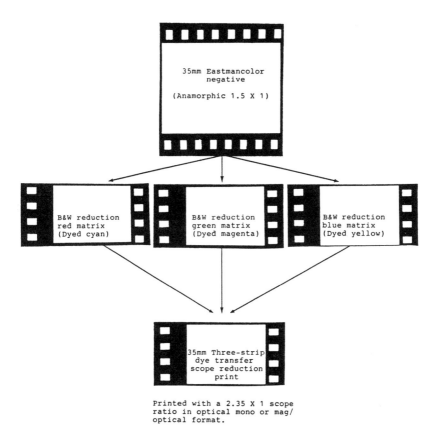

Fig. 18. Technirama reduction dye transfer.

With the introduction of Technirama, Technicolor was able to offer an ultrasharp scope image that rivaled the quality of Todd AO reduction IBs but had the advantage of using 35mm rather than 65mm film for principal photography. Prints were made in either optical mono or mag/optical formats.

Meanwhile, the popularity of 70mm Roadshow prints inspired the research department to modify the process further. They adapted a printer to optically derive a 70mm positive from the 35mm Technirama negative, thus launching Super Technirama 70. As previously mentioned, optical printing in Eastmancolor did not work as well as it did in the dye transfer process. The grain structure of the silver halides that generated the latent image of the matrix was finer and

more precise than the dye couplers exposed during Eastmancolor reductions or enlargements. As a result, the 70mm optical prints derived from Technirama negatives were not as good as those contact printed from 65mm negatives, although audiences probably would not have noticed the difference. The bulk of the release copies of Super Technirama 70 features continued to be 35mm dye transfer prints.

The cameras used for Technirama features were modified three strip units. The Panavision company supplied the lenses for the process. Among the notable Super Technirama 70 features were *Spartacus* (1960), *El Cid* (1961) and *The Music Man* (1962).

TECHNIRAMA AND SUPER TECHNIRAMA 70 FEATURES

35mm dye transfer features derived from Technirama negative

Escapade in Japan (U, 1957)
Legend of the Lost (UA, 1957)
The Monte Carlo Story (UA, 1957)
Night Passage (U, 1957)
Sayonara (WB, 1957)*
Auntie Mame (WB, 1958)
The Big Country (UA, 1958)*
Paris Holiday (UA, 1958)
This Angry Age (Col, 1958)
The Seven Hills of Rome (MGM, 1958)*
The Vikings (UA, 1958)
For the First Time (MGM, 1959)*
John Paul Jones (WB, 1959)*
The Miracle (WB, 1959)*
The Naked Maja (UA, 1959)
Solomon and Sheba (UA, 1959)*
Sleeping Beauty (BV, 1959)
The Tempest (Par, 1959)*
The Grass Is Greener (U, 1960)
Spartacus (U, 1960)*
The Trials of Oscar Wilde (Kingsley, 1960)

Blood and Roses (Par, 1961)
Carthage in Flames (Col, 1961)
El Cid (AA, 1961)
King of Kings (MGM, 1961)*
The Savage Innocents (Par, 1961)
World by Night (WB, 1961)
Barabbas (Col, 1962)
55 Days at Peking (AA, 1962)
Gypsy (WB, 1962)
The Hellions (Col, 1962)
Merrill's Marauders (WB, 1962)
The Music Man (WB, 1962)*
My Geisha (Par, 1962)
World by Night No. 2 (WB, 1962)
The Leopard (British and Italian prints only) (Fox, 1963)
Circus World (Par, 1964)
The Golden Arrow (MGM, 1964)
The Long Ships (Col, 1964)
The Pink Panther (UA, 1964)
Zulu (Embassy, 1964)*

Released in both mag/optical and optical mono formats.

PANAVISION

The Panavision company entered the widescreen field in 1957 with its improved series of anamorphic lenses. The major difference

between CinemaScope lenses and Panavision lenses (both used the identical 2 × 1 compression) was that the latter used "primes," similar to the lenses created for the CinemaScope 55mm format, rather than an attachment. A series of standard prime lenses (25mm, 50mm, etc.) was developed that had the anamorphic compression as part of the optics. This resulted in a scope image that was sharper than that shot with CinemaScope attachments.

The first dye transfer release to be photographed with the upgraded Panavision primes was *The Big Circus* in 1959. Other studios began using these lenses throughout the sixties, while Fox stayed with their CinemaScope attachments. Eventually, Fox switched over to Panavision, and the obsolete attachments were abandoned except for use in some independent, low budget features.

In 1963, Technicolor adapted their optical printer to derive "blowup" 70mm Eastmancolor positives from the 35mm Panavision negatives. *The Cardinal* was the first feature presented this way. As with any optical enlargement, the 70mm prints made in this fashion were not as sharp as those made from 65mm negatives. Given careful handling of fully exposed 35mm Panavision negatives that used high key lighting, the blowups could look good. In all cases, the bulk of the release prints were made in the 35mm dye transfer process (see fig. 19, page 110).

PANAVISION FEATURES

35mm dye transfer features derived from Panavision negative

The Big Circus (AA, 1959)
Ocean's 11 (WB, 1960)
Pepe (Col, 1960)*
Swiss Family Robinson (BV, 1960)
The Unforgiven (UA, 1960)
Blue Hawaii (Par, 1961)*
Come September (U, 1961)
Flower Drum Song (U, 1961)*
Love in a Goldfish Bowl (Par, 1961)
On the Double (Par, 1961)
Summer and Smoke (Par, 1961)
X-15 (UA, 1961)
Dangerous Charter (CI, 1962)
Geronimo (UA, 1962)
A Girl Named Tamiko (Par, 1962)
Hero's Island (UA, 1962)

Sergeants 3 (UA, 1962)
Who's Got the Action? (Par, 1962)
Come Blow Your Horn (Par, 1963)
Critic's Choice (WB, 1963)
Irma La Douce (WB, 1963)
Love Is a Ball (UA, 1963)
McLintock! (UA, 1963)
PT 109 (WB, 1963)
The Running Man (Col, 1963)
Spencer's Mountain (WB, 1963)
Who's Been Sleeping in My Bed?
 (Par, 1963)
A Distant Trumpet (WB, 1964)
Ensign Pulver (WB, 1964)
Masque of the Red Death (British
 prints only) (AIP, 1964)

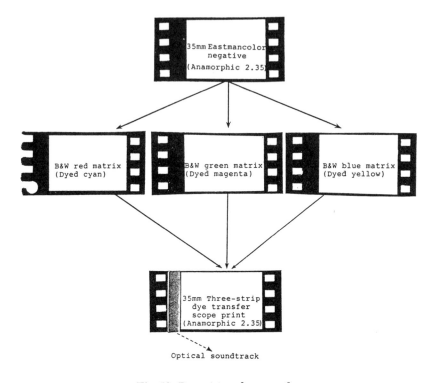

Fig. 19. Panavision dye transfer.

Robin and the 7 Hoods (WB, 1964)
Amorous Adventures of Moll
 Flanders (Par, 1965)
Battle of the Villa Fiorita (WB,
 1965)
Harlow (Par, 1965)
Inside Daisy Clover (WB, 1965)
Mister Moses (UA, 1965)
The Naked Prey (Par, 1965)
Never Too Late (WB, 1965)
None but the Brave (WB, 1965)
Sands of the Kalahari (Par, 1965)
Sons of Katie Elder (Par, 1965)
The Third Day (WB, 1965)
Thunderball (UA, 1965)*
The War Lord (U, 1965)
Arabesque (U, 1966)
Arrivederci Baby! (Par, 1966)
Assault on a Queen (Par, 1966)
Blindfold (U, 1966)

Born Free (Col, 1966)
The Chase (Col, 1966)
Harper (WB, 1966)
Mademoiselle (L, 1966)
A Man Could Get Killed (U, 1966)
The Rare Breed (U,1966)
Walk, Don't Run (Col, 1966)
Billion Dollar Brain (UA, 1967)
Cool Hand Luke (WB, 1967)
The Cool Ones (WB, 1967)
First to Fight (WB, 1967)
The Graduate (Emb, 1967)
Hurry Sundown (Par, 1967)
Night of the Generals (Col, 1967)
President's Analyst (Par, 1967)
Relections in a Golden Eye (WB,
 1967)
Taming of the Shrew (Col, 1967)
War Wagon (U, 1967)
You Only Live Twice (UA, 1967)

Barbarella (Par, 1968)
Blue (Par, 1968)
Boom! (U, 1968)
Cubasco (WB, 1968)
A Dandy in Aspic (Col, 1968)
Firecreek (WB, 1968)
The Green Berets (WB, 1968)
Hell in the Pacific (CRC, 1968)
Odd Couple (Par, 1968)
The Party (British prints only) (UA, 1968)
Skidoo (Par, 1968)
The Stalking Moon (NG, 1968)
Tarzan and the Jungle Boy (Par, 1968)
Villa Rides! (Par, 1968)
The April Fools (NG, 1969)
The Arrangement (WB, 1969)
Assignment to Kill (WB, 1969)
The Big Bounce (WB, 1969)
Camille 2000 (A, 1969)
Castle Keep (Col, 1969)
Charro! (NG, 1969)
A Fine Pair (NG, 1969)
The Good Guys and the Bad Guys (WB, 1969)
The Great Bank Robbery (WB, 1969)
The Illustrated Man (WB, 1969)
The Learning Tree (WB, 1969)
The Lost Man (U, 1969)
The Madwoman of Chaillot (WB, 1969)
My Side of the Mountain (Par, 1969)
Oh! What a Lovely War (Par, 1969)
On Her Majesty's Secret Service (UA, 1969)
Catch-22 (Par, 1970)
The Cheyenne Social Club (NG, 1970)
Chism (WB, 1970)
Colossus, the Forbin Project (U, 1970)
Cromwell (Col, 1970)
Darling Lili (Par, 1970)*
The Executioner (Col, 1970)
Fellini's Satyricon (UA, 1970)
Flap (WB, 1970)
Julius Ceasar (AIP, 1970)
Little Big Man (NG, 1970)

The Looking Glass War (Col, 1970)
A Man Called Horse (NG, 1970)
The Molly Maguires (Par, 1970)
Monte Walsh (NG, 1970)
On a Clear Day You Can See Forever (Par, 1970)*
The Pizza Triangle (WB, 1970)
Scrooge (NG, 1970)*
Skullduggery (U, 1970)
There Was a Crooked Man (WB, 1970)
WUSA (Par, 1970)
You Can't Win 'em All (Col, 1970)
The African Elephant (NG, 1971)
The Andromeda Strain (U, 1971)
Big Jake (NG, 1971)*
Carnal Knowledge (Avco, 1971)
Death in Venice (WB, 1971)
The Deserter (Par, 1971)
Diamonds Are Forever (UA, 1971)
Dirty Harry (WB, 1971)
Klute (WB, 1971)
Man in the Wilderness (WB, 1971)
McCabe and Mrs. Miller (WB, 1971)
Nicholas and Alexandra (British prints only) (Col, 1971)
The Omega Man (WB, 1971)
Scandalous John (BV, 1971)
Skin Game (WB, 1971)
The Todd Killings (also known as A Dangerous Friend) (NG, 1971)
Zeppelin (WB, 1971)
Dealing (WB, 1972)
The Groundstar Conspiracy (U, 1972)
Jeremiah Johnson (WB, 1972)
Joe Kidd (U, 1972)
Life and Times of Judge Roy Bean (NG, 1972)
Pete 'n' Tillie (U, 1972)
Portnoy's Complaint (WB, 1972)
Prime Cut (NG, 1972)
Public Eye (U, 1972)
Snow Job (WB, 1972)
All American Boy (WB, 1972)
Cahill, United States Marshall (WB, 1973)
Class of '44 (WB, 1973)
Cleopatra Jones (WB, 1973)
Day of the Dolphin (Avco, 1973)

Fear Is the Key (Par, 1973)
High Plains Drifter (U, 1973)
Hit! (Par, 1973)
The Long Goodbye (UA, 1973)
The Mackintosh Man (WB, 1973)
Magnum Force (WB, 1973)
The Nelson Affair (U, 1973)
Night Watch (Avco, 1973)
Papillon (AA, 1973)
Scarecrow (WB, 1973)
A Touch of Class (Avco, 1973)
Airport 1975 (U, 1974)
The Black Windmill (U, 1974)
Blazing Saddles (WB, 1974)
Chinatown (Par, 1974)

The Dove (Par, 1974)
Freebie and the Bean (WB, 1974)
The Front Page (U, 1974)
Gold (AA, 1974)
Mame (WB, 1974)*
McQ (WB, 1974)
My Name Is Nobody (U, 1974)
The Parallax View (Par, 1974)
The Savage Is Loose (Ind, 1974)
The Sugarland Express (U, 1974)
Zandy's Bride (WB, 1974)
Jaws (British prints only) (U, 1975)
Star Wars (British prints only) (Fox, 1977)

Released in both mag/optical and optical mono formats.

PANAVISION BLOWUPS FEATURES

35mm dye transfer features derived from Panavision negative
(All features blown up to 70mm for Roadshow engagements.
General release prints were in the dye transfer process.)

The Cardinal (Col, 1963)*
Becket (Par, 1964)
The Carpetbaggers (Par, 1964)
First Men in the Moon (Col, 1964)
Dr. Zhivago (British prints only) (MGM, 1965)
Genghis Khan (Col, 1965)
The Great Race (WB, 1965)
Marriage on the Rocks (WB, 1965)
The Professionals (Col, 1966)
Camelot (WB, 1967)*
Casino Royale (Col, 1967)
Finian's Rainbow (WB, 1968)*
Funny Girl (Col, 1968)*
Hellfighters (U, 1968)
Oliver (Col, 1968)*

Sweet Charity (U, 1968)*
Paint Your Wagon (Par, 1969)*
Those Daring Young Men in Their Jaunty Jalopies (Par, 1969)
The Wild Bunch (WB, 1969)
The Adventurers (Par, 1970)*
Anne of the Thousand Days (U, 1970)
Two Mules for Sister Sara (U, 1970)
Winning (U, 1970)*
The Devils (WB, 1970)
Fiddler on the Roof (UA, 1971)*
Mary, Queen of Scots (U, 1971)
Waterloo (Par, 1971)
The Cowboys (WB, 1972)
Deliverance (WB, 1972)

Released in both mag/optical and optical mono formats.

OTHER ANAMORPHIC SYSTEMS

A number of other anamorphic systems that used lens attachments or primes came and went over the years. Most were comparable

to CinemaScope quality; all fell short of the Panavision optics. Listed below are the names of the formats and studios that released the film.

OTHER SCOPE SYSTEMS FEATURES

35mm dye transfer features derived from various anamorphic processes

Jet Pilot (RKO, 1957)	RKO scope†
Run of the Arrow (RKO, 1957)	RKO scope†
The Naked and the Dead (RKO, 1958)	RKO scope
Hannibal (WB, 1960)	Supercinescope
The Cossacks (U, 1960)	Totalscope
The White Warrior (WB, 1961)	Dyaliscope
The Minotaur (UA, 1961)	Totalscope
I Bombed Pearl Harbor (Ind, 1961)	Tohoscope
Story of the Count of Monte Cristo (WB, 1962)	Dyaliscope
The Tartars (MGM, 1962)	Totalscope
Dr. Terror's Gallery of Horrors (AG, 1962)	Totalvision
Shalako (Col, 1968)	Franscope
Sweet Body of Deborah (WB, 1969)	Cromoscope
Woodstock (WB, 1970)*	16mm multiscreen
Macbeth (Col, 1971)	Todd AO 35
The Getaway (NG, 1972)	Todd AO 35
Jesus Christ Superstar (U, 1973)*	Todd AO 35
Showdown (U, 1973)	Todd AO 35

Released in magnetic stereo and optical mono formats.
†*Shot in 1.33 and optically cropped and squeezed into an anamorphic image.*

MGM CAMERA 65 AND ULTRA PANAVISION 70

MGM developed their own 70mm system, known as MGM Camera 65. The Panavision company developed anamorphic lenses for 65mm camera units that contained a slight 1.25×1 compression. The 70mm Eastmancolor positives were printed and shown in the six track Todd AO format. For projection, an anamorphic lens with the same 1.25×1 compression would unsqueeze the image to a wide 2.76×1 ratio, rivaling the width of Cinerama but not the field of vision.

Only two features were made in this process. The first film, *Raintree County* (1957), had reduction matrices derived from the anamorphic 65mm negative in the standard 2.35×1 ratio and mag/optical format. The dye transfer reduction copies had comparable quality to Todd AO and Technirama prints, although the edges of the image were slightly cropped.

For *Ben-Hur* (1959), MGM wanted to retain the complete 70mm aspect ratio in 35mm. Technicolor made reduction matrices with a thin black border on the top and bottom of the frame and dye transfer release prints in the mag/optical format. When unsqueezed, the complete 2.76 × 1 ratio was maintained, albeit with a slight letterboxing. Special projection plates had to be made to crop the borders. It would appear that all 1959 dye transfer prints contained magnetic and optical tracks. Matrices were shipped to the London Technicolor facility, which made mono optical copies. The print quality of MGM Camera 65 reduction IBs of *Ben-Hur* was superb.

Although the process was discontinued after *Ben-Hur*, the Panavision company developed a near identical process named Ultra Panavision 70, which was used for a few features and some single panel Cinerama releases in the midsixties. A different 65mm camera was used for principal photography; otherwise, the aspect ratio was the same. The 35mm dye transfer reduction prints were made on all titles in the cropped 2.35 × 1 ratio, resulting in extraordinary sharpness, resolution and color (fig. 20).

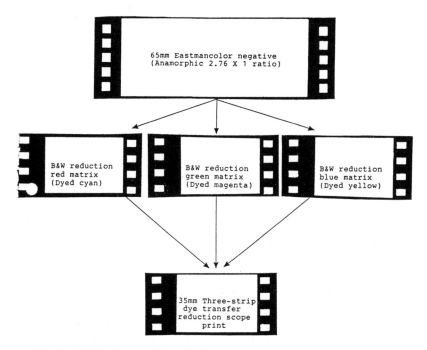

Fig. 20. MGM Camera 65 and Ultra Panavision reduction dye transfer.

206

The Academy Award Champ, winner of 11 Oscars including BEST PICTURE is writing a new page in the history of show business.

MGM CAMERA 65 AND ULTRA PANAVISION 70 FEATURES

35mm dye transfer scope reduction features derived
from 65mm anamorphic negatives

Raintree County (MGM, 1957)*	MGM Camera 65
Ben-Hur (MGM, 1959)*	MGM Camera 65
The Big Fisherman (BV, 1959)	Ultra Panavision 70
Mutiny on the Bounty (MGM, 1962)	Ultra Panavision 70
It's a Mad, Mad, Mad, Mad World (short version) (UA, 1963)*	Ultra Panavision 70
Fall of the Roman Empire (Par, 1963)	Ultra Panavision 70
Battle of the Bulge (WB, 1965)	Ultra Panavision 70
Greatest Story Ever Told (UA, 1965)	Ultra Panavision 70
The Hallelujah Trail (UA, 1965)	Ultra Panavision 70
Mediterranean Holiday* (Con, 1965)	Ultra Panavision 70
Khartoum (UA, 1966)	Ultra Panavision 70

Released in both mag/optical and optical mono formats.

TECHNICOLOR ITALIANA

In 1955, Kalmus and associates launched Technicolor Italiana in Rome, and the new facility began making dye transfer prints for the European markets not handled by the London lab. Among the filmmakers that used the process creatively were Luchino Visconti, Federico Fellini, Michelangeleo Antonioni and Dario Argenta. Fellini's brilliant color schemes greatly enhanced his films. Technicolor Italiana continued to use the dye transfer process for several years after the U.S. facility had shut it down.

An attempt was made the same year to set up a Technicolor plant in Paris called Société Technicolor. According to the surviving U.S. technicians, the French would not cooperate with the American staff and never made a go of it.

END OF AN ERA

As the fifties came to a close, the aging Kalmus decided to retire. He had achieved his goal of creating a near perfect color image with the advent of large format photography and dye transfer reduction printing. The quality of the 35mm VistaVision, Todd AO reductions, Technirama and MGM Camera 65 reductions were vastly superior

Societé Technicolor

a new

TECHNICOLOR LABORATORY

to serve the increasing demands

on the Continent of EUROPE

for

THANK YOU FOR YOUR ORDER

OF DECEMBER 1977 . . .

☆

THE TECHNICOLOR RESEARCH LABORATORIES
ARE WORKING ON THIS ORDER NOW.

FROM A RESEARCH POINT OF VIEW

TWENTY YEARS IS TOMORROW, AND

TECHNICOLOR TAKES THIS VIEW.

THE FUTURE IS TODAY'S BUSINESS

AT TECHNICOLOR.

Two ads placed by the Technicolor
company in the 1957 edition of
FILM DAILY YEARBOOK. No one knew
at the time that the 1977 order
would be for Eastmancolor prints
made on a continuous high speed
printer rather than the superior
dye transfer process used through
1974.

TECHNICOLOR SERVES THE WORLD
with a complete line of color release prints

Through its world-wide facilities, Technicolor answers the
need of every theater by supplying a complete variety of
release prints from Technirama, 65mm, Vistavision, Full
Aperture, Reduced Aperture, Cinemascope Aperture, Cin-
erama, Successive frame, and 16mm negatives.

CinemaScope NEGATIVE · FULL APERTURE NEGATIVE · SUCCESSIVE FRAME NEGATIVE · TECHNIRAMA NEGATIVE · 65mm NEGATIVE · VistaVision NEGATIVE · REDUCED APERTURE NEGATIVE · 16mm NEG. · CINERAMA NEGATIVE

to any 35mm Eastmancolor positive. No other multihued process was able to match the ultrasharp appearance, vibrant color or grain free image. For standard flat and scope releases, the competing labs like WarnerColor and DeLuxe continued to send their top features to Technicolor for dye transfer printing.

Technicolor expanded its facility to include large format positive printing. The 70mm Roadshow prints of *South Pacific* and *Porgy and Bess* were made there, along with the 35mm dye transfer reduction copies. Both formats featured first generation opticals via the A and B roll negative process and scratch free images due to wet gate printing.

The first generation positives manufactured by Pathé color, Metrocolor and others were sharp and had acceptable color but also contained grainy opticals and displayed negative wear from excessive contact printing. It was not uncommon for Pathé color or DeLuxe positives to fade before the end of the theatrical date. For second run theaters and reissues, Eastmancolor features posed a real problem. The release prints were faded, and the color negatives worn and often faded as well.

After the release of *Spartacus*, Kalmus went on a European vacation and retired from active management. He assumed that the standards he set would be maintained by his staff. Unfortunately, some in business outside of the industry noticed the price of Technicolor stock soar. One of them was Patrick Frawley, who made his fortune marketing the Bic pen. During Kalmus's absence, Frawley bought a controlling interest in the company. When Kalmus returned, he had lost his influence on the process he had nurtured and perfected for 32 years.

<div align="right">

┌─────────┐
│ │
│ 5 │
│ │
└─────────┘

</div>

Decline and Demise

Under the new regime, changes were implemented and corners cut. Kalmus was powerless to do anything about it since he was no longer the guiding force. A new board of directors was elected that included Alfred Bloomingdale. Kalmus's retirement was now permanent, and his parking space at the lab was eliminated. One of the running jokes with the new management was that Kalmus had to park his car in the Technicolor "red zone" if he wanted to enter the building. This was a typical American tragedy—a daring entrepreneur develops a wonderful new invention and then has it undermined by corporate raiders who eventually dismantle everything he worked so hard to create.

It is a testament to the surviving technicians that the decline was gradual and the quality of dye transfer release prints remained excellent until 1971, even though the new management eliminated some of the formats that offered superior quality.

This "Was" Cinerama

After a last hurrah, the Cinerama company pushed out its spectacular three panel process and switched over to the 70mm format, adding a slight anamorphic squeeze to the negative, which generated a comparable aspect ratio to the MGM Camera 65 and Ultra Panavision processes. The single panel 70mm prints were shown on modified curved screens that were impressive but did not give the wraparound sensation of peripheral vision of the original.

At least the three panel process went out with a bang. The research department adapted an optical printer for the six sprocket

frame and made matrices and dye transfer three panel prints of *How the West Was Won, The Wonderful World of the Brothers Grimm* and *This Is Cinerama* in 1962.

Starting with *It's a Mad, Mad, Mad, Mad World* in 1963, all Cinerama films were shot in 65mm. The first and last two three-panel films were converted to this format, with less impressive results, for future reissues. In the late sixties the anamorphic squeeze was eliminated, reducing Cinerama to spherical 70mm shown on a curved screen. *2001* was shot and projected this way. The presentations were still good but so far removed from the three panel experience that the word Cinerama had lost its meaning.

Meanwhile, Kodak upgraded their negative/positive stock and lowered prices in the early sixties to the level where labs that usually sent their negatives to Technicolor for dye transfer printing began handling their own orders. Many facilities cut corners, which resulted in poor quality control in large print runs. Competition among the labs were directed at how "cheap" and fast, not how well, the positive prints could be made. The heyday of quality Eastmancolor was over, with the exception of the custom made, large format Roadshow prints. Circa 1955, the General Tire Corporation sold its entire RKO backlog of features for television airing. The other studios gradually followed suit, and television ceased to be the "competition" but another venue for distributing old product. The lack of competition made the industry lose interest in new technology. The Age of Showmanship was coming to an end.

Kalmus Dies

In 1963, Herbert Kalmus died at the age of 81. With him went the quest and dedication for perfect motion picture color. It is unlikely the actions taken by the succeeding Technicolor managements would have met with his approval.

The relationship between Technicolor and Eastman Kodak changed with the passing of Kalmus. From the beginning, Kalmus tried to maintain a cooperative relationship with the stock manufacturer, even after it was strained with the introduction of Kodak's proprietary dye coupler process. Kalmus had been close friends with Kenneth Mees, one of the top executives at the company.

Rather than continue this relationship, the Frawley management

tried to compete with their own supplier, an unfortunate mistake. Kodak lowered the price of positive stock and increased the price of matrix and blank stock in reaction to the new attitude. Frawley, in turn, began downsizing the company to try to match the cheaper prices of the other color labs. He should have promoted the superior quality of the dye transfer process, but that was not in his agenda. After a lucrative government contract fell through in 1965, Frawley sent a memo to the research department, stating he was "getting rid of dead wood" and shut it down, discounting all of the contributions the researchers had made over the years. Richard Goldberg left the lab and set up his own dye transfer facility for still photography, which is still in operation today.

With the shutdown, the superior Technirama process was phased out. VistaVision had already been eliminated circa 1963, after Frawley took over the lab. Even without the research department, some of the technicians continued to work on new technology, although much of it was ignored by the management. Another attempt was made to eliminate the silver content of the blank stock. An improved Prussian blue (Ferric-Ferrocyanide) dye, which was found to have excellent infrared absorbing properties for modulating emissions from projector exciter lamps, was used to transfer the optical track. Demo prints might have been made, but it was not used on any feature productions.

One notable improvement that was implemented with Kodak's assistance was the introduction of ester base matrices. Both nitrate and safety base stock was subject to shrinkage, which could cause it to break in the machines. Ester base was the most durable preprint available and not subject to these problems or to base deterioration (nitrate decomposition, vinegar syndrome). Ester base matrices enabled the speed of the machines to be increased.

TECHNISCOPE

Technicolor Italiana developed their own economy process, called Techniscope, in 1961. A two sprocket image, instead of the standard four sprocket square frame, was shot during principal photography. By cutting the image in half, less raw stock was used.

The two sprocket wide image was then enlarged in an optical printer, which added an anamorphic squeeze resulting in matrices

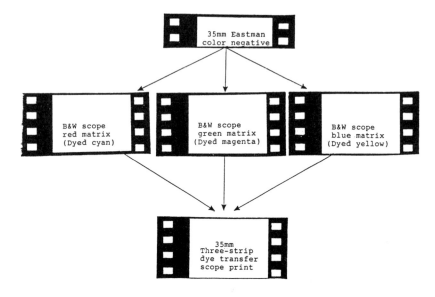

Fig. 21. Techniscope dye transfer.

and dye transfer prints with the standard 2.35 × 1 aspect ratio. The dye transfer Techniscope features were grainier than standard Panavision prints because the image was blown up. Its poor quality made it as worthless as SuperScope (fig. 21).

TECHNISCOPE FEATURES

35mm dye transfer features derived from Techniscope negative

East of Sudan (Col, 1964)
For Those Who Think Young (UA, 1964)
Law of the Lawless (Par, 1964)
Robinson Crusoe on Mars (Par, 1964)
Roustabout (Par, 1964)
Where Love Has Gone (Par, 1964)
Arizona Raiders (Col, 1965)
Billie (UA, 1965)
Black Spurs (Par, 1965)
Bounty Killer (Emb, 1965)
Coast of Skeletons (7A, 1965)
Dr. Terror's House of Horrors (Par, 1965)
Face of Fu Manchu (7A, 1965)
Go Go Mania (AIP, 1965)
Ipcress File (UA, 1965)
Moment of Truth (Rizzoli, 1965)
Revenge of the Gladiators (Par, 1965)
The Skull (Par, 1965)
A Swingin' Summer (UA, 1965)
Town Tamer (Par, 1965)
Young Fury (Par, 1965)
Alfie (Par, 1966)
Appaloosa (UA, 1966)
Beau Geste (U, 1966)
Funeral in Berlin (Par, 1966)
Gambit (Par, 1966)

Incident at Phantom Hill (U, 1966)
Johnny Reno (Par, 1966)
Night of the Grizzly (Par, 1966)
Psychopath (Par, 1966)
Texas Across the River (U, 1966)
Waco (Par,1966)
Africa Addio (Cinemation, 1967)
Banning (U, 1967)
Blood Fiend (Hemisphere, 1967)
Busy Body (Par, 1967)
Clambake (UA, 1967)
C'mon Let's Live a Little (Par, 1967)
Daleks' Invasion of Earth 2150 A.D. (Con, 1967)
Deadlier Than the Male (U, 1967)
Deadly Bees (Par, 1967)
A Fistful of Dollars (UA, 1967)
For a Few Dollars More (UA, 1967)
Games (U, 1967)
Good, Bad and the Ugly (UA, 1967)
Hills Run Red (UA, 1967)
Hired Killer (Par, 1967)
Hostile Guns (Par, 1967)
House of a Thousand Dolls (AIP, 1967)
Lightning Bolt (Woolner, 1967)
Made in Italy (Royal, 1967)
Naked Runner (WB, 1967)
Navajo Joe (UA, 1967)
Operation Kid Brother (UA, 1967)
Projected Man (U, 1967)
Rough Night in Jericho (U, 1967)
Tobruk (U, 1967)
The Viscount (WB, 1967)
Waterhole #3 (Par, 1967)
What Am I Bid? (Emerson, 1967)
Young Warriors (U, 1967)
Any Gun Can Play (RAF, 1968)
Arizona Bushwackers (Par, 1968)
Assignment K (Col, 1968)
Ballad of Jose (U, 1968)
Champagne Murders (U, 1968)
Charly (CRC, 1968)
Counterpoint (U, 1968)
Did You Hear the One about the Traveling Saleslady? (U, 1968)
Don't Just Stand There! (U, 1968)
Fever Heat (Par, 1968)
Grand Slam (Par, 1968)

The Hell with Heroes (U, 1968)
In Enemy Country (U, 1968)
Journey to Shiloh (U, 1968)
Knives of the Avenger (WE, 1968)
Long Day's Dying (Par, 1968)
Madigan (U, 1968)
Man Outside (AA, 1968)
A Matter of Innocence (U, 1968)
Nobody's Perfect (U, 1968)
P.J. (U, 1968)
Paper Lion (UA, 1968)
Payment in Blood (also known as Winchester for Hire) (Col, 1968)
Pink Jungle (U, 1968)
Secret War of Harry Frigg (U, 1968)
Shakiest Gun in the West (U, 1968)
Strange Affair (Par, 1968)
Up the Junction (Par, 1968)
Violent Four (Par, 1968)
What's So Bad about Feeling Good? (U, 1968)
Death Rides a Horse (UA, 1969)
Love God? (U, 1969)
Loving Feeling (U-M, 1969)
Once upon a Time in the West (Par, 1969)
Southern Star (Col, 1969)
They Came to Rob Las Vegas (WB, 1969)
Captain Milkshake (Richmark, 1970)
Mercenary (UA, 1970)
Olympics in Mexico (Col, 1970)
Sabata (UA, 1970)
Savage Wild (AIP, 1970)
Adios, Sabata (UA, 1971)
Black Jesus (Plaza, 1971)
Brotherhood of Satan (Col, 1971)
Cat o' Nine Tails (NG, 1971)
Death of Summer (Plaza, 1971)
Dirty Heroes (GE, 1971)
A Man Called Sledge (Col, 1971)
Medicine Ball Caravan (WB, 1971)
THX 1138 (WB, 1971)
Blindman (Fox, 1972)
A Fistful of Dynamite (also known as Duck, You Sucker) (UA, 1972)
Four Flies on Gray Velvet (Par, 1972)
Johnnie Hamlet (Transvue, 1972)
Return of Sabata (UA, 1972)

Slaughterhouse Five (U, 1972) Steel Arena (L-T, 1973)
Weekend Murders (MGM, 1972) A Boy and His Dog (LQ Jaf,
American Graffiti (U, 1973) 1973)

Super Panavision 70 and Panavision 70

As interest in technology declined, at least one company, the
Panavision Corporation, continued to introduce new products. Its
anamorphic primes were improved to the level where Technicolor
prints derived from 35mm Panavision negatives were only a notch
below those derived from large format negatives in the fifties.
The 35mm dye transfer Panavision prints of titles like *Thunderball*
(1965), *The Great Race* (1965) and *The Wild Bunch* (1969) featured
razor sharp widescreen images with no apparent grain and excellent
color.

A desaturated look was attempted with *Reflections in a Golden
Eye* (1967), similar to the look used in *Moby Dick* (1956). While lack-
ing in vibrant primary colors, these two films still contained the rich
contrast and "pure" blacks that made them so superior to color
positives. If this look had been attempted in Eastmancolor, the image
would have appeared murky. Both films displayed the versatility of
the dye transfer process and proved that Technicolor films did not
have to be saturated with color.

The Panavision company also developed its own series of spher-
ical (nonanamorphic) primes lenses for use with 65mm cameras.
Aside from the difference in the lenses, Super Panavision 70 and
Panavision 70 were identical to the Todd AO format, with 70mm
Eastmancolor prints derived from the 65mm negative along with
35mm dye transfer reductions in the cropped 2.35 × 1 ratio.

Automatic Selective Printing

Prior to the shutdown, the research department devised another
method of incorporating first generation optical effects into the
70mm positive prints and dye transfer reduction matrices, known as
Automatic Selective Printing. Rather than A and B rolling the nega-
tives into two strips, the camera negative was assembled onto one
reel. For shots that required fades or dissolves, the entire sequence,

including the camera slate, would be incorporated on the reel. The printer would be programmed to automatically expose the effects as the release copies or matrices were being made. For example, if the first shot of a scene was going to be dissolved to the second shot, the printer would automatically fade out the first one and then double expose the second shot directly onto the print. Technicolor received another Academy Award for this innovation in 1961.

Among the notable titles reduction printed via the auto select method were *Lawrence of Arabia* (1962), *My Fair Lady* (1964) and *Cheyenne Autumn* (1964).

SUPER PANAVISION 70 AND PANAVISON 70 FEATURES

35mm dye transfer scope reduction features
derived from 65mm spherical negatives

Exodus (UA, 1960)*
West Side Story (UA, 1961)*
Lawrence of Arabia (Col, 1962)*†
Cheyenne Autumn (WB, 1964)*
My Fair Lady (WB, 1964)*
Lord Jim (Col, 1965)

Chitty Chitty Bang Bang (UA, 1968)
2001 (British prints only) (MGM, 1968)*
MacKenna's Gold (Col, 1969)
Krakatoa East of Java (Cinerama, 1969)

Released in both mag/optical and optical mono formats
†*U.S. prints ran 202 min.*

SOVSCOPE 70

In the early sixties, the Russians devised their own 70mm system, called Sovscope 70. It was identical to the Todd AO format. Only one feature was printed in the dye transfer process domestically, *Bolshoi Ballet 67*, in both mag/optical and optical mono formats. Matrices were derived from a 35mm reduction scope internegative.

SOVSCOPE 70 FEATURES

35mm dye transfer feature derived from
Sovscope reduction 35mm negative

Bolshoi Ballet 67 (Par, 1967)

8MM AND SUPER 8MM DYE TRANSFER

In the sixties, both 8mm and Super 8mm became popular home movie formats as well as film collecting mediums. Several distributors offered shorts subjects, cartoons and some features for sale to consumers. The Technicolor company adapted its process to the formats.

The 8mm dye transfer prints contained no soundtrack and were manufactured on a four rank system similar to the double rank method used for 16mm in the forties and fifties. Four images were optically reduction printed to 35mm matrices that contained the tiny 8mm sprockets on either side of the film. They were then transferred to 35mm blank stock and slit into four dye transfer 8mm silent prints. Technicolor developed a cartridge projector that required no reels or threading, with the entire print encased in a plastic covering, similar to a videocassette.

Circa 1968, Technicolor adapted the process to the Super 8mm format, which contained a gray optical track. The same four rank method was used, except that the blank had reduction optical gray tracks exposed on it prior to transfer. The 35mm film was slit into four Super 8mm dye transfer sound prints.

The resolution of 8mm and Super 8mm dye transfer prints was inferior to the 16mm format although, considering the size of the image, acceptable.

TECHNICOLOR ON TELEVISION

In 1966, CBS, NBC and ABC began broadcasting in color, and Technicolor offered its process to the networks and independent stations. Programs on NBC were advertised as being shown in "Living Color," a catchy logo that certainly applied to dye transfer prints aired on television.

Networks usually played 35mm Technicolor prints, while the syndicated stations aired the less expensive 16mm dye transfer copies. A common deal was for stations to pay a flat rate to broadcast for "the life of the print." A smart executive would have ordered a dye transfer copy rather than a positive print that would eventually fade and limit the showings. Some stations played the faded prints anyway.

Among the notable dye transfer programs shown on television was Walt Disney's "Wonderful World of Color," which displayed how beautiful the process could look on video. *The Wizard of Oz* was aired in Technicolor by CBS. One of the dye transfer prints was retrieved from the station and released on videotape by the Turner Company in 1989, with excellent results. Technicolor also offered positive printing to the networks, which they used on shows like "Dragnet" and "Get Smart." Although not printed in the dye transfer process, these shows tried to simulate the "Technicolor look" by using saturated fleshtones and vibrant primary colors.

In 1972, ABC made a new dye transfer print of *Vertigo* for its "Sunday Night Movie." The quality was vastly superior to the grainy, faded 1983 reissue in Eastmancolor. (A collector salvaged this copy from the network garbage bins, and it was shown at the Cleveland Cinematheque's Technicolor festival in 1991.)

Technicolor adapted an optical printer that could "scan" a scope negative to derive a 1.33 × 1 dye transfer print for network broadcast (this was preletterbox days). Even with the cropped picture, the dye transfer "flat" prints of *The Music Man,* which played on NBC and PBS, looked quite impressive.

The 35mm and 16mm dye transfer prints made specifically for broadcast were printed with a lighter contrast, since television was a low contrast medium. The blacks were not as rich as in a theatrical density copy but worked nicely for video. With today's upgraded and sophisticated video transfer machines, an original dye transfer print could be adapted to this medium successfully.

COLOR REVERSAL INTERNEGATIVE

Circa 1968, Kodak tried to improve its Eastmancolor process by introducing a new intermediate stock known as Color Reversal Internegative, or CRI. As the name implied, this was a reversal negative stock made directly from the camera negative. Eastmancolor prints could now be mass-produced from intermediate materials rather than from the camera negative, thus reducing wear. Unfortunately, CRI was very difficult to process correctly. Many Eastmancolor prints derived from them were grainy and inferior to mass produced dye transfer prints, although better than positive copies derived from internegatives. The CRIs also had poor image

stability and faded quicker than internegatives. Some technicians referred to it as CRY rather than CRI.

To try to persuade Technicolor to switch to positive printing, Kodak lowered the price of their CRI intermediate and raised the price of matrix and blank stock again. Fortunately, the dye transfer process continued to hang in there, even with the "cheap" CRI competition. This was about to change in 1970, when another proxy battle for control of the company took place.

DEMISE

Circa 1970, Patrick Frawley left the company, and a period of executive shuffling ensued. Donald O. McFarlane became president for a brief period but later resigned and was replaced by William E. McKenna. The influential figure, however, was Harry Saltzman, who liquidated his partnership with Albert Broccolli (they coproduced the early Bond films) and used these funds to enhance his stock position at Technicolor.

This new management team economized even further and tarnished Technicolor's reputation. Matrices were used to make upwards of nine hundred prints, even though they wore out after four hundred. Mediocrity started setting in between 1971 and 1974. While 35mm dye transfer prints of films like *Diamonds Are Forever* (1971) retained their visual beauty, many release copies of *Cabaret* (1972) had mistimed color and reels that did not match. Some reissue prints of *Lawrence of Arabia* (1971) had a greenish tint due to improperly manufactured matrices.

Around the same time, high speed film became popular, and cinematogaphers began to shoot with very little light. However, the end result was a "thin" negative with weak contrast. Grain became more apparent in Eastmancolor prints due to negatives that were not as fully exposed as pre–1970 features. Color was becoming merely functional rather than dramatic and atmospheric. Many cinematographers opted for the desaturated look and tried to pass it off as "style." In reality, it was cheaper to shoot with less light. It made one miss the days when color consultants were used.

At least some interesting films were made with the new "look." The *Godfather* pictures were examples of how it could be used artistically. However, it wasn't appropriate for all subjects. Adventure

films and comedies suffered from bland photography and the lack of vibrant colors.

According to William Ward, a dye transfer technician who worked at the facility in this era, Kodak called a meeting with the Technicolor executives to announce they were going to raise the price of matrix and blank stock again. They gave fluctuations in the silver market as the excuse, but the surviving technicians interviewed for this book felt Kodak was trying to persuade them to abandon the dye transfer process and convert to the Eastmancolor method.

Simultaneously, the Technicolor company was having trouble getting money out of their Italian facility, so they began importing Ferrania blank to resolve this problem as well as to offset the price increases. Many dye transfer copies from 1972 to 1974 were printed on the Italian stock, which had the identification on the sprockets. Ferrania stock caused problems in the dye transfer machines because the base was thinner and broke easily. The mordant was not as good, and it was easy to peel off the image with splicing tape.

Distribution patterns also changed in the seventies. After a few big-budget fiascos (*Doctor Doolittle, Star*), the studios began ordering smaller print runs and testing the film regionally rather than ordering the saturation bookings common in the sixties. This created additional financial worries for management, since the dye transfer process was profitable only in print orders exceeding approximately 75 copies. The management misread the market and assumed this would be the trend of the future. Ironically, the opposite turned out to be the case. Following the demise of the process, print orders increased to upwards of 1,500 copies per film, the highest in history.

Had the research department been around, they might have come up with a solution to cut costs, like perfecting soundtrack transfer and eliminating the silver content of the blank. Sadly, the management was far removed from the days of Kalmus and taking the company in other directions. A new automated Eastmancolor facility was under construction in Universal City to expand Technicolor's television division.

Conflict between management and staff (who were trying to save the dye transfer process) came to a head in the November 11, 1974, shareholders' meeting. *Variety* reported, "there was a 'tremendous gap' between rank-and-file wages and executive compensation

is 'absolutely unbelievable' and that the 'stench is extremely heavy in some areas' of Technicolor operations."*

According to *Variety*, shareholder activist John Gilbert complained about the lack of dividends on the common stock. The management's solution was to cut costs further by shutting down the Hollywood plant, eliminating the imbibition process and switching over to contact printing in the automated lab in Universal City.

As *Variety* continued, "McKenna was emphasizing the possibility of greater future profits from the new system. There is indeed a major transition in this regard, but it is being camouflaged in the p.r. of expectant profits."†

TECHNICOLOR PROCESS NUMBER SIX: EASTMANCOLOR

The management announced to a confused press the introduction of Technicolor Process Number Six in their plant at Universal City as if it were some new development. In reality, it was the identical Eastmancolor process used by other labs.

The combination of Kodak pressure, bad management and problems with the Italian stock contributed to the demise of the greatest color process ever invented. Movies would never look the same again. Not only was the superior dye transfer process phased out, so was much of the advanced technology associated with it: A and B rolling camera negatives for first generation opticals; auto select Printing; large format photography and reduction printed matrices; color enhancement; and image stability. Forty years of research and development in perfecting the color image were abandoned.

Technicolor devised a new slogan, "Still the Greatest Name in Color," although without the dye transfer process, their prints looked comparable to those coming out of other labs. They lost their uniqueness and competitive edge. This is not to suggest the new facility was not capable of making quality Eastmancolor prints. But the words "Color by Technicolor" no longer meant what they once had.

The Hollywood Technicolor Plant was sold to Television Center Studios. Had Kalmus been alive and in control of the company, it is unlikely he would have allowed this to happen.

*"*Some Sparks, No Fire at Annual Techni Meet*," Variety, *November 1, 1974.*
†*Ibid.*

PURGE

The purge that followed the shutdown was a cultural tragedy. The first elements destroyed were the stable, fade-proof prints. As detailed by John Belton in the December 30, 1974, issue of the *Village Voice*, "Technicolor, one of the most famous names in cinema, is closing its dye-transfer color lab in Hollywood (rumor has it that they have already destroyed 4 million feet of 16mm Technicolor answer prints stored there) and, starting next year, no more American films will be made using this process. . . . Nothing is forever but Technicolor used to come pretty close."*

A letter was sent to the studios, stating that any materials not retrieved by them would be thrown away. As detailed in the April 19, 1978, issue of *Variety*, "Filmmakers, distributors, archivists, buffs and perhaps even some lawyers and trustees representing estates should take notice that Technicolor Inc. has alerted customers that, unless otherwise directed — and soon — by the owners of the films involved, it plans to destroy the matrices used in the obsolete imbibition printing process."† It would appear that all of the durable, ester base black and white matrices were destroyed, leaving only faded negatives, IPs, INs and CRIs as the color legacy. As one technician noted, "When they closed up imbibition, it was one hell of a blunder. It was like losing a leg."†† Had the matrices been saved, they could have been shipped to China to reprint films in the dye transfer process, with all of the original color kept intact, at a cost far below that of U.S. laboratories.

The Eastman Kodak Company removed most references to dye transfer printing in their literature, and when it was mentioned, it was usually linked with the cumbersome three strip cameras, an association that ignored the advancements made in dye transfer prints derived from Kodak color negatives from 1954 to 1974 (VistaVision, Technirama, etc.). It was almost as if the process never existed.

Meanwhile, the British and Italian plants continued to use the process through 1978. The British prints of *Jaws* (1975) and *Star Wars* (1978) were made in the dye transfer process (the latter in Dolby stereo). The foreign prints still have vibrant colors, while the U.S. positive prints have all faded.

*"The Demise of Technicolor: Will Movies Fade?" P. 56.
†"Techni Warns Trade of Plan to Destroy 'Imbibition' Matrices," April 19, 1978.
††"Old Pix Don't Die, They Fade Away," Variety, July 8, 1980, p. 1.

According to some technicians interviewed at the London lab, the decision to shut the process down in that country was imposed on them by the Americans. Prior to the shutdown, the British Technicolor lab reprinted many classics in the process in order to have archival reference prints.

DECLINE IN EXHIBITION

Following the shutdown of the Hollywood plant, motion picture exhibition began its slow decline. One by one, the spectacular Road-show houses were torn down. Other large screen cinemas were twinned into "shoebox" multiplexes designed for economy, not comfort or quality. New tenplexes began appearing throughout the country, all with small screens. In many cases, presentation was substandard.

THE PLATTER

A new type of projection system, known as the Platter, was adopted by most theaters, replacing the standard reel to reel method. The entire feature was assembled onto a large plate, dragged across the booth with rollers and twisted into the projector gate. Few theaters knew how to set up the system properly, and prints displayed excessive wear and dirt after a few screenings. The light source was also changed from the carbon arc lamphouse to the xenon bulb. The xenons required precise adjustment to generate the full 16-foot lamberts of illumination. Not many multiplex operators had this level of technical expertise, and the result was dim screen illumination.

FALLOUT

While the exhibitors cut corners, the industry was alerted to the color fading crisis by film director Martin Scorsese and archives like the Museum of Modern Art, Eastmanhouse, the British Film Institute, the Library of Congress and the American Film Institute. Eastmancolor negatives, CRIs, interpositives, internegatives and prints were fading. The only color materials that displayed no deterioration

were Technicolor dye transfer prints in the various formats and the three strip black-and-white negatives.

Black and white separations existed on many color negatives, but making new internegatives from them was so costly that distributors continued to print from the faded originals. Faded copies began turning up in revival theaters and on television.

Articles about the deterioration of color materials began appearing in film journals: "The Color Film Crisis," in *American Film Magazine* (November 1979); "Crisis in Color Films," in *Film Comment* (September-October 1979); and "Colour," in *Sight and Sound* (Winter 1980–81). The headline of the July 9, 1980, issue of *Variety* boldly stated "Old Pix Don't Die, They Fade Away."

Prompted by Scorsese, a petition was sent to Kodak and signed by industry personnel that demanded they improve the stability of their negative and print stock. It was not until 1983 that "low fade" stock was offered (labeled LPP, or "low fade positive print," below the sprockets). For many films it was too late—the color negatives were too far gone. Even with the improved stability, "low fade" was not "no fade," which had been one of the major attributes of the dye transfer process.

Eastmancolor Today

After the smoke cleared from the color fading crisis, the industry went back to business as usual. Agfa and Fuji followed Kodak's example and offered low fade film, although their stock had better image stability to begin with. All three manufacturers continued to carry the disclaimer stating they would not warrant against color fading. The stability of post–1975 color features remained uncertain.

Circa 1988 Kodak improved their intermediate stocks, phasing out the unstable CRI. Thereafter, features were mass-produced from internegatives, three generations removed from the camera negative. Kodak also improved the grain structure with its T-Grain line.

How did a T-Grain positive print compare to a dye transfer print? For copies made directly off the camera negative, the quality was much better than pre–1988 Eastmancolor stock. However, the contrast was still weak, blacks were transparent and the color was inferior to dye transfer prints of any era. Within the limitations of the dye coupler process, the T-grain stock was an improvement.

The paradox was that Eastmancolor prints never looked worse. Most general release copies were grainy, murky and lacked definition. In this instance, it was not the fault of the stock manufacturers but the method used to make the prints.

CONTINUOUS HIGH SPEED CONTACT PRINTER

In 1975, the "new" Technicolor facility discovered it was not easy to mass-produce Eastmancolor release prints with the speed and quality of the abandoned dye transfer process, which had operated at the rate of 330 feet per minute on a 24 hour basis in 1974. The

compromise method they adopted was the Continuous High Speed Contact printer, for which Technicolor inexplicably received an Academy Award in 1976. The other large facilities also adopted this technique.

Properly processed Eastmancolor positives must be printed at a speed that allows for contrast changes and developed precisely or the quality will suffer. For example, if a scene cuts from daytime to nighttime, the printing lights must be altered. Rather than deal with this complexity, many of the labs made "thin" internegatives that were printed at one setting ("one lite"), resulting in the murky, grainy prints with poor contrast usually shown at the multiplexes.

Technicolor continued to speed up their printers until they reached the rate of two thousand feet per minute. Image steadiness was affected at this speed, and some prints "jiggled" on screen. In addition, some of the labs cut corners in processing, which resulted in contaminated chemicals and reels with a greenish tint. Many release copies smelled of residue hypo caused by improper washing, rendering the term "low fade" questionable. There were simply too many variables to generate the kind of quality control and image stability the dye transfer process offered in large print runs.

The "system" that most distributors adopted was to make between five and ten first generation prints for press screenings, Hollywood insiders and a few top houses in large cities like New York. The rest of the theaters got the high speed prints, which in many cases were substandard. Ten good copies out of two thousand was not a good ratio; quality exhibition became an elitist experience. Judging from the results, high speed printing was retrograde technology. (*Lawrence of Arabia* and *Spartacus* restorations were not made on high speed printers, which is why they looked good.) For post–1983 features, it was not uncommon for the home video versions to have superior color and contrast to the theatrical release copies. Most video masters were made from interpositives only one generation removed from the camera negative rather than three generations removed from "thin" internegatives like the high speed prints.

THE BEIJING FILM LAB

After 1980, the only facility that continued to use the superior dye transfer process was the Beijing Film Lab in China. The history

The Beijing Film Lab.

of the BFL was interesting. In the 1970s, the lab made a deal with the London Technicolor facility to purchase two machines, one for 35mm dye transfer printing and a second for 16mm IB printing. They never set up the 16mm line, although they custom-built a second 35mm machine. Most of the technical know-how came from American technicians, including the former vice-president of the research department at Techicolor, Richard Goldberg.

The lab became operational in 1978. A ten year contract was signed with Kodak to supply the matrix and blank stock. According to the Beijing staff, Kodak would not renew the deal in 1988, so the Chinese began to manufacture their own matrix and blank stock. (Kodak still offers matrix stock for dye transfer still printing, however.) By 1989, the BFL was entirely self-sufficient.

The BFL continued to improve dye transfer technology. They shortened the pin belt and were able to increase the speed of the machines. They also cut costs by printing the entire frame and allowing the projector to crop the image to the appropriate aspect ratio, thus eliminating the added expense of the gray printer for silver framelines. They continued to develop soundtrack transfer to eliminate the silver content of the blank stock. The BFL expanded to include a videotape department, using the British PAL format,

Matrices were assembled on continuous loops and traveled on rollers to the roll tank, where the matrix and blank came into contact via the pin belt as the dyes were transferred.

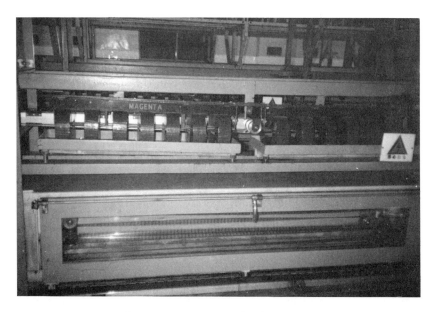

The Green matrix was dyed magenta.

which featured 625 lines of resolution compared to the domestic 525 lines. The BFL also custom made laserdiscs that had a pink rather than a silver coating. It would appear that many advancements in motion picture technology are coming out of China rather than the United States.

In 1989, I traveled to China to make matrices and dye transfer release prints of the feature film *Space Avenger*, which played regionally throughout the United States, including New York, Los Angeles and Washington, D.C. The Cleveland Cinematheque featured it, along with original dye transfer prints of *The Gang's All Here* and *Vertigo*, as part of their 1991 Technicolor festival. Program director, John Ewing tried an interesting experiment with *Vertigo*. He played the first reel in the Eastmancolor print supplied by Universal and then the entire feature in a mint dye transfer copy borrowed from a film collector. After the screening, people of all ages wanted to sign a petition to the Technicolor company to bring back the process in the United States.

The premiere of Chinese Technicolor attracted the attention of the press. Articles appeared in *Variety* and the *Hollywood Reporter* detailing the superior quality of color prints coming out of Beijing. Leonard Maltin, another notable Technicolor buff, devoted a segment to the process on "Entertainment Tonight."

Unfortunately, response within the industry was less enthusiastic. The emphasis in film marketing was on video, and no distributor seemed to be interested in improving the quality of general release prints. Many considered theatrical exhibition paid advertising for home video and cable releases. As long as the video master was good, it did not matter if the release prints were poor since, unlike tapes and discs, they were considered expendable. Besides, the Hollywood insiders got to see the first generation prints, which were good, although inferior in color and contrast to dye transfer prints. The fact that audiences were being charged to see substandard general relese prints seemed unimportant. Motion picture exhibition had been in decline for so long, most audiences didn't know what they were missing.

The future of motion pictures is uncertain as of this writing. Some insiders feel that theaters will eventually switch to video projection (videoplexes), eliminating release prints altogether. Perhaps the introduction of high definition television will contribute to a decline in theatrical and create some healthy competition among

distributors to bring back quality exhibition. It is still possible to make a beautiful, fade proof, dye transfer release print, even if one has to travel to Beijing. The Chinese have stood by the process against all odds. Herbert Kalmus would have been proud.

Bibliography

Much of the documentation of this book was extracted from a series of technical lectures by the Technicolor staff which were written down and saved by the technicians as their legacy. It proved to be an excellent source of what the company offered and their printing methods. I interviewed many of the surviving technicians at the annual Technicolor retirees luncheon in 1991 where I was a guest speaker. I continue to correspond with Dr. Richard Goldberg, Stan Solo and Jeffrey Selznick who worked at the facility.

Film collectors were very supportive of this project and allowed me to screen their private collections of rare 35mm and 16mm dye transfer prints in the various formats. It was encouraging to discover that a large percentage of the U.S. features printed in the stable dye transfer process exist in excellent condition through these collectors although few copies exist in studio vaults. Film collectors may turn out to be the unofficial curators of our color film legacy since many dye transfer prints will outlast the negatives they were made from.

BOOKS

Adair, Paul E. *Everything You Wanted to Know about 3-D but Were Ashamed to Ask.* Adair, 1972.

Basten, Fred E. *Glorious Technicolor.* San Diego, CA: A. S. Barnes, 1980.

Cameron, Evan William. *Sound and Cinema.* New York: Redgrave, 1980.

Carr, Robert E., and Hayes, R. M. *Wide Screen Movies.* Jefferson, NC: McFarland, 1988.

Coe, Brian. *The History of Movie Photography.* Westview, NJ: Eastview Editions, 1981.

Fielding, Raymond. *A Technological History of Motion Pictures.* Berkeley, CA: University of California Press, 1967.

Film Daily Yearbook of Motion Pictures, 1929–1970. Wid's Film and Film Fol, 1929–1970.

Hutchitson, David. *Fantastic 3-D.* New York: Starlog Press, 1982.

Limbacher, James L. *Four Aspects of the Film.* Limbacher, 1968.

Morgan, Hal, and Symmes, Dan. *Amazing 3-D.* Boston, MA: Little, Brown, 1982.
Walker, Alexander. *The Shattered Silents.* New York: William Morrow, 1979.

ARTICLES

Belton, John. "The Demise of Technicolor: Will Movies Fade?" *Village Voice,* December 30, 1974.
Bliss, Michael. "Technical Tips: 'Not Fade Away.'" *Classic Image,* no. 73.
"Colour." *Sight and Sound,* Winger 1980–81.
Dutfield, R. J. "Silver Separation Masters Can Protect Color Prints: Dutfield." *Variety,* February 11, 1981.
"Dye Transfer Plant in Peking." *Variety,* May 7, 1980.
Harwood, Jim. "Distribs Won't Pay Extra for No-Fade Stock." *Variety,* February 11, 1981.
Hunt, C. Bradley. "Corrective Reproduction of Faded Color Motion Picture Prints." *SMPTE Journal,* July 1981, and vol. 90 November 7.
Jacobson, Harlan. "Old Pix Don't Die, They Fade Away." *Variety,* July 9, 1980.
Kalmus, H. T. "Technicolor Adventures in Cinemaland." *Journal of of the Society of Motion Picture Engineers,* December 1938.
Linsey, Robert. "Martin Scorsese's Campaign to Save a Film Heritage." *New York Times,* October 5, 1980.
Murphy, A. D. "Some Sparks, No Fire at Annual Techni Meet." *Variety,* November 13, 1974.
O'Connell, Bill. "Special Report: Crisis in Color Films, 'Fadeout.'" *Film Comment,* September–October 1979.
Salk, Jaan. "Then You Saw It—Now You Don't (The Vanishing Art of Colour Film)." *Toronto Film Society Newsletter,* Spring, 1981.
Spehr, Paul C. "The Color Film Crisis." *American Film,* November 1979.
Stull, William. "Technicolor Bringing New Charm to Screen." *American Cinematographer,* June 1937.
"U.K. Technicolor Subsidiary Sells Equipment to Peking." *Variety,* August 2, 1973.
"VistaVision." Paramount brochure, 1954.

TECHNICOLOR LECTURES, 1955–1957

1955

Lecture no. 1. General Introduction to Light and Optics, by Donald H. Kelly, August 16, 17.
Lecture no. 2. General Characteristics of Photographic Materials, by Richard J. Goldberg, August 18, 19.
Lecture no. 3. Photometry, Spectrophotometry and Colorimetry, by Donald S. Nicholson, August 23, 24.
Lecture no. 4. Photographic Sensitometry, by James P. McTear, August 25, 26.
Lecture no. 7. Technical Characteristics of Sensitometers and Densitometers, by Charles D. Bennes, September 20, 21.

Lecture no. 8. Eastman Color Negative, Color Positive and Kodachrome. by Dr. Norwood Simmons, September 22, 23.

Lecture no. 9. Precision of Measurements Applied to Process Control, by William F. Ward, September 27, 28.

Lecture no. 11B. Technical Performance from the Management Viewpoint, by Leland B. Prentice, October 4, 5.

1956

Lecture no. 1. The Film Products of the Technicolor Plant, by Alan M. Gundelfinger, January 17, 18, 20.

Lecture no. 2A. The Flow of Film Products Through the Technicolor Plant, by Roland R. Forcier, January 24, 25, 27.

Lecture no. 2B. Review of Matrix Manufacture, by Frank P. Brackett, January 24, 25, 27.

Lecture no. 3. Track Printing, Blank Processing and Transfer, by John F. Kienninger, January 31, February 1, 3.

Lecture no 4A. Rating Density and Ratio of Release Prints and Use of Wash Back, by Arthur J. Salkin, Feburary 7, 8, 10.

Lecture no. 4B. Film Demonstration of Processing Defects, by Arthur J. Salkin, February 7, 8, 10.

Lecture no. 5A. Register, by Alan M. Gundelfinger, February 14, 15, 17.

Lecture no. 5B. Rating of First Transfer Prints, by R. Thomas Cave, February 14, 15, 17.

Lecture no. 6. Classification and Disposition of Prints, by Cutler B. Speed, February 21, 22, 24.

Fundamentals of Track and Gray Printers, by Howard C. Fundle and Peter J. Warren, September.

Flow of Products Through the Positive Blank Department, by John J. Haller, September.

Lecture no. 1A. Introducing Our Program, by John J. Haller, November 8, 9.

Lecture no. 2A. Fundamentals of Blank Processing, by Robert G. Buckley, November 15, 16.

Lecture no. 3, Fundamentals of Sound Track Printing and Developing, by Ferdinand L. Eich November 29, 30.

1957

Lecture no. 4. Review of Film Defects for Cause and Prevention, by John J. Haller and James R. Johnson, January 2.

Index

A&B roll negatives 86, 105, 119, 128, 134
Academy Awards 18, 20, 32, 105, 106, 129, 140
The Adventures of Robin Hood 31
The Adventures of Tom Sawyer 35
Agfa 59, 139
Agfa Color 57
American Film Institute 60, 136
Anaglyphic 3-D 72
Ansco Color 57, 59, 65, 72, 73, 79, 88
Antonioni, Michelangelo 116
Argenta, Dario 116
Around the World in 80 Days xv, 103, 105
Athena 77
Audioscopiks 69
Automatic Selective Printing 128, 129, 134

Ball, Joseph Arthur 3, 21
Barrymore, John 9
Becky Sharp 20
Beijing Film Lab xiii, xvi, 73, 140, 141, 143, 144
Belton, John 135
Ben-Hur 114, 115, 116
Beneath the 12-Mile Reef 53
Berkeley, Busby 35
The Big Circus 109
black and white panchromatic separation positives 56, 137
Black Narcissus 32
The Black Pirate 7
blank 8, 12, 24, 26, 33, 77, 125, 130, 132, 133, 141

Bloomingdale, Alfred 121
blow up 28, 29, 30, 109, 112
Blue Track Technicolor 30
Bolshoi Ballet 67 129
The British Film Institute 136
The British Lab 31, 32
British lacquer 32
Broccolli, Albert 132
Bwana Devil 72

Cabaret 132
Captains of the Clouds 28
Cardinal 109
Carousel 100
C.F.I. Lab 103
Cheyenne Autumn 129
Cinecolor 52, 56, 57, 59
CinemaScope 55, 73, 74, 75, 77, 79, 83, 99, 100, 103, 106, 109, 113
Cinemiracle 68
Cinerama 66, 67, 68, 69, 74, 99, 102, 106, 114, 121, 124
Cinestage 105
"The Colgate Comedy Hour" 61
color consultant 20, 27, 132
Color Reversal Internegative 131, 132, 135, 136, 140
color timing 24
Comstock, Daniel 1, 2, 3, 4, 6
Consent Decree 49, 51, 52, 53
Continuous High Speed Contact Printer 139, 140
Cooper, Merian C. 67
Cretien, Henri 74
La Cucaracha 20
Cytheria 7

DeLuxe Color 52, 53, 55, 88, 100, 119
DeMille, Cecil B. 6–7
Dial M for Murder 73
Diamonds Are Forever 132
Disney, Roy 17
Disney, Walt 17, 18, 19, 29, 86, 131
Dive Bomber 28
Divorce of Lady X 32
Doctor Doolittle 133
Doctor X 13
Don Juan 9
double rank 16mm 30, 31
"Dragnet" 131
Drums 32
Dunfee, Natalie 1
Du Pont 77
Du Pont positive stock 57
dye transfer xv, xvi, 5, 12, 30, 31, 35,
 59, 60, 72, 73, 77, 79, 81, 82, 83,
 85, 86, 88, 99, 100, 101, 105, 106,
 107, 108, 109, 113, 114, 116, 119, 121,
 124, 126, 128, 129, 130, 131, 132, 133,
 134, 135, 137, 139, 140, 141, 143

Eastmancolor 23, 33, 35, 51, 53, 54,
 55, 59, 65, 79, 81, 82, 86, 87, 100,
 102, 103, 106, 107, 108, 109, 119, 124,
 128, 131, 132, 133, 134, 139, 140, 143
Eastmancolor negative 49, 53, 136
Eastmanhouse 136
8mm dye transfer 130
El Cid 108
Ewing, John 143

Fairbanks, Douglas 7
Fantasia 101, 102
Fantasound 102
Fellini, Federico 116
Ferrania stock 133
First Generation Opticals 86, 87, 88,
 119, 134
Flowers and Trees 17
The Forest Rangers 28
Fox holes 74
Frawley, Patrick 119, 124, 125, 132
Frischmuth, Robert xv
Fritzche, William 27
Fujicolor 57, 139

Gance, Abel 69
The Gang's All Here 35, 143
Garland, Judy 37
General Tire Corporation 124
"Get Smart" 131
Giant xiii, 27
Gilbert, John 134
Godfather 35, 132
Goldberg, Richard 65, 66, 77, 125, 141
Goldwyn, Samuel 7
Gone with the Wind 35, 66, 86
Gray Printer 24
The Great Race 128
The Gulf Between 2, 3

Hell's Angels 13
Henry V 101
Hitchcock, Alfred v, 27, 85
Hopkins, Miriam 20
House of Rothschild 21
How the West Was Won 68, 69, 124
How to Marry a Millionaire 53
Hughes, Howard 100, 101

imbibition xiii, 8, 9, 30, 65, 107, 114,
 134, 135, 141
It Came from Outer Space 86
It's a Mad, Mad, Mad, Mad World xv,
 124
It's Always Fair Weather 79

Jaffa, Henri 27
Jaws 135
The Jazz Singer 10
Jolson, Al 10
The Jolson Story 37

Kalmus, Herbert 1, 2, 4, 6, 13, 17, 19,
 21, 24, 27, 32, 51, 52, 53, 73, 74,
 88, 116, 119, 121, 124, 134, 144
Kalmus, Natalie 1, 20, 27, 57
Keaton, Buster 5
Kid Millions 20
Kinemacolor 2
kinescope 61
The King and I 100
King Kong 67
King of Jazz 13

King Solomon's Mines 28
Kiss Me Kate 73, 88
kodachrome 28, 29
Kodak, Eastman 27, 51, 53, 54, 55, 56, 57, 59, 65, 66, 67, 77, 79, 99, 102, 124, 125, 131, 132, 133, 134, 135, 137, 139, 141
Korda, Alexander 32

Lassie Come Home 28
Laurel and Hardy 13
Lawrence of Arabia 129, 132, 140
Library of Congress 130
lilly 25, 33
Live Action Photography 19, 20
The Living Desert 30
LPP stock 137
Lust for Life 59

McFarlane, Donald O. 132
McKenna, William E. 132, 134
magnetic stereo 68, 72, 74, 75, 102, 105
mag/optical format 75, 106, 107, 108, 112, 113, 114, 129
Maltin, Leonard 136, 137
Mammy 13
Mamoulian, Rouben 20
The Man Who Knew Too Much 85
Marionettes 7
matrix 2, 5, 8, 9, 11, 12, 18, 23, 25, 29, 32, 33, 77, 81, 83, 105, 106, 107, 113, 114, 125, 128, 129, 130, 132, 133, 134, 135, 141
Mayer, Louis B. 19
Mees, Kenneth 124
Meet Me in St. Louis 37
Metrocolor 55, 59, 119
MGM Camera 65 113, 114, 116, 121
Miranda, Carmen 35
Mitchell, George 21
Moby Dick 24, 128
Monopack 27, 28, 29, 30, 53, 73
movietone 10, 11
multiple component dyes 65, 66
multiplex 136
Museum of Modern Art 136
The Music Man 108, 131
My Fair Lady 129
Mystery of the Wax Museum 13

Napoleon 69
nitrate base 31, 59, 60, 125
North by Northwest 85, 106

Obler, Arch 72
O'Brian, Dr. Brian 102
O'Connell, Bill 55
Oklahoma! 103
opticals 25, 26

Panavision 70, 78, 109, 113, 126, 128, 129
panchromatic matrix stock 66
Paramount on Parade 13
Pathé Color 55, 119
Penthouse 75, 76
Perspecta sound 81, 85, 105
photophone 10, 11
Platter 136
polarized 3-D 72
Polaroid company 73
Porgy and Bess 119
Powell, Michael v, 32
Prouch, Henry 21

Raintree County 113
Reclaim Blank 26
Reeves, Hazard 67
Red Shoes 32
Reflections in a Golden Eye 128
Reynolds, Albert H. 99
The Robe 74, 77, 79
The Rogue Song 13
Russell, Dowlen 99

safety base 31, 59, 60, 125
Saltzman, Harry 132
Schenck, Joseph 5
Scorsese, Martin 136, 137
Seal Island 30
selsyn interlock motors 72
Selznick, David O. v, 27, 35
Show Boat 60
"The Show of Shows" 61
single component dyes 65, 66
single rank 30, 31
16mm dye transfer prints 30, 141
Smith, Pete 69

Société Technicolor 116
Son of Sinbad 101
South Pacific 119
Sovscope 70 129
Space Avenger xvi, 143
Spartacus 108, 119, 140
Spilker, Eric 35
Star 133
A Star Is Born 79
Star Wars 135
Stars and Stripes Forever 28
State Fair 37
Steamboat Willie 17
stripping negative 65
Successive Exposure Animation 17, 18, 19
Super Cine Color 57
Super 8mm dye transfer 130
Super Panavision 70 128, 129
SuperScope 100, 101, 102, 126

Technicolor Italiana 116, 125
Technicolor package 32, 33
Technicolor Process Number Five 66
Technicolor Process Number Four 17
Technicolor Process Number One 1, 2
Technicolor Process Number Six 134
Technicolor Process Number Three 8
Technicolor Process Number Two 4
Technirama 106, 107, 113, 116, 125, 135
Technirama 70 106, 107
Techniscope 125, 126
Television 50, 51, 60, 61, 64
The Ten Commandments 7
T-Grain stock 137
Thief of Bagdad 32
The Third Dimension Murder 69
This Is Cinerama 68, 69, 102, 124
Thomas, Lowell 67, 68
3-D 69, 72, 73
Three Strip Camera 21, 23
Three Strip Matrices 23
Thrillarama 99
Thrillarama Adventure 99
Thunder Bay 86
Thunderball 128

Thunderhead, Son of Flicka 28
To Catch a Thief 85
Todd, Michael 67, 102, 105, 106
Todd AO 100, 102, 103, 106, 116, 128
Toll of the Sea 6
Tom Jones 56
Troland, Leonard 3, 4, 28
The Trouble with Harry 85
Trucolor 52, 56, 57, 59
Tushinsky brothers 100, 101

Ultra Panavision 70 113, 114, 121

variable area track 11
variable density track 11
Vectograph 3-D 73
Vertigo 85, 131, 143
The Viking 11
Visconti, Luchino 116
VistaVision 73, 77, 81, 82, 83, 86, 99, 105, 106, 125, 135

Waller, Fred 67
Wanderer of the Wasteland 7
Ward, William 133
Warnercolor xiii, 27, 55, 88, 119
washback 33
Weaver, Eastman 3
Wescott, W. Burton 1, 2, 4, 6
West Side Story xv
Wet Gate Optical Printer 87, 88, 119
White Christmas 82
Whitney, Jock 19, 20
Whitney, Sonny 20
Wichita 79
Widescreen "Flat" Films 86, 88
Wild Bunch 128
Windjammer 68
Wings of the Morning 32
The Wizard of Oz xv, 31, 33, 66, 86, 131
The Wonderful World of the Brothers Grimm 68, 69, 124
Wong, Anna May 6